AFTERWARDS

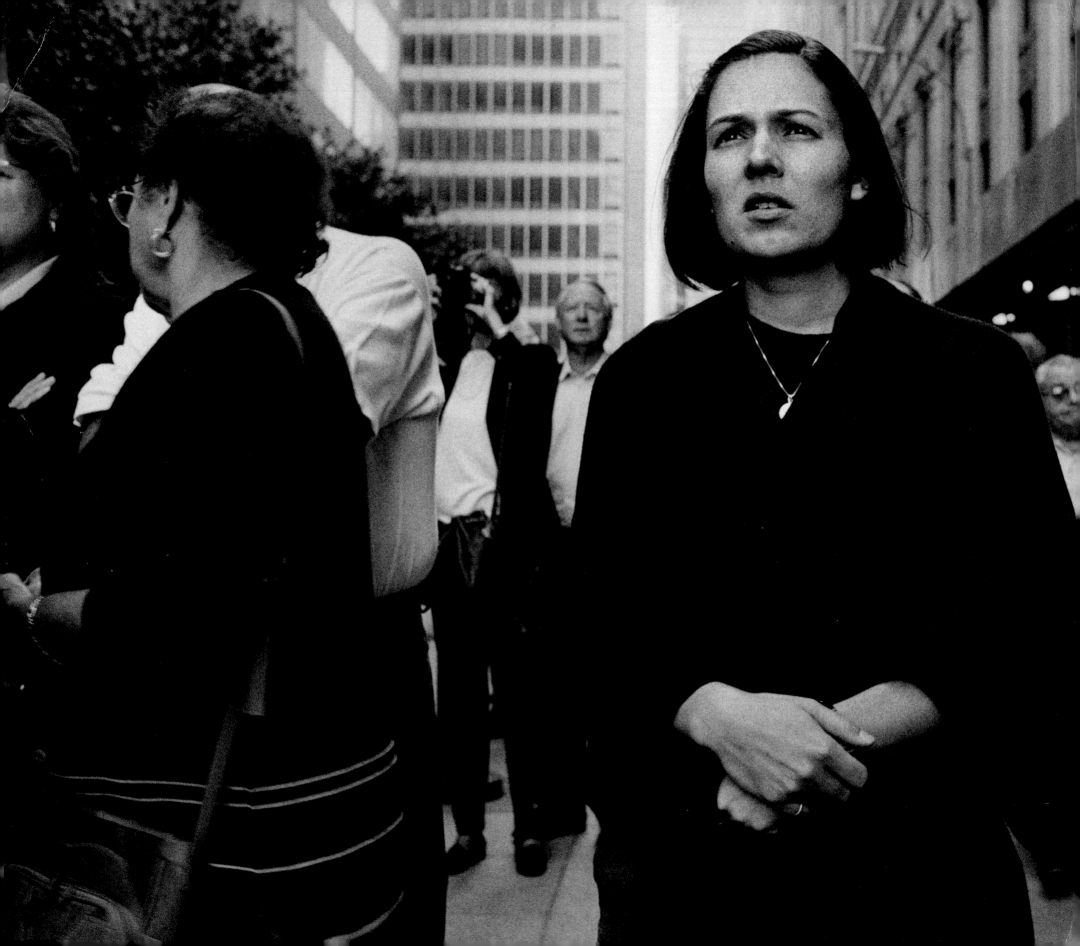

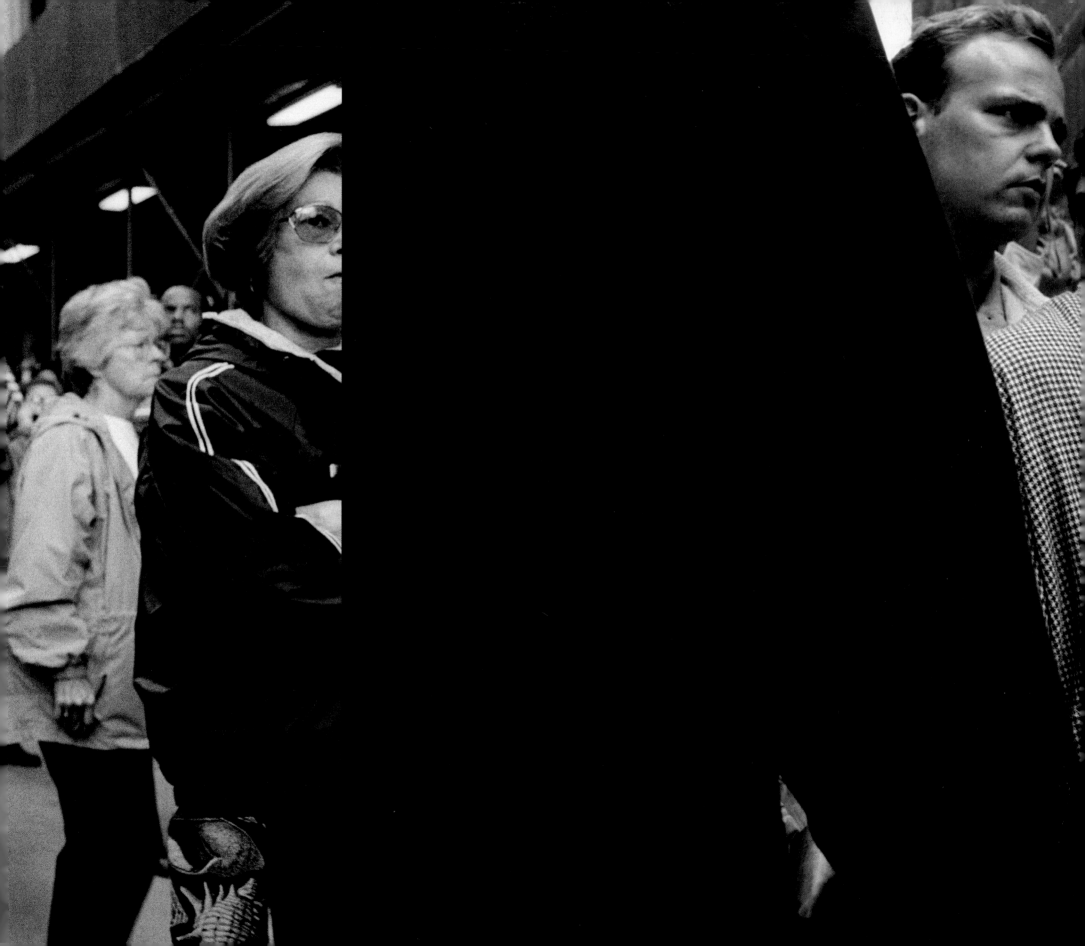

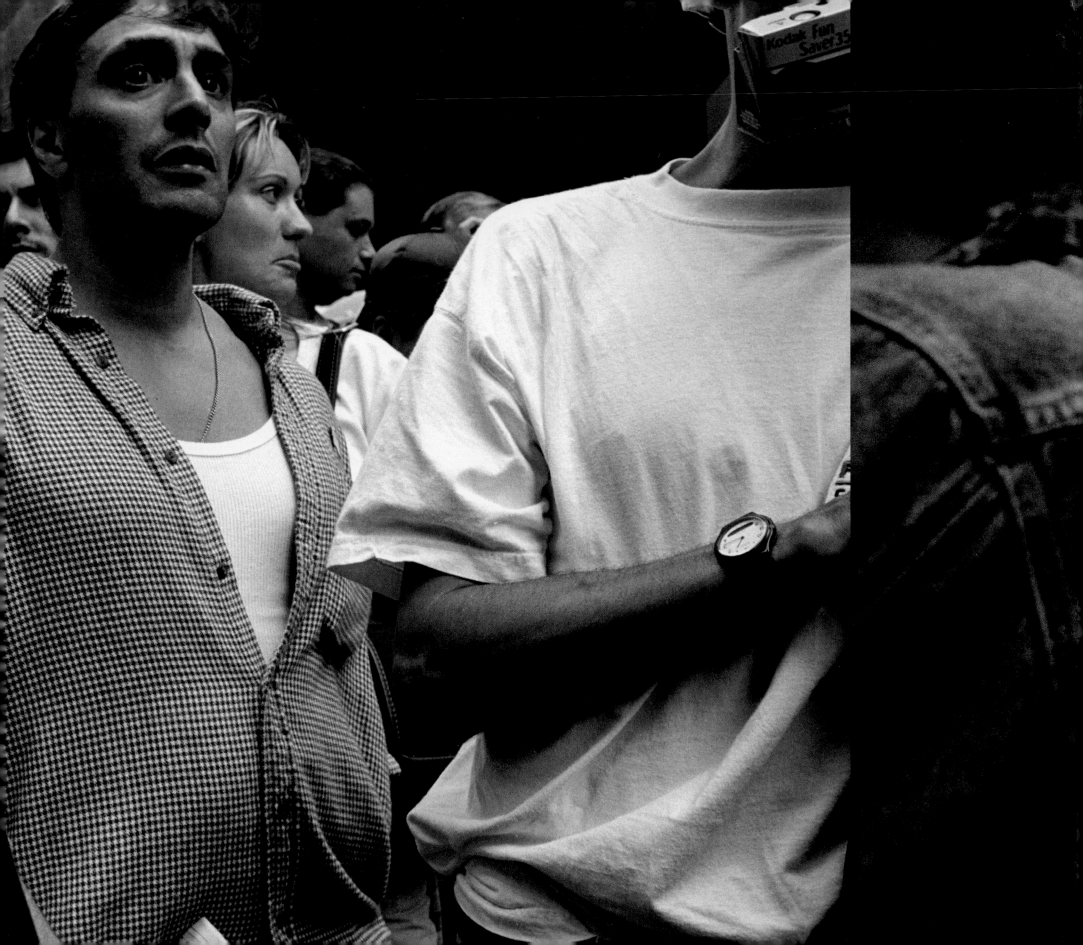

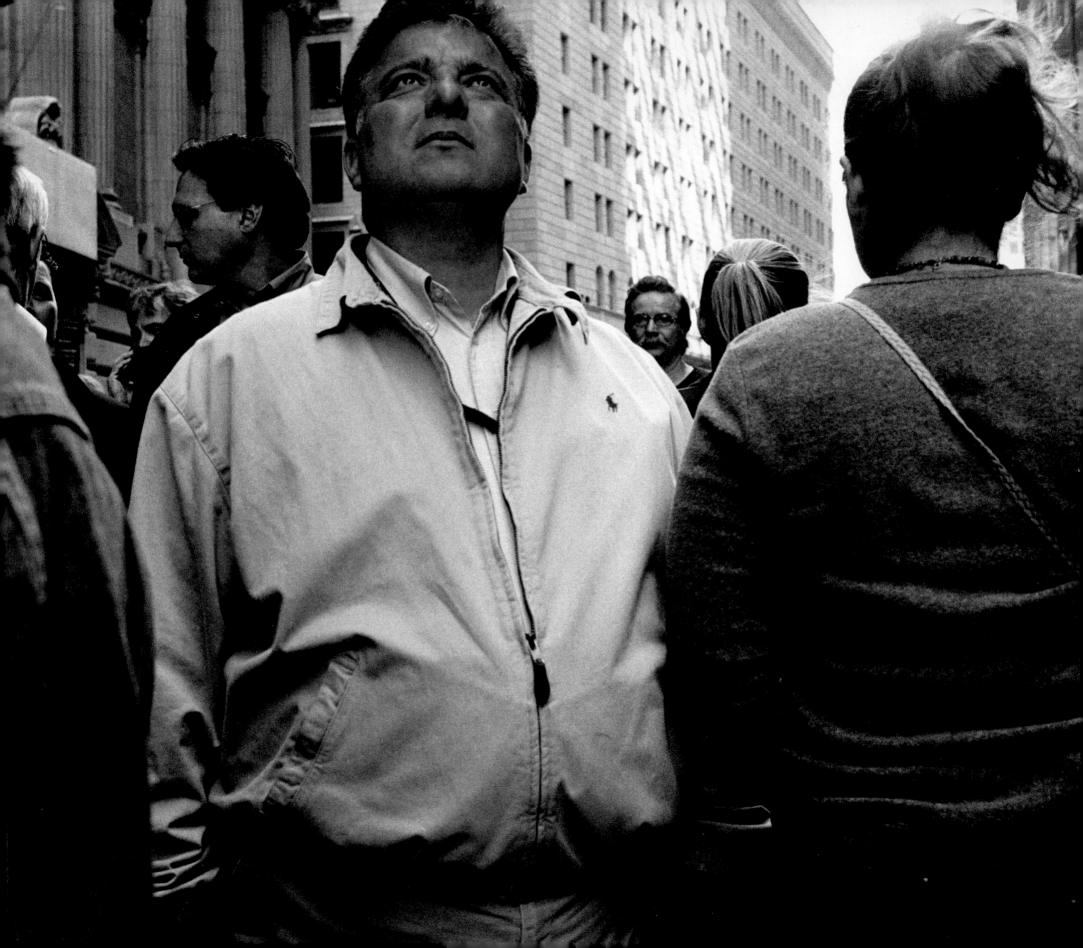

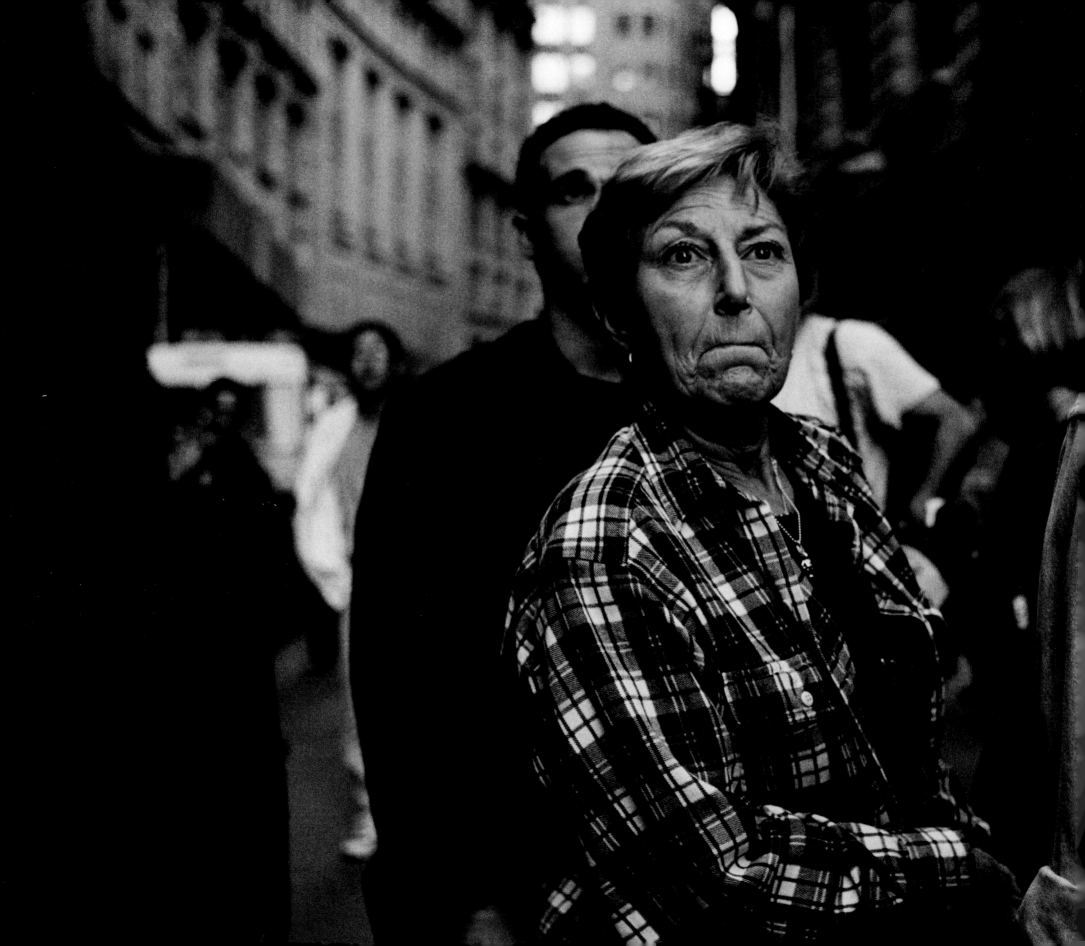

AFTERWARDS

Contemporary Photography Confronting the Past

Nathalie Herschdorfer

with 189 illustrations, 158 in colour

 Thames & Hudson

 Elysée Lausanne

FRÉDÉRIC SAUTEREAU

(France, b. 1973)

N40°42'42" W74°00'45", September 22–28, 2001

The subject of unprecedented global media coverage, the events of 9/11 marked the start of the 21st century with a profound visual impression. The World Trade Center in New York was the focus point for all news cameras from the moment the first plane hit, and the image of the falling towers was omnipresent on front pages and television screens. While the press churned out pictures of the towers swathed in thick smoke, their fall and the dust filling the city, Sautereau chose to turn his back on the ruins of Ground Zero. He understood that the catastrophe was written in the eyes of those who were watching in disbelief as ash clouds rose from the crumbling buildings. As a collective trauma, the September 11 attacks were a wound shared by many people all over the world. Sautereau makes this fact palpable by turning his lens towards the human rather than the urban.

Pages 2–7
N40°42'42" W74°00'45"

Contents

Preface

WILLIAM A. EWING, Director, Musée de l'Elysée, Lausanne (1996–2010)
ROGER MAYOU, Director, International Red Cross and Red Crescent Museum, Geneva
KLAUS SCHERER, Director, Swiss Center for Affective Sciences, University of Geneva

From the very early days of photography, photographers felt compelled to bear witness to significant events, since their testimony was thought to be of such veracity and exactitude that it would stand up in a court of law. However, in the beginning photography was, literally and figuratively, too slow a medium to grasp newsworthy moments. For one thing there were the cumbersome technical constraints to contend with: the awkward cameras anchored to tripods, the fragile glass negatives, the complexity and unreliability of the chemicals and the substantial expense of materials and manpower (working further afield required a coterie of assistants to carry heavy glass plates and bottles of chemicals). Second, there was an absence of professional 'templates' or codes to follow. And who would be willing to pay for the results? Moreover, even someone who could justify a purchase of such photographs – what would he do with them, given the technical impossibility of reproduction in newspapers? For the pioneers of what has come to be called, unsatisfactorily, 'reportage', 'photojournalism' or 'documentary photography', there was little to provide a solid foundation for a new genre. During those first decades, these photographers had to practically invent their field.

Therefore one searches more or less in vain for vivid photographs of great battles, massacres and catastrophes in 19th-century photography. Early 'news photography' always happened after the fact; when the dust had already settled. Occasionally one comes across something purporting to show 'an event' but in fact the staging is always obvious, or shows something mistaken for something else, such as a battle scene that turns out to be an army training manoeuvre. Today a debate rages about one such early image, relating to the Crimean War. Roger Fenton's famous photograph of an empty field strewn with cannon balls (see p. 15) has been the subject of much debate: some claim the cannon balls were placed there after the battle, in what we would today call a 'photo opportunity'; others insist that no, they were not.

Over the years, as photographers began to overcome the many obstacles, two distinct photographic personalities, or types, emerged: one, the news photographer who rushed to the scene of a crime or accident at the drop of a hat, ready to join a battle in a flash. Often this type of photographer took huge personal risks, with many paying the ultimate price for their courage or reckless-ness. At the other end of the spectrum was the contemplative type who adopted a 'wait-and-see' approach, attracted to battlefields certainly, but well after the smoke had cleared. Bigger truths, this camp argued, came after much reflec-tion, intense scrutiny of the terrain, and often a reading of history for the bigger picture. Those who believed in striking while the iron was hot argued that events had to be captured as they were unfolding or they would never be truly under-stood, but those of a more reflective persuasion argued that focus is sharpened with the passage of time.

Afterwards is aimed, quite squarely, in the direction of this second camp. The book has grown, quite naturally and rapidly, from an exhibition conceived by curator Nathalie Herschdorfer , then of the Musée de l'Elysée, who was respond-ing to a request from the International Red Cross and Red Crescent Museum in Geneva for an exhibition on the theme of socially engaged photography. Herschdorfer came up with an idea that would look at the aftermath of signifi-cant historical events as interpreted by half a dozen committed photographers. The proposal was accepted and the exhibition 'Stigmates' was mounted in 2009. As often happens with such exhibitions, related projects subsequently came to our attention. This fact, coupled with the enthusiastic reaction to the show by the public and the photographic community alike, suggested that a much more extensive publication could be realized. *Afterwards* is that project: it features pho-tographs by more than thirty photographers whose work covers a wide range of events and situations: wars and civil wars, massacres, terrorism, imprisonment, displacement, exile, human bondage, genocide and natural disaster.

However, this work was never meant to be forensic: none of the photographers expect their pictures to be held up in court as evidence, or hope to inflame pas-sions for a cause or support an ideology. It is a step *back* these imagemakers take, suggesting that the lessons to be learned are not about pointing fingers at a party, army, state, sect or individual, but about identifying repeated social behaviours, with their terrible consequences. Why, they prompt us to ask, do we repeat these intolerable acts? What are the emotional and psychological factors that keep us on this infernal treadmill? Individual photographs are rooted in very specific cir-cumstances – this civil war, that massacre. They are always *local* in this sense, but they also invite generalization. Each terrible case resembles numerous others.

In 2005 the Swiss federal government launched a unique, multi-university research programme on emotions: the Swiss Center for Affective Sciences, headquartered at the University of Geneva. In a close working relationship with the International Red Cross and Red Crescent Museum, the proposal was made to study the exhibition 'Stigmates' from this point of view, and nine researchers were asked to contribute papers on such varied subjects as empathy, discrimination, exclusion and victimization. These essays are included in the Further Texts at the back of the book. Some take specific bodies of work as their focus while others address issues that cut across several or all of them. Relevant terms, such as 'victim' and 'stigma', are closely examined and their meanings are explored as they have changed with time. Finally parallels are drawn between the photographers and the humanitarian workers. Together the essays bring an unusual perspective to a photography book and remind us that the curators and photohistorians do not necessarily have the last word on photographic meaning and that photographs can be prime carriers of emotion.

Afterwards – the word itself and the book's title – can mean many things. In his essay 'Scars on the Soul' Tobias Brosch quotes Samuel Pepys, who after the Great Fire of London in 1666 reported: 'So great was our fear, it was enough to put us out of our wits. Afterwards, news of a chimney fire some distance away put me into much fear and trouble.' In a sense all catastrophes, man-made or natural, can have this effect on people far removed from the actual events: afterwards, then, every reader of this book can rightfully expect to feel, 'much fear and trouble'.

No matter how much we learn about photography, no matter how much we have learned to distrust its claims to show the 'truth' (a distrust that has taken a quantum leap in the digital age), the fact remains that photographs still carry an undeniable evidentiary weight. We look, we see 'with our own eyes', we believe. As a result, photography has often been employed for propaganda, with an intentionally blinkered vision. But thankfully the talented and dedicated photographers in *Afterwards* vehemently reject this approach – instead they work to enlarge and enrich our view of the world.

Introduction

NATHALIE HERSCHDORFER

We now know what happens every day throughout the whole world ... the descriptions given by the daily journalists put those in agony on fields of battle under the eyes of readers, and their cries resonate in their ears. Gustave Moynier (President of the International Committee of the Red Cross), 1899

A claim to know what is happening 'every day throughout the whole world' sounds like an exaggeration, particularly in 1899. Even today, we cannot be aware of all the suffering that is being inflicted across the globe. Nonetheless, it is true that 'being a spectator of calamities taking place in another country is a quintessential modern experience', as Susan Sontag said in her essay 'Regarding the pain of others' (2004). It is no coincidence that the earliest generations of photographers were present on the battlefield.

We are subject to a constant flow of images – via the internet, television and the press. But in an era of information overload, a fixed image can be very powerful. A photograph provides a means of rapidly grasping a subject and committing it to memory. Each of us has a store of hundreds of remembered photographic images. Think of the piles of bodies at Auschwitz, or Robert Capa's image of a Republican soldier being hit by a bullet in the Spanish Civil War. These are shocking images: they grab our attention and stay with us.

Since its invention, photography's vocation has been to communicate the world. The photojournalist dives into the heart of the action, seeking speed, spectacle and impact. All the tension of the situation must be concentrated into a single frame. But other photographers question this approach. Side-stepping the stream of real-time images, they seek to cultivate distance and to break free from the dictates of photojournalistic convention and the demand for sensationalist pictures. Their visions, very different from the style of images that dominate our current media, follow a different quest.

Afterwards aims to provide an overview of contemporary forms of documentary photography and the controversial role of the image as record, eyewitness

account and tangible trace. The works brought together here display a measured, innovative and ambivalent approach to the documentary tradition. These are images that are 'out of sync', existing in parallel with mainstream media. The photographers have not tried to enter the eye of the storm but rather to capture its impact in what remains. In doing so, they are questioning their own profession as well as our modern-day fixation with immediacy.

But is it possible to communicate events that took place before a picture was taken? The range of subjects is broad: journeys through killing fields, military training camps or a city devastated by a hurricane; encounters with people who find themselves cast out; the faces of soldiers who have returned from combat, or refugees forced to leave their homelands; the families of victims of forced disappearances. The photographers invite us to reflect on the way in which wars, human suffering and natural disasters leave their mark on people and landscapes. Can faces and bodies truly reveal the pain that has been endured? Can peaceful, seemingly ordinary places evoke experiences of horror and death? Do the scars of history leave a permanent imprint on a landscape?

Although they are in a sense 'pre-recorded', the images collected in this book nonetheless say something about the conflicts and catastrophes of our world. The images raise issues relating to our planet and to people caught up in painful events. After the drama, the scars, marks and consequences remain. These images speak of suffering, disorder, grief and injury. Today a huge wealth of pictures is available, and although these cannot take into account every aspect of the reality that they depict, they nonetheless fulfil a vital function. Without necessarily resorting to spectacle, a photograph is able to convey pain. These images should encourage us to think, to pay attention and to examine the suffering that they represent. We should allow these images – and their serious, traumatic, horrifying subject matter – to haunt us.

Beyond what it actually depicts, a photograph retains the capacity to evoke reactions and associations in those who look at it. Looking at an image also means assimilating its history, culture and related emotion.

Photography has been entrusted with the task of providing a visual record of its time: through press images, photographic archives, amateur snapshots and photo-essays, memories are 'documented' in photography. It was not until the 20th century that this 'regime of belief in the image' took root. Photography had begun to make its mark during the Crimean War and the American Civil War, but it could never capture the action as it was happening because of the long exposure times required. Furthermore, its focus was always on the results, the traces – in other words, the ruins. The work of Roger Fenton (see p. 15) in the

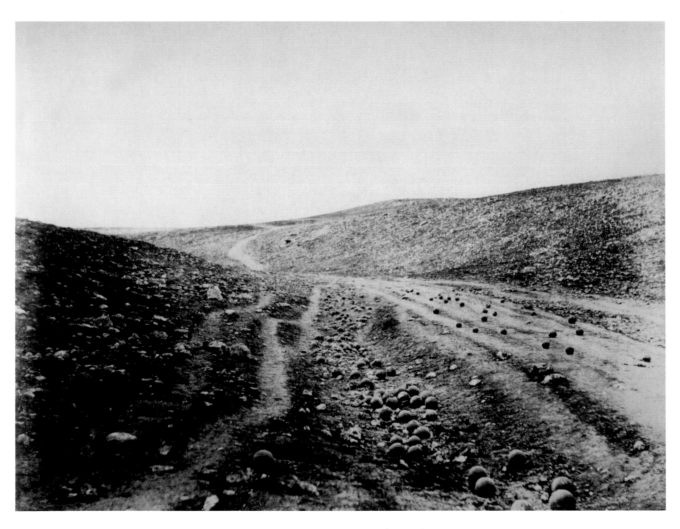

Roger Fenton, *The Valley of the Shadow of Death*, 1855

Crimea does not show a single corpse. The battlefields appear in harmonious compositions. War is a no-man's-land. It was only during the First World War that photography replaced illustration, and it took in all the fighting, the frontline, and proved to be a valuable tool for the military. From 1917 onwards, aerial photography became a weapon in itself because it offered a better view of the terrain, the condition of the trenches and the position of the troops. This information was vitally important to the combatants. Edward Steichen (see opposite page), one of the first specialists in aerial photography, was put in command of the photographic division of the American Expeditionary Forces. His images reveal what was then an unprecedented view of the land. Professional reporters with permission to accompany the troops were able to capture some moments of the war, but the army controlled the pictures that they took. Although war reporting came much closer to the action during the Spanish Civil War and the Second World War – Robert Capa famously said 'If your pictures aren't good enough, you aren't close enough' – it entered a period of crisis after Korea and Vietnam. The same kind of close proximity was no longer conceivable. The Falklands War and the first Gulf War were virtually wars without images, and in Iraq in 2003 the accompanying reporters found themselves a long way behind the front lines. Photojournalists were in effect banned from the battlefield.

The past twenty years have called for some serious consideration regarding the non-representation of war. The media have found themselves faced with a lack of images of the places where the action is really happening. In any case, there is also a need to question the representation of war even before the crisis within photojournalism. The truth is that 'a war photograph, taking into account the total number of photographs taken, is only rarely a factual image' (Vincent Lavoie). Troops getting ready, people waiting or on the move, rubble – as the historian Laurent Gervereau has pointed out, fighting is rarely in the foreground. Indeed, what images have we actually seen of people suffering? Images of the atomic bombs dropped on Hiroshima and Nagasaki are nearly all aerial. But what about the effects on the ground? What have we seen of the massacre of the Armenians or the Nazi concentration camps?

War is a complex reality, and the violence and terror are difficult to depict visually. Contemporary photographers often deliberately emphasize their detachment from the event. Sophie Ristelhueber (see p. 18) conjures up this *invisible* war in her views of the first Gulf War. The traces she records – relics of the conflict in the Kuwaiti desert – only reinforce the absence of the true subject: the military operations themselves. Her work can certainly be seen as a document of the war, but what is striking about it is its abstraction, its enigmatic aspects.

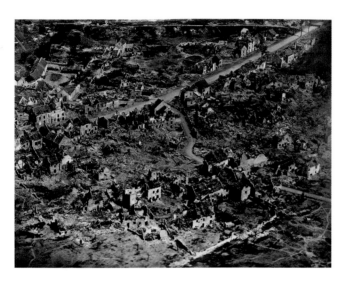

Edward Steichen, *After the Final Retreat*
(battlefield seen from an aeroplane), Vaux, France, 1918

What do these geometric lines mean? What evidence of the war do they provide? What is their significance in relation to the history of the site? The summing-up of an event in images is a task that is always assigned to professionals. The image is generally planned: photographers are situated within a story, and the information that they record has mostly been commissioned in advance and will be distributed through a specific channel. Chance images are rare. Since 9/11, the world has also begun to look at photographs taken by amateurs in places that have become the scene of major events, and it is true to say that the pictures taken by these 'citizen journalists' suddenly seem more 'real' than those of the professionals. There is clearly a grey area now between news and propaganda. Today, photographers are looking for a new form of engagement, knowing that it is often impossible to document what is happening. However, they also wish to distance themselves from the global spectacle that has now become suspect.

There are many photographers today who focus their lens on the consequences of violent events. People have even begun to speak of a new genre, 'aftermath photography', which focuses on places ruined by war and other disasters. Bosnia, Iraq, Afghanistan, Palestine and Ground Zero are among those surreal landscapes, devoid of human life. These images, often taken with a keen attention to composition and the use of colour, on a monumental scale, are more reminiscent of the tradition of sublime painting than that of humanist, black-and-white photojournalism. These works are especially notable for the detachment of the photographer. Such objective distancing is a formal quality of so-called documentary photography and expresses a desire to break away from the characteristic elements of subjective photography, such as soft focus or deframing, which allow photographers to work on the emotional level we experience in conventional war photography. Here, the presence of the photographer is not expressed through the image but in the composition and the organization of the series. Sometimes the images steer a course between fact and fiction. Their creators seek out new strategies in order to capture modern conflicts that remain fundamentally impossible to grasp. 'How can we grant the premier award for a picture that is not immediately identifiable?' asked the jury of the renowned World Press Photo Awards in 2010.

The desire to be as neutral as possible and the prioritizing of restraint and detachment are the hallmarks of a particular aesthetic style. The atmosphere is often one of contemplation. If we recall the images of Ground Zero the day after the 9/11 attacks, we might criticize them for seducing us – oh, the terrible beauty of those ruins! – but that beauty has a powerful impact on the viewer. War can also be conveyed by means of suggestion. Suffering may be invisible and yet at

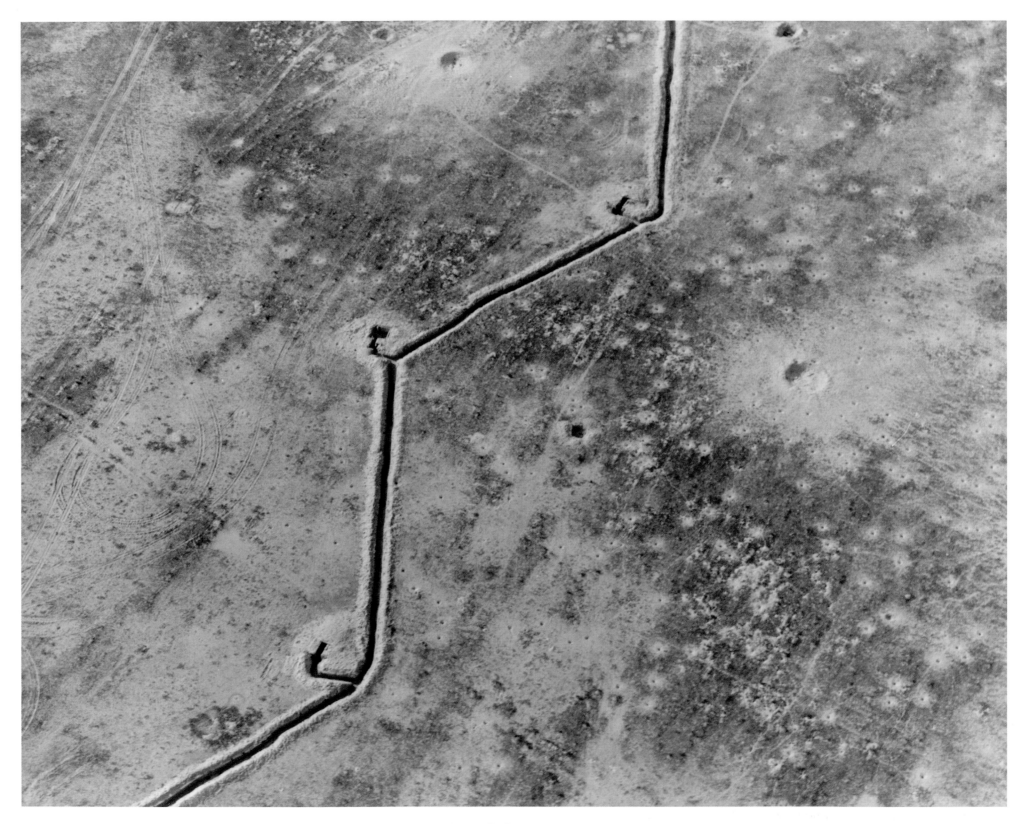

Sophie Ristelhueber, *Fait (#40)*, 1992

the same time identifiable through the image. Photographers communicate their interpretation of the world in all its chaos by inscribing themselves in a history of images. The photograph becomes part of a network, and the way in which an image is viewed cannot be separated from the global perspective of society as a whole. Any image is always an interpretation – it reflects the thoughts, beliefs and torments of its time. It is neither evidence nor illustration. When we look at it, we want to believe that it represents a record of reality – we want it to be authentic, objective, true. Reading images, however, is always more complex than it seems, because when we do it, we impose hypotheses, imaginings and beliefs, according to our own culture, together with the preconceived ideas we have about the subject, and the images we have already seen, all of which combine to fill the gaps in our knowledge. At the beginning of the 21st century we cannot ignore the mass of images that was absorbed in the course of the last century, with some images having made more of an impact than others. They influence the way in which we read the new images we see.

The photographers brought together in *Afterwards* therefore make the viewers confront their own interpretations of each subject; the images awaken the viewers' visual memories of history. There are many written accounts of the conditions victims have lived through but it is difficult to show images of the suffering endured. Today the notion of trauma is present in every mind when the subject turns to survivors of genocide, persecuted asylum seekers, victims of slavery or war. We have come to think of trauma as a psychic mark that is as real as a physical scar – this awareness of trauma has given victims a new legitimacy and it gives contemporary society a conduit for reflecting on the horrors of the world. Also, today the border between victims on the side of 'good' and 'evil' has become blurred: American war criminals and survivors of massacres may suffer the same psychological damage. Our whole relationship with history has changed: from hero worship, spectacle and propaganda we have now moved to denunciation. Instead of the winning side's version, we now focus on the tales of the vanquished. The media have focused on suffering and disaster, and mental disorders are being highlighted as major problems of our age. In a way, contemporary photographers are also seeking to use their work as a form of treating the psyche of the victims.

References

Susan Sontag, *Regarding the Pain of Others*, New York: Picador/Farrar, Straus and Giroux, 2003
Bruno Serralongue, *La Otra, Lyon: La Salle de Bains*; Geneva: Centre de la Photographie, 2007
Michel Poivert, 'De l'image imprimée à l'image exposée', in *Photojournalisme et art contemporain. Les derniers tableaux* (ed. Gaëlle Morel), Paris: Éditions des Archives Contemporaines, 2008
Vincent Lavoie, 'The Atlas Group Archive. Les imaginaires factuels d'une guerre civile', in *Photojournalisme et art contemporain. Les derniers tableaux* (ed. Gaëlle Morel), Paris: Éditions des Archives Contemporaines, 2008
Laurent Gervereau, *Montrer la guerre? Information ou propagande*, Paris: Éditions Sept/Isthme, 2006
The Aftermath Project, founded by the American photographer Sara Terry, following her project on the war in Bosnia: www.theaftermathproject.org
Olivier Lugon, *Le style documentaire. D'August Sander à Walker Evans 1920–1945*, Paris: Macula, 2001
Mark Reinhardt, *Beautiful Suffering: Photography and the Traffic in Pain*, Chicago and Williamstown, MA: University of Chicago Press/Williams College Museum of Art, 2006
Didier Fassin and Richard Rechtman, *The Empire of Trauma: An Inquiry into the Condition of Victimhood*, Princeton, NJ, and Oxford: Princeton University Press, 2009

The Photographers

FRANK SCHWERE

(Germany, b. 1966)

9/11, 2001

These images of Ground Zero in Manhattan are as surreal as they are abstract. Are we looking at urban installations? Frank Schwere's photographs are very different from traditional black-and-white photojournalism. Perhaps they are closer to the work of the earliest generation of photographers: even in the 19th century, photographers had already begun to take pictures of places devastated by war and natural catastrophes. Photographers were fascinated by the spectacle of Paris after the fall of the Commune in 1871: the exposure time of several seconds at that time made it impossible to capture movement, but a sort of poetics of destruction was developed in tandem with political discourse and created the fiction of a Paris in ruins. In a similar fashion, Schwere's images of Ground Zero, taken two days after the attacks of 9/11, create a surreal effect. How could a city like New York find itself in ruins?

In these frozen scenes time seems to have stopped in Manhattan, and humanity seems to have abandoned the city. This aesthetic of ruins has become more and more dominant in contemporary photography, and there are now countless photographers who focus on destruction, the consequences and repercussions of war on the urban landscape – these pictures are halfway between documentary and landscape shots. Gone are the days when humanist photographers would place people at the heart of their reportage. Wars and earthquakes are particularly photogenic subjects. The photographers who roamed the ruins of Ground Zero – Schwere did not wait for permission to enter the site – have given expression to the need for a redefinition of the sublime.

Viewers may find themselves fascinated by the beauty of Schwere's carefully composed scenes, which are in striking contrast to the TV images that showed the impact of the planes and collapse of the towers. All the same, one cannot suppress a feeling of unease when confronted by such pictures, as they bring home the sheer magnitude of the terrible event.

O'Hara's Restaurant & Pub, Greenwich Street, 13 September 2001, 9.30 p.m.

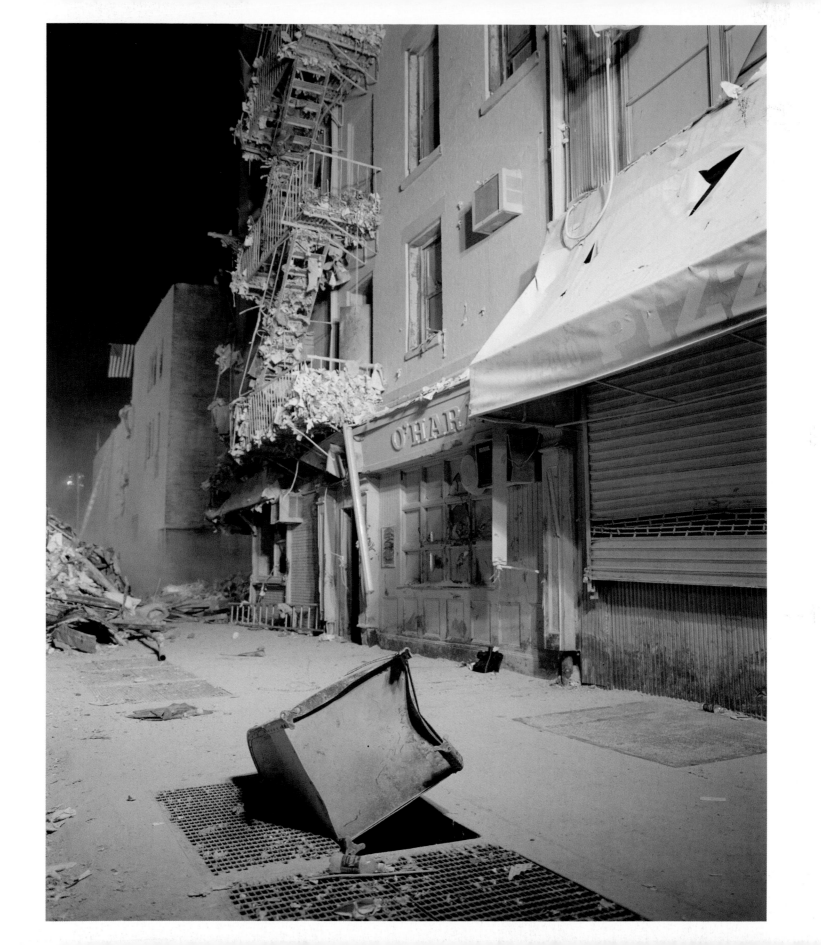

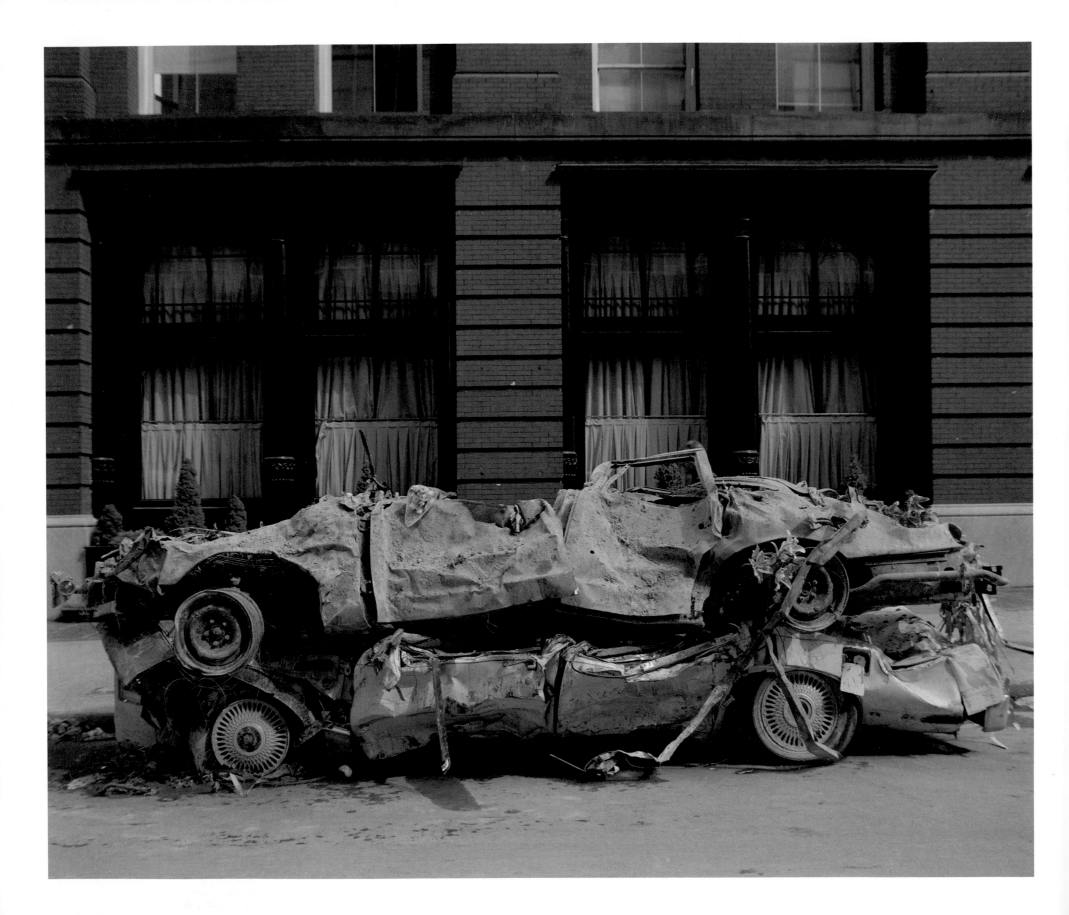

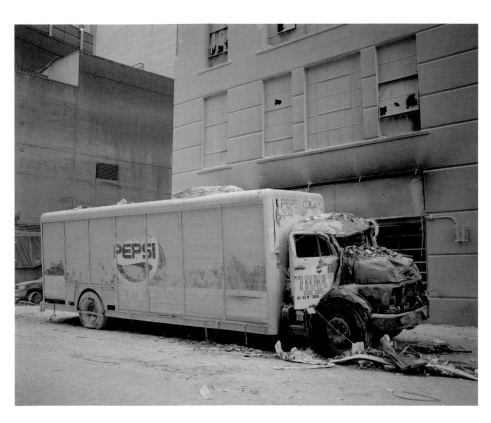

Pepsi truck, Washington Street, 13 September 2001, 6.30 p.m.

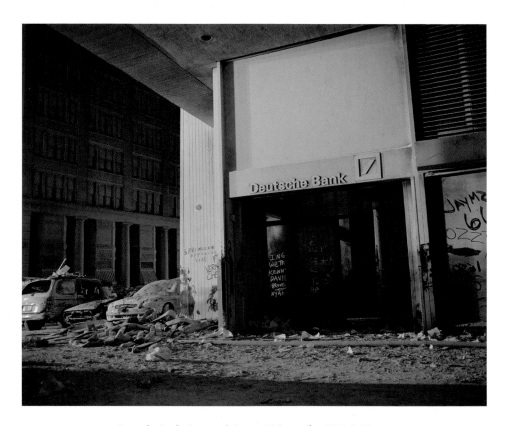

Deutsche Bank, Greenwich Street, 13 September 2001, 9.45 p.m.

Opposite: West Broadway, 13 September 2001, 3 p.m.

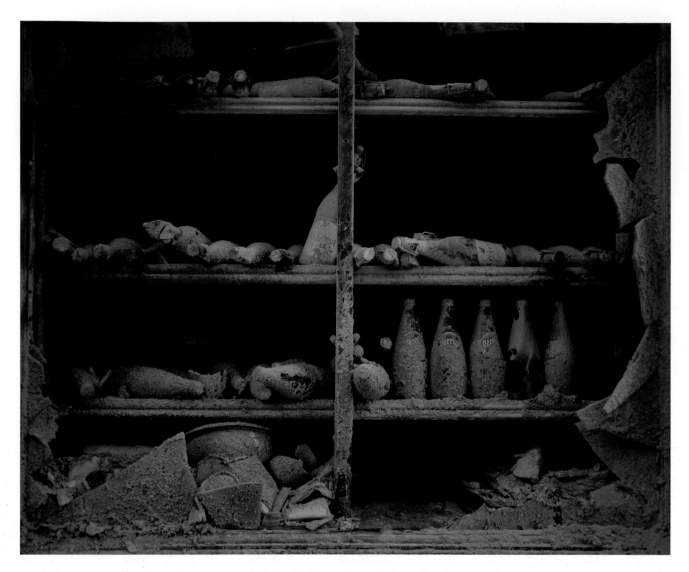

Amish market, Washington Street, 13 September 2001

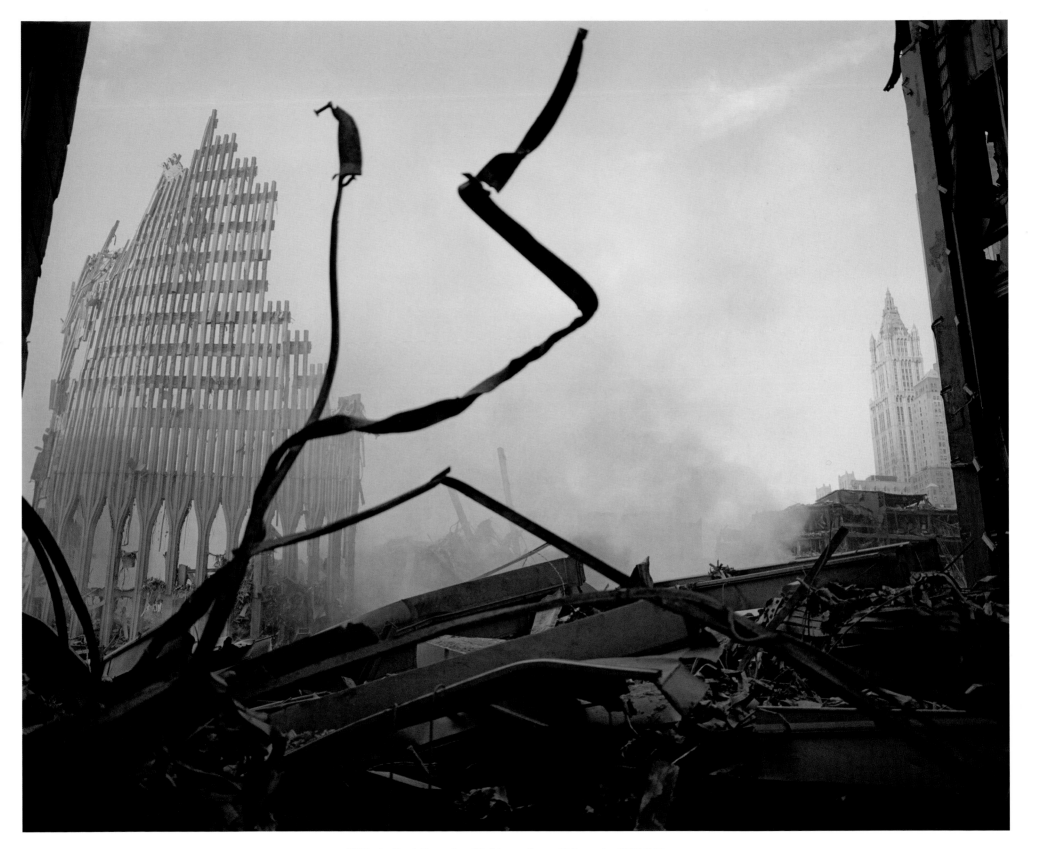

WTC ruin, South Tower, from Washington Street, 13 September 2001, 7.00 p.m.

PAULA LUTTRINGER

(Argentina, b. 1955)

El Lamento de los Muros/The Wailing of the Walls, 2000–2010

On 31 March 1977, Paula Luttringer, a twenty-one-year-old student, was kidnapped by members of the Argentinian armed forces. She was pregnant at the time of the abduction and was kept prisoner for five months in a secret detention centre, where she gave birth to her first daughter. When she left the prison, she was driven out of the country and took refuge in Uruguay and subsequently France. Since 2000 Luttringer has regularly returned to Argentina in order to meet women who, like herself, were kidnapped and imprisoned during the military dictatorship. That was how she came to start photographing the detention centres used by the armed forces between 1976 and 1983.

In her photographs Luttringer does not show any portraits or locations in their entirety. On the contrary, she has chosen close-up shots that show nothing but the details of the cells that would have attracted the attention of the prisoners in them. She focuses on the walls, those silent witnesses to the violence suffered by the *desaparecidos*. She highlights the steps, the holes in the ground, the lights that were permanently switched on – all the little things that made up the oppressive world in which the regime kept its detainees.

How can the terror of the hours and months spent in conditions of such tense uncertainty be described? The world depicted by Luttringer has no colour and no horizon; it reflects the darkness into which the prisoners were plunged. A sensation of cold and damp rises from these images, which are accompanied by brief first-hand accounts: only a few scenes are recounted, and these are echoed by the architectural details that seem to ooze with the blood from the victims' wounds.

'I went down about twenty or thirty steps and I heard big iron doors being shut. I imagined that the place was underground, that it was big, because you could hear people's voices echoing and the planes taxiing overhead or nearby. The noise drove you mad. One of the men said to me: "So you're a psychologist ? Well bitch, like all the psychologists, here you're really going to find out what's good." And he began to punch me in the stomach.'

Marta Candeloro was abducted on 7 June 1977 in Neuquén. She was then taken to the secret detention centre 'La Cueva'.

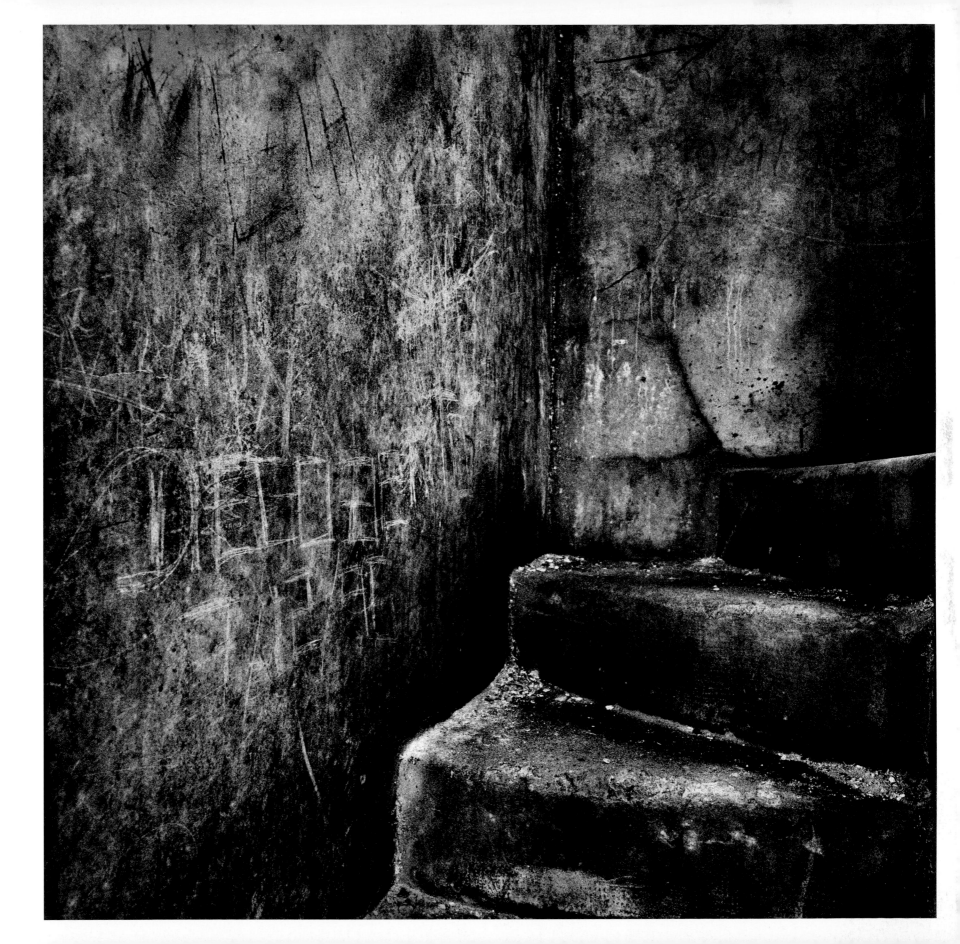

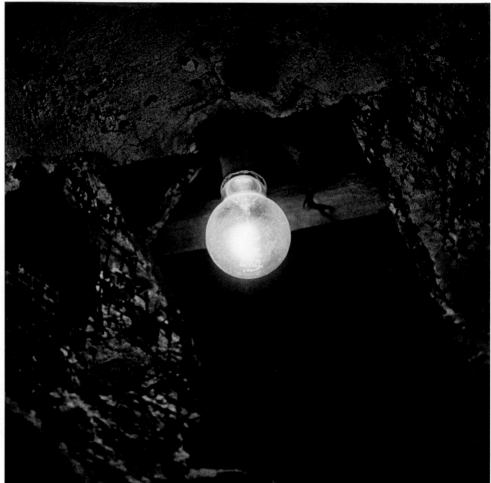

'It is very hard to describe the terror of the minutes, hours, days, months spent there. At first when you've been kidnapped you have no idea about the place you are in. Some of us imagined it to be round, others like a football stadium with guards walking above us. We didn't know which direction our bodies were facing, where our head was, where our feet were pointing. I remember clinging to the mat with all my strength so as not to fall down even though I knew I was on the floor.'

Liliana Callizo was abducted on 1 September 1976 in Córdoba.
She was then taken to the secret detention centre 'La Perla'.

'Light from outside ? No, it was a basement, we only ever had artificial light, which itself went off from time to time as the light bulbs exploded from being on day and night. Whenever the light went off they went crazy and hurried to replace the bulb because then things were reversed – it was they who couldn't see us.'

Marta Candeloro was abducted on 7 June 1977 in Neuquén.
She was then taken to the secret detention centre 'La Cueva'.

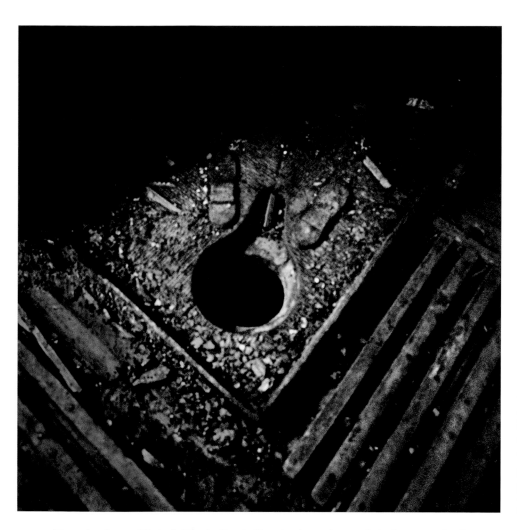

'Once when I was still being held at the Hospital Posadas they took me to the bathroom. I took off the blindfold and looked at myself in the mirror: I didn't recognize myself and yet I knew it was me. I looked at the face staring back at me and said "that's not me". There was fear in my eyes; it was the look of someone cornered, a terrible staring, as if waiting for the next blow.'

Gladis Cuervo was abducted on 25 November 1976 in Buenos Aires.
She was then taken to the secret detention centre 'Hospital Posadas'.

'Something strange used to happen at night, the screams of torture were different from those during the day. Even if the screams of torture are always the same they sound different at night. And it's also different when they come to get you at night. The noises and the screams are not always with me, but when I do remember them, it makes me very sad. I am paralysed by those screams, I'm back in that time and place. As somebody once said – and I've given this some thought and I think it's right – although life goes on, although some of us were freed, you never get out of the pit.'

Isabel Cerruti was abducted on 12 July 1978 in Buenos Aires.
She was then taken to the secret detention centre 'El Olimpo'.

PETER HEBEISEN

(Switzerland, b. 1956)

Metamorphosis and Myth, European 20th-Century Battlefields, 2001–10

The way we read an image can be completely changed by the presence of a caption. In our text-dominated society, accustomed to receiving news and information in written form, our interpretations are steered by the words. Peter Hebeisen's landscapes, photographed from a platform and always with a degree of detachment, reproduce the point of view of somebody walking by, looking out over the landscape. These peaceful shots show places that have been the scene of the most appalling violence: Verdun, Guernica, Stalingrad. Since 2001, Hebeisen has travelled 40,000 kilometres across Europe in order to photograph the major battlefields of the 20th century. They range from the site of the First Balkan War (1912–13) to the conflicts in the former Yugoslavia during the 1990s, and they encompass both world wars as well as the Spanish Civil War. The whole project brings together a vast series of landscapes that were once theatres of war.

In the 20th century, photography allowed us to grow accustomed to an inside view of warfare: a world of trenches, ruined cities and soldiers on the front line, with photographers accompanying the armed forces wherever they went. Hebeisen, however, offers us an external view of the locations in which these battles took place. He has focused on the moment when things have returned to normal, when the terrible massacres have given way to scenes of peace and tranquillity. The elevated viewpoint accentuates the impression of domination and contemplation, which in some ways resembles the panoramic view of a general surveying his troops. The image is one of calm, the horizon is clear, and we wonder if the soldiers are waiting in the wings or have already left the stage.

Battle of Stalingrad, Wolgograd, Russia 1942–43

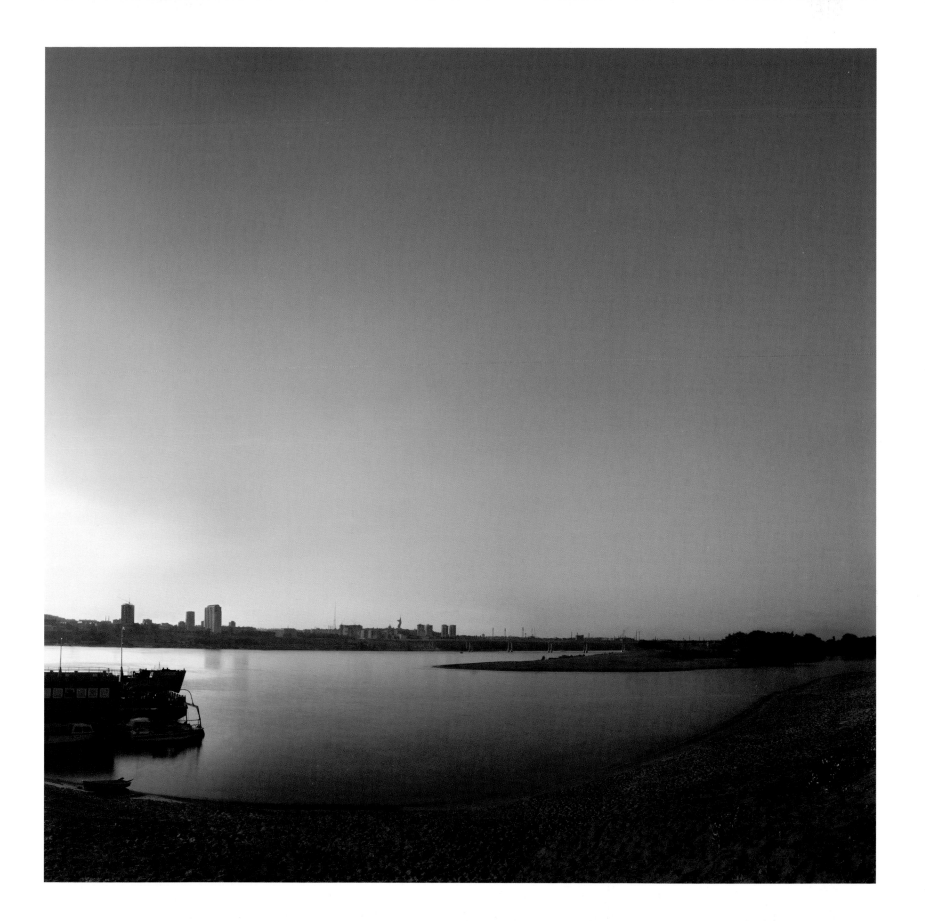

Battle of Gallipoli, Anzac, Turkey 1915–16

Battle of Verdun, Meuse, France 1916

Opposite: Siege of Leningrad, St Petersburg, Russia 1941–44

Bombing of Guernica, Spain 1937

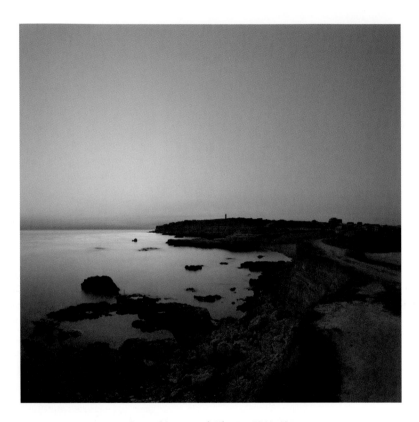

Siege of Sevastopol, Ukraine 1941–42

Siege of Sarajevo, Bosnia 1992–96

London Blitz, Great Britain 1940

IVOR PRICKETT

(Ireland, b. 1983)

The Quiet after the Storm: Croatia's Displaced Serbs, 2006–07

Thanks to the media, we are used to the sight of refugees from distant countries landing in the West and living in transit camps. Ivor Prickett's work, however, deals with a different kind of refugee: Croatian Serbs returning to their homeland. Between 1991 and 1995, 300,000 Serbs left Croatia because of the war. This was the largest displacement of a European population since the Second World War. Only 120,000 of them have been able to go back, with the aid of various humanitarian organizations. All too often, the task of returning to their house, their village and their neighbours is extremely difficult. Their homes have often been destroyed, occupied or left to fall apart. Almost twenty years after the start of the conflict that ripped Yugoslavia apart, the Croatian Serbs are still living in horrendous conditions, like many other groups that were driven out of the Balkans. Having been forced to flee at a moment's notice – the title of the series refers to 'Operation Storm', which was the brutal expulsion of the Serbs in 1995 – they wished only to go home. But although their return was facilitated at an administrative level, the task of rebuilding their lives after their long exile has often proved to be impossible.

Prickett records the poverty in which these people live. The environment is wretched, and their lives are spent fighting an age-old battle: trying to find food and to keep warm. The photographer has gone into their homes and captured the essence of their daily lives. These domestic scenes are in a way reminiscent of Dutch painting, and the softness of the natural light makes it seem as if the people have emerged from classical pictures of rural life. However, these images were taken in the 21st century, right in the heart of Europe.

Slavica Eremic feeds her baby son Nikola while her husband Nebojsa sleeps. Twenty-one-year-old Slavica married Serbian Nebojsa when she was nineteen. Nebojsa had returned to Croatia after several years of exile in Serbia only to find his family home inhabited by a Bosnian refugee. The young family now live in what used to be Nebojsa's grandmother's house. Jurga, Croatia, July 2006

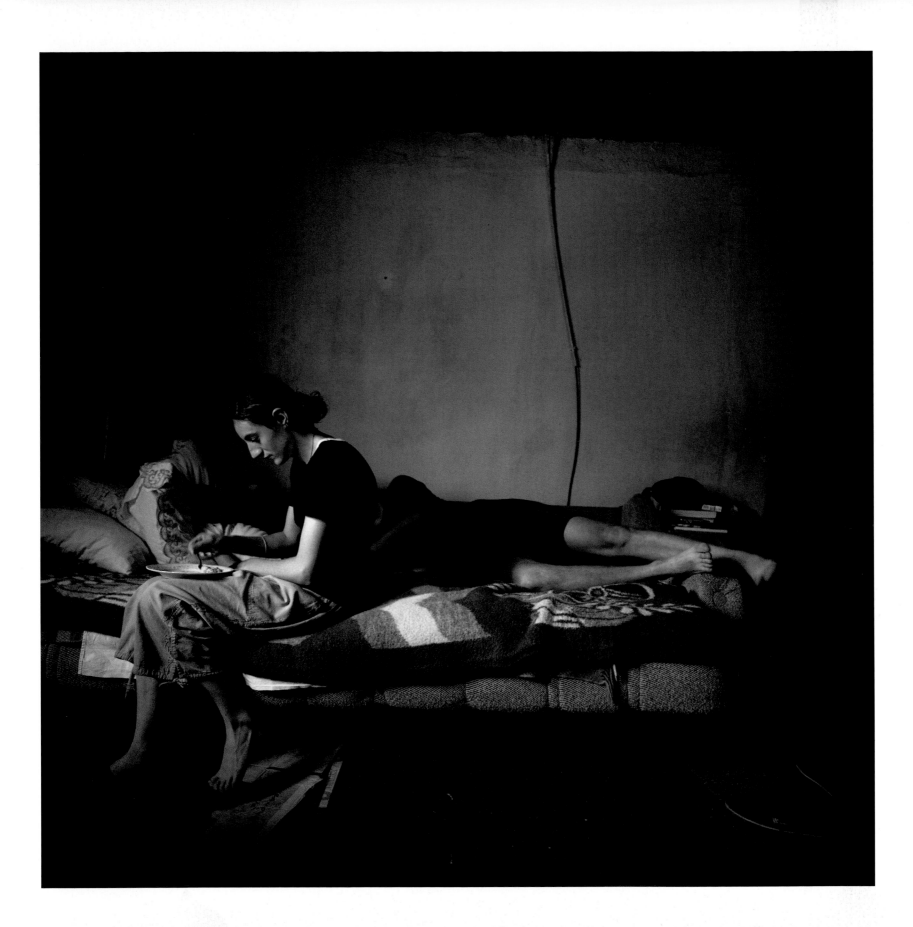

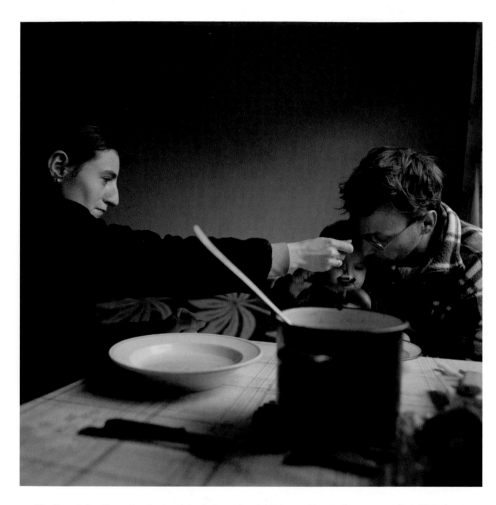

The Eremic family eat Sunday lunch in their newly rebuilt house. Despite having a small child, Nebojsa struggled to gain support from the government in order to repair the cottage he inherited from his grandmother. Instead he was given building materials by a small international organization and did the work himself. Jurga, Croatia, February 2007

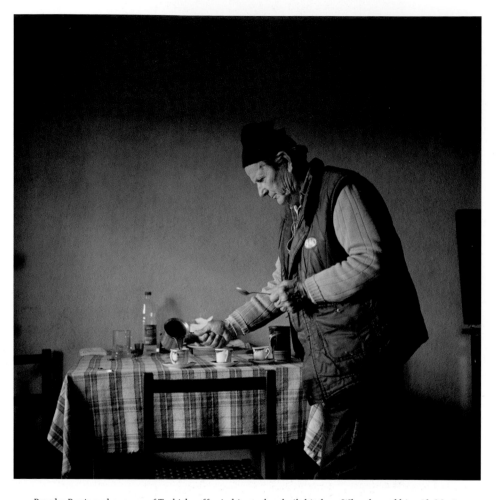

Branko Banic makes a cup of Turkish coffee in his newly rebuilt kitchen. When he and his wife Maria returned to Croatia in 2006 their house was completely dilapidated. After six months of living with cousins nearby the elderly couple were given some help by the Norwegian refugee council so they could begin to rebuild their old lives. Brgud, Croatia, February 2007

Opposite:
Stana Davidovic is from Kostanica in central Croatia. Having survived the Second World War she now lives as a refugee in Rtanj collective centre in Serbia. Although her sister has returned to their village in Croatia, Stana is too upset by the destruction in her home country to consider living there again. Rtanj, Serbia, October 2007

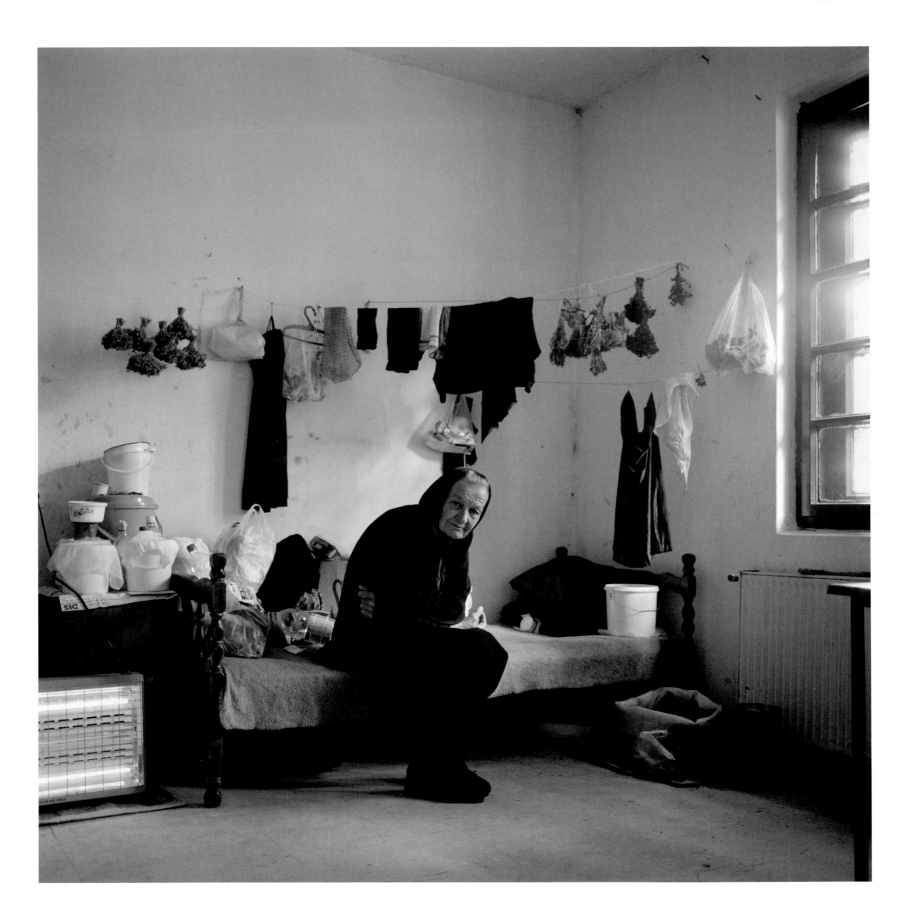

PIETER HUGO

(South Africa, b. 1976)

Rwanda: Vestiges of a Genocide, 2004

For half a century, photography has accustomed us to viewing post-colonial Africa as a continent of people in distress – victims of famine, genocide, disease and war. That suffering is scandalous and unjust, but it has never come close to the enormity of what occurred in Rwanda in 1994. Pieter Hugo knows Africa well. Although he usually specializes in portraits, for this series he decided to document the Rwandan genocide through the personal belongings, clothes and human remains left in mass graves.

Beginning on 7 April 1994 – the day after the death of the presidents of Rwanda and Burundi – and lasting for a hundred days, the genocide of the Tutsi people was conducted systematically across the whole country. Carefully organized assassinations, mass killings and arson attacks laid waste to Rwanda. Corpses were left lying on the roads, abandoned at the place of death or thrown into communal pits. Rape, machete massacres, torture: the few escapees have described the horrific scenes they witnessed.

Ten years after the genocide, Pieter Hugo wanted to preserve a certain distance from the victims. Photographing at the site of a massacre, he chose to adopt a distant and rigorous approach. All that is left of the victims are a few remains and some personal items. The images are so similar and repetitive that they almost take on the quality of an inventory. Thousands of innocent people were murdered at Ntarama Catholic Church, and it has now become a memorial to the victims of the genocide.

Partial remains and personal belongings between church pews at genocide site. Ntarama Catholic Church #9

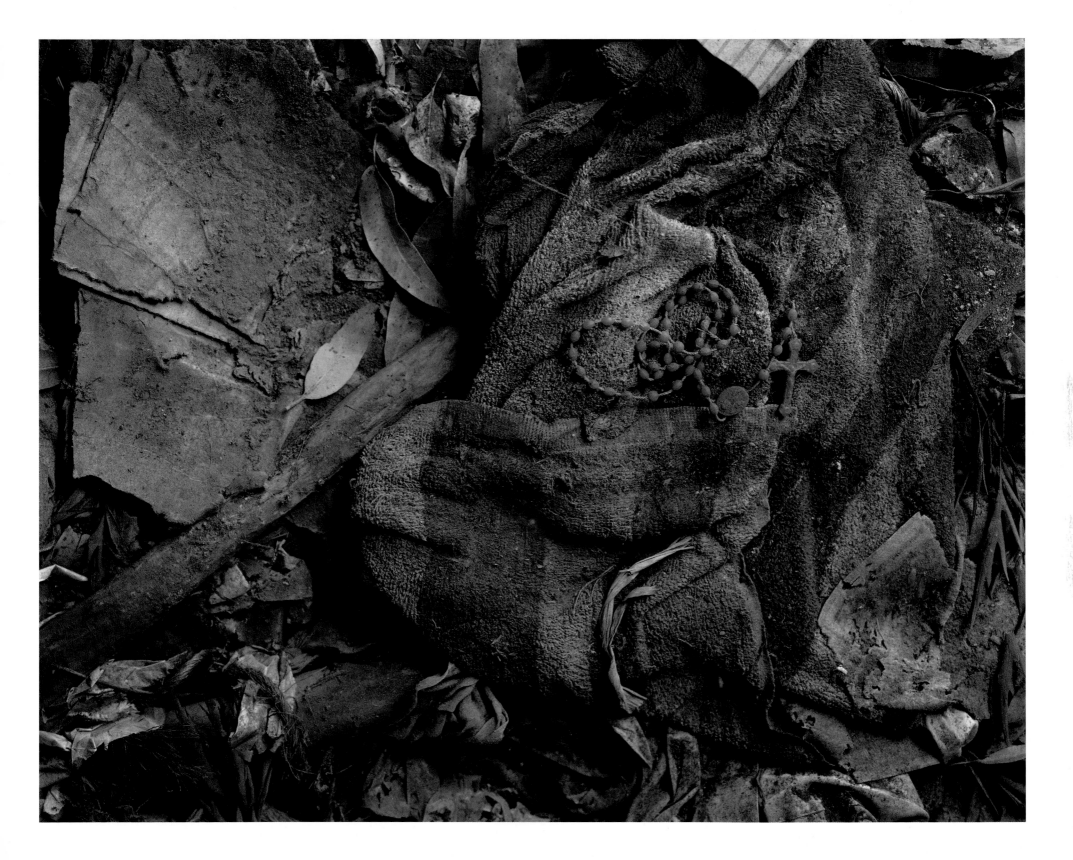

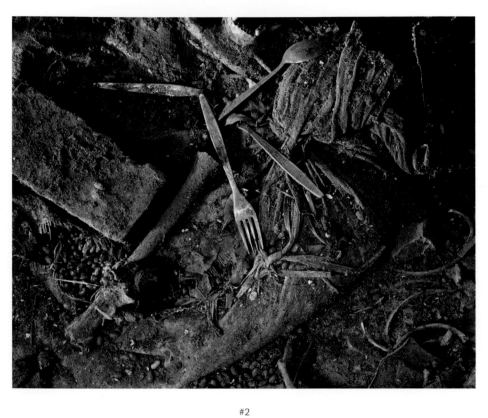

#2

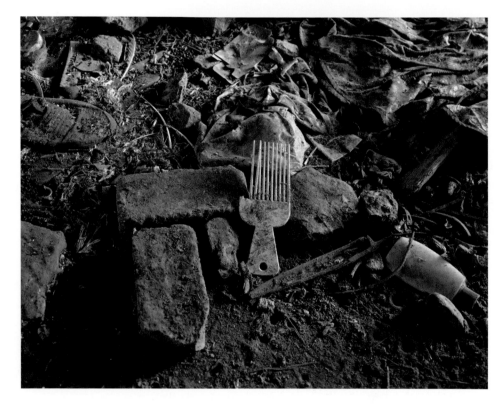

#1

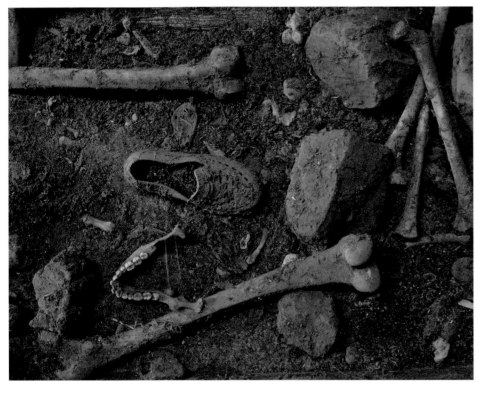

#6

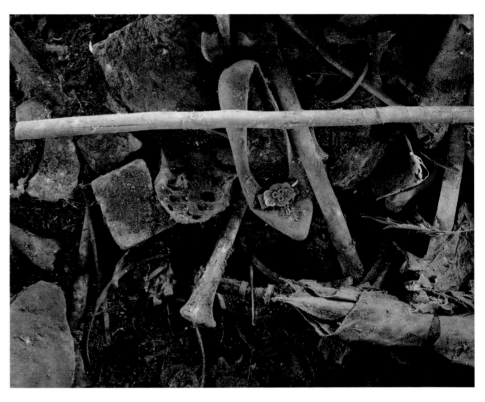

#5

STEVEN LAXTON
(Australia, b. 1977)

Holocaust Survivors, 2008

What can faces say about traumatic experiences that occurred more than half a century ago? The title of Steven Laxton's series tells us that these people all survived the Holocaust. Does this information change our interpretation of the portraits? Today, at the start of the 21st century, the Holocaust (the etymology of the word refers to religious sacrifices in which the victims were burned to death) remains as vivid as ever. The Nazi concentration and extermination camps generally evoke stereotypical images in our memories: piles of corpses, emaciated faces, barbed wire. Laxton's images are different and remain engraved on our minds.

Laxton has said that he wants to pay homage to these people and, through them, to all the victims of the Second World War. The fact that they posed for the photographs and were willing to talk about their experience of the Holocaust is proof of their resilience and their faith in the future. Years have passed. What remains of their terror, their traumas, the ordeals that they went through seventy years ago? The format of these photographs is always the same: a shot in close-up, dark background, light directly on the face on which the years have left their mark. By choosing to photograph people who have all lived through the same tragedy, by naming them, and by giving their date of birth and place of origin, Laxton is able to convey both the individual and the collective impact of the horror.

Tkach Anna. DoB 15/08/1935, Ghetto Domanevka, Ukraine

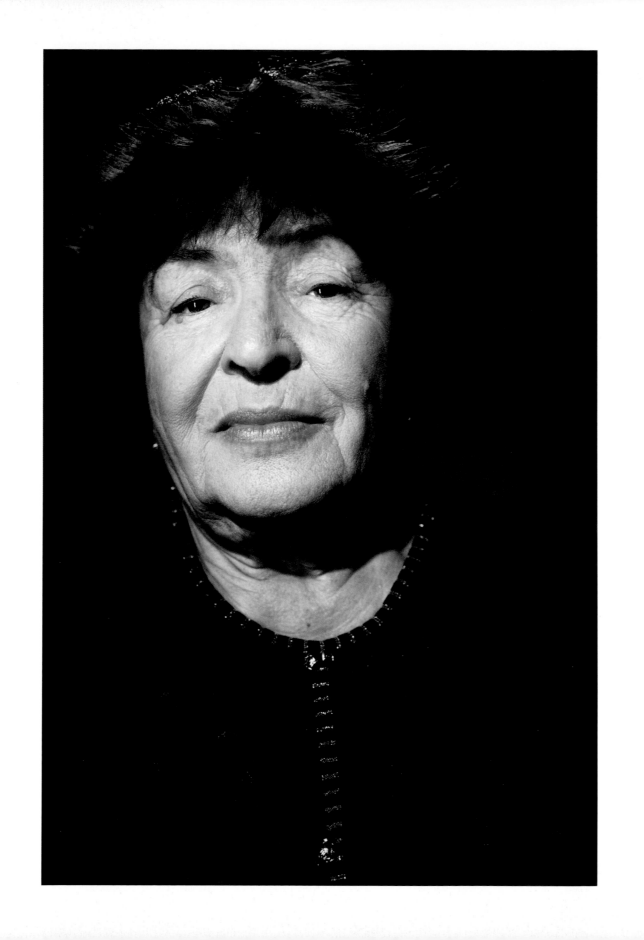

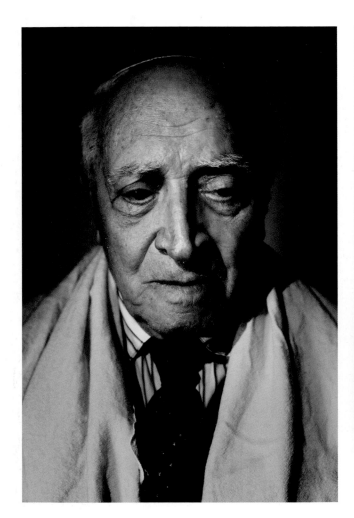

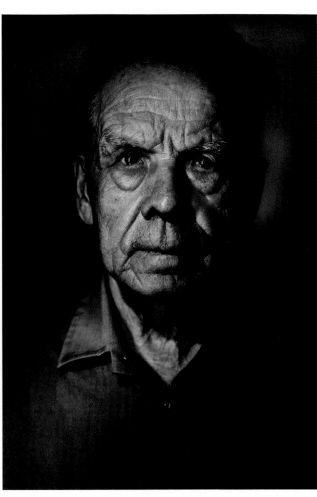

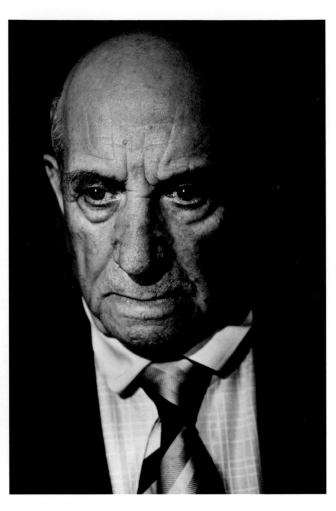

Lozanskiy Michail. DoB 22/02/1924, Russia (Nazi occupation)

Kalinin Vasiliy. DoB 22/02/1927, Russia

Khagan Wolf. DoB 18/01/1915, Ukraine (Nazi occupation)

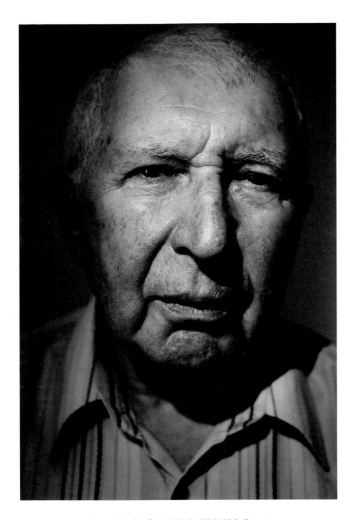

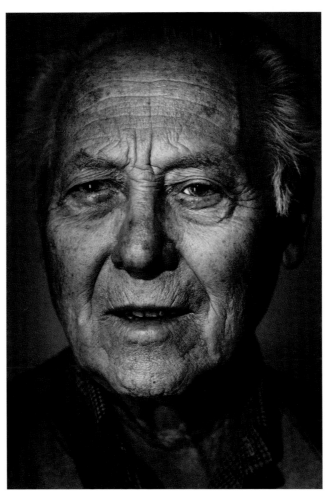

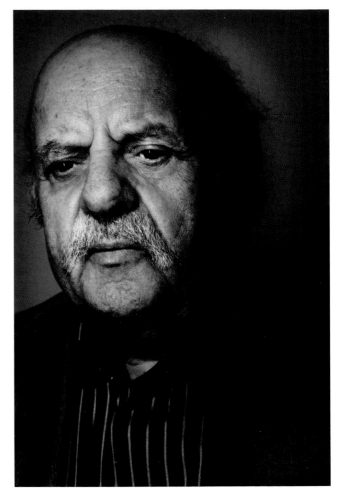

Zinoviy Galinskiy. DoB 04/03/1933, Russia Vaynshelboym Isaak. DoB 1921, Ukraine Volshemboym Isaak. DoB 12/08/1922, Russia

FRANZISKA VU

(Germany, b. 1976)

Detained – Photographs and Eyewitness Accounts from a Stasi Jail, 2006

*D*etained focuses on the prison in Berlin-Hohenschönhausen, the largest penitentiary used by the East German secret police between 1950 and 1990. Franziska Vu photographed various areas, including the cells and interrogation rooms, as well as a number of former prisoners, whom she also interviewed. Few people even knew of the existence of this detention centre, which was built by the Soviet armed forces at the end of the Second World War. It was not to be found on any map. Nevertheless, thousands of political dissidents were incarcerated here, as well as would-be escapees to the West who had been caught on the run or denounced to the authorities. Twenty years after the reunification of Germany, there is still a great deal that is not known about the operations of the Staatssicherheitsdienst, known as the Stasi, the East German secret police.

Vu set out to tell the stories of some of the detainees, such as Edda Schönherz, who was arrested during a trip to Hungary, where she was on holiday with her children. A well-known personality on East German television, she was detained when she attempted to flee the Eastern bloc. After three years behind bars she was released, eventually reunited with her children and, two years later, was finally able to emigrate to West Germany. Matthias Bath, who came from West Berlin, was arrested at the age of twenty when he tried to smuggle three East Germans to the West by hiding them in his car. He was released after three years. The impact of Vu's photographs comes from the contrast between the prison – symbol of oppression and isolation – and the portraits of the former detainees, who barely show any visible traces of their experience of incarceration. They might be our neighbours, and we might be them. Thirty years later, they agreed to return to the scene of their ordeal and to talk of the distress, anguish and confusion caused by their arrests and by the psychological torture they endured, as did so many of their fellow prisoners.

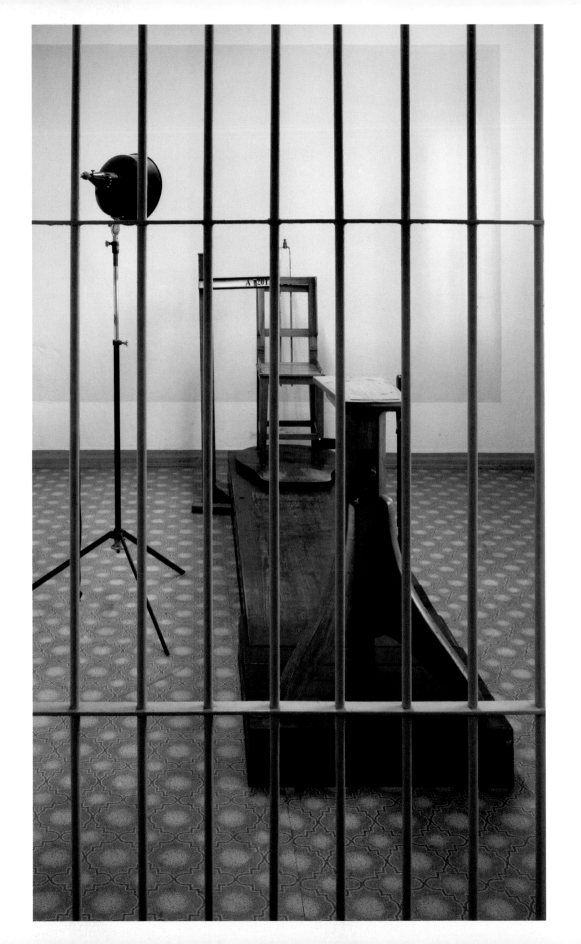

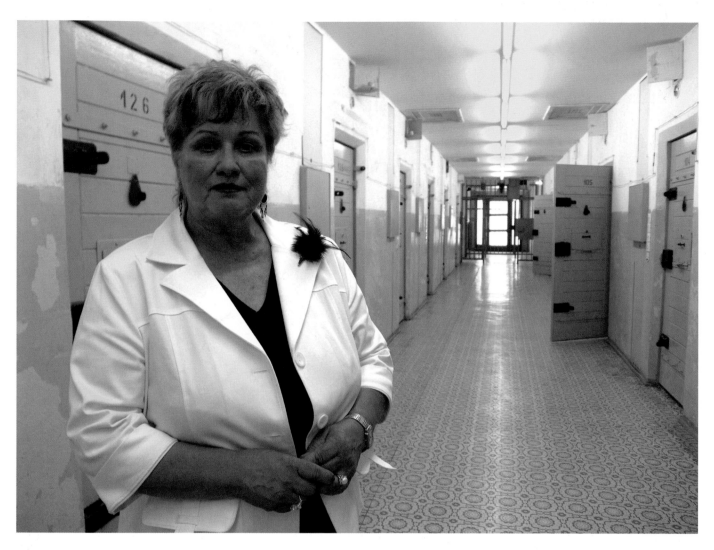

Edda Schönherz

Opposite: Dr Matthias Bath

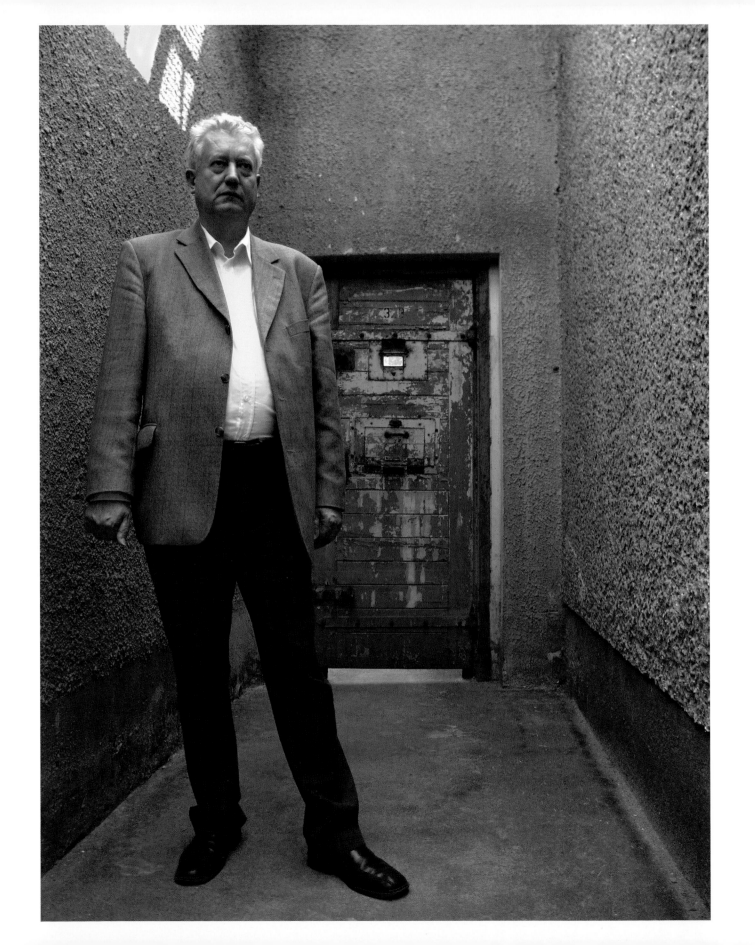

INDRE SERPYTYTE

(Lithuania, b. 1983)

1944–1991: Former NKVD – MVD – MGB – KGB Buildings, 2009

I n 1944, Lithuania was taken over by the Soviet Union. The occupation, which lasted until 1991, led to the formation of a resistance movement by partisans whose aim was to topple the Soviet regime. In order to consolidate the power of the occupying forces, the KGB established and ran centres for interrogation, detention and torture in towns and villages all over the country. These places, which looked just like ordinary houses, were converted into centres from which the KGB imposed their reign of terror.

Indre Serpytyte spent several years investigating the mysterious death of her father, a minister in the Lithuanian government, who had been found dead, allegedly following a car accident. Serpytyte began her series '1944–1991' by photographing the houses used by the Soviet secret police. In order to locate them, she used archive photographs and then traced the records of the different sites in order to find out about the tragedies that had taken place there. However, frustrated by all the difficulties she faced in trying to uncover the facts, she decided to change her approach. She asked a wood sculptor – this form of art has a long tradition in Lithuania – to make models based on the photographs she had taken on the spot, but insisted that the wood should not be hollowed out in any way. These solid blocks are a little reminiscent of the objects carved by the prisoners themselves. Set against a totally neutral background and photographed from a distance, these strange houses allow no concrete insight of any kind. They have no colour and no context, no indication of where they are located or what they were used for. The wood seals in the tragic histories that once took place inside them.

3 Geliu Street, Rudiskes, Lithuania

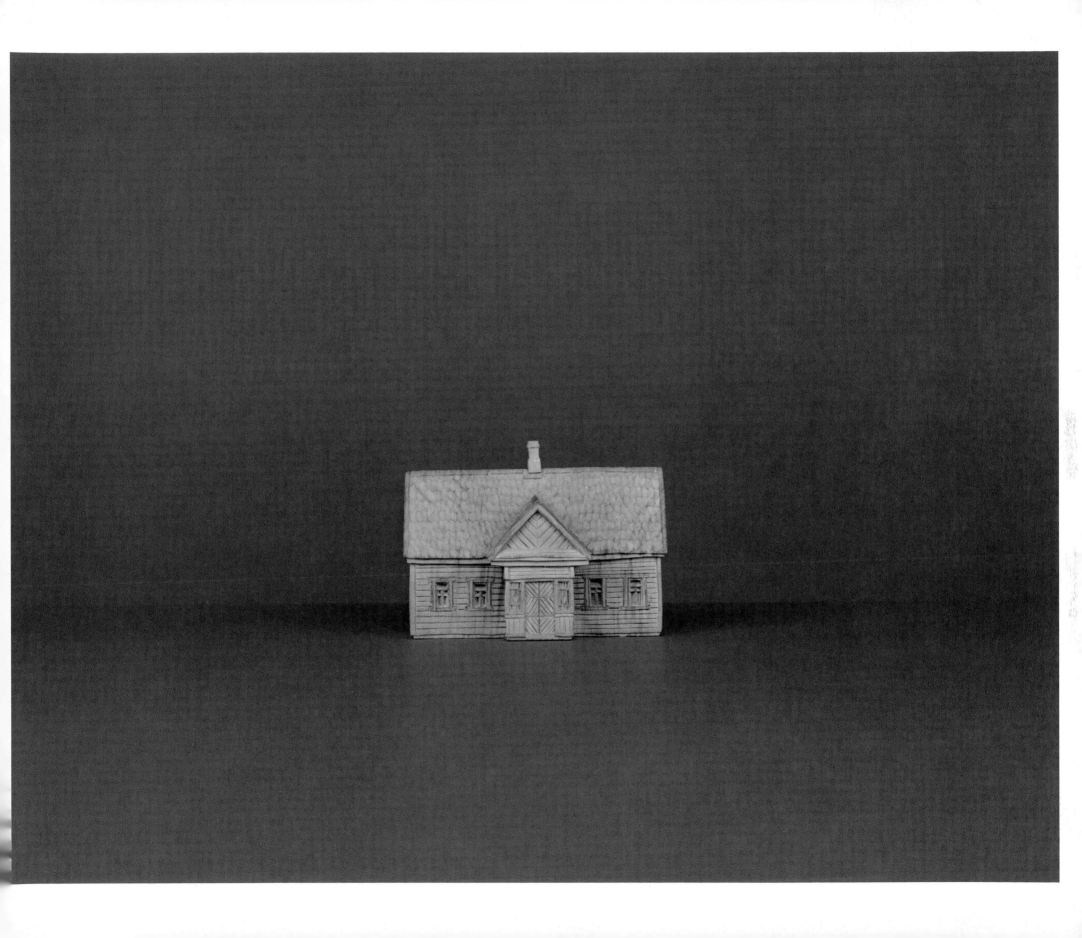

14 Gelvonu Street, Musninkai

13 Vytauto Street, Prienu Miestas

24 Vilniaus Street, Aukstadvaris

Uzusaliai, Jonavos Rajonas

ANNA SHTEYNSHLEYGER

(Russia/USA, b. 1977)

Siberia, 2001

Untitled

Siberia has been synonymous with exile and imprisonment throughout Russian history. From the late 16th century onwards, it has been peopled by means of forced resettlements and deportations. The repressive systems of the Russian empire and the Soviet Union alike deported prisoners to these remote regions. Following the abolition of the death penalty in 1753, exile to Siberia allowed the government to populate a region that was known primarily for the harshness of its climate.

Exile, forced resettlement and forced labour: for almost three centuries, criminals and political prisoners were sent to live in this hostile terrain. In 1862, the writer Dostoyevsky recorded the terrible conditions for detainees in his book *The House of the Dead*. A century later, in 1973, Aleksandr Solzhenitsyn wrote his own account of the gulag, the Soviet regime's brutal system of labour camps. But it was not until the era of glasnost, introduced by Mikhail Gorbachev in the late 1980s, that the archives were opened and the history of these places of exile could be more widely known.

Anna Shteynshleyger belongs to the generation born shortly before the Gorbachev years. She travelled to Siberia several times, but her photographs do not depict the villages, towns and camps where the exiles were housed. They show only the steppes, the swamps, the forests and mountains, the lands of internment that deportees and their families had to pass through. 'There was something intensely melancholy in that wild and desolate landscape,' wrote Dostoyevsky. Shteynshleyger's work contains no traces of forced labour, death, violence, suffering, brutality or humiliation, and yet the experiences of the gulag, as lived by countless victims, were clearly in the mind of the photographer as she journeyed through these landscapes.

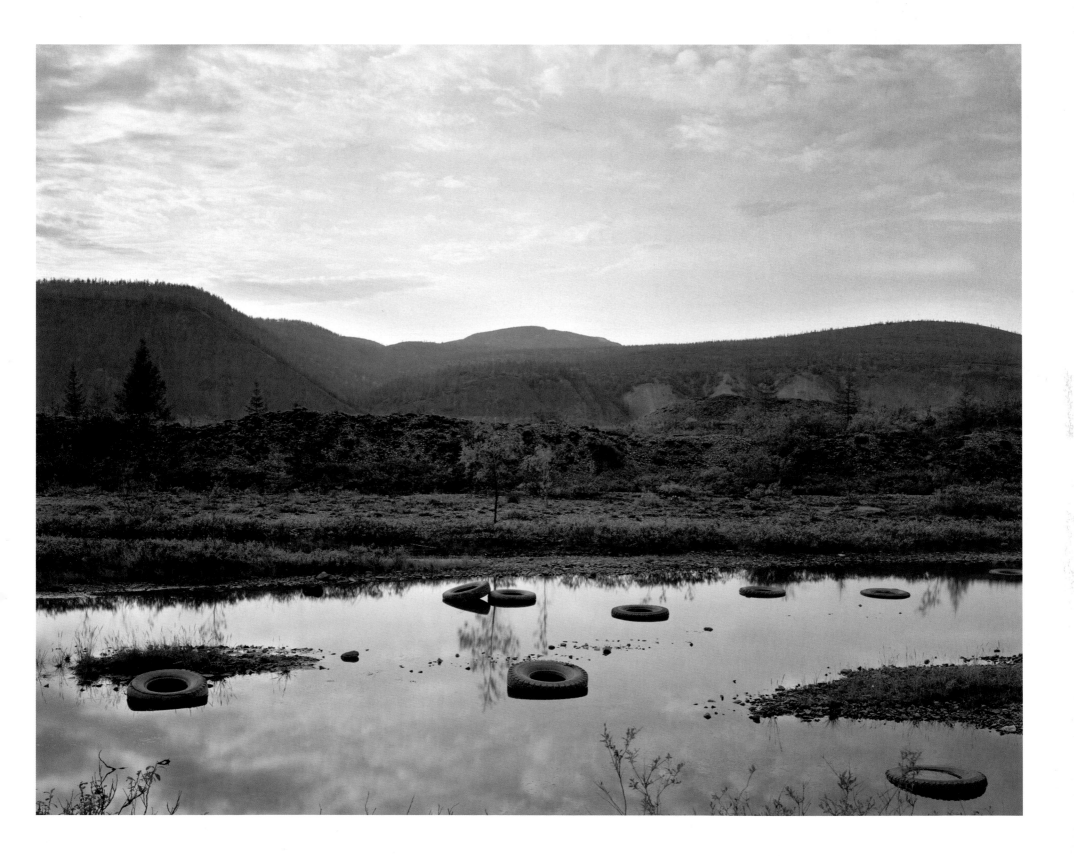

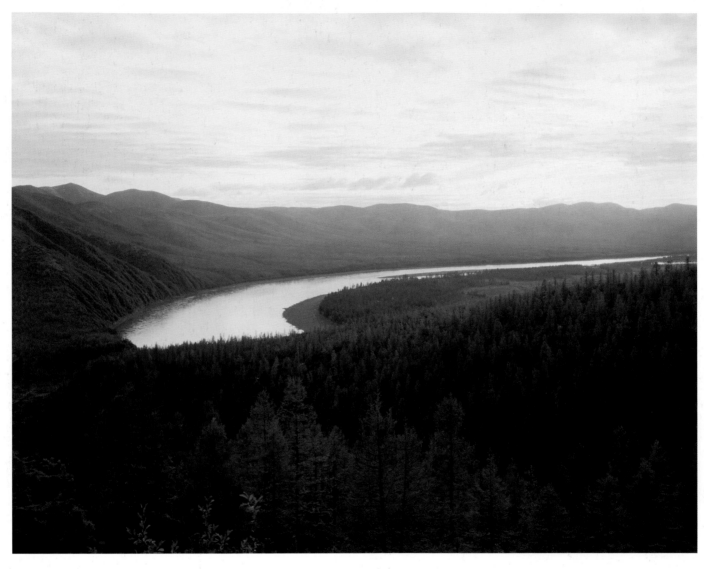

Untitled

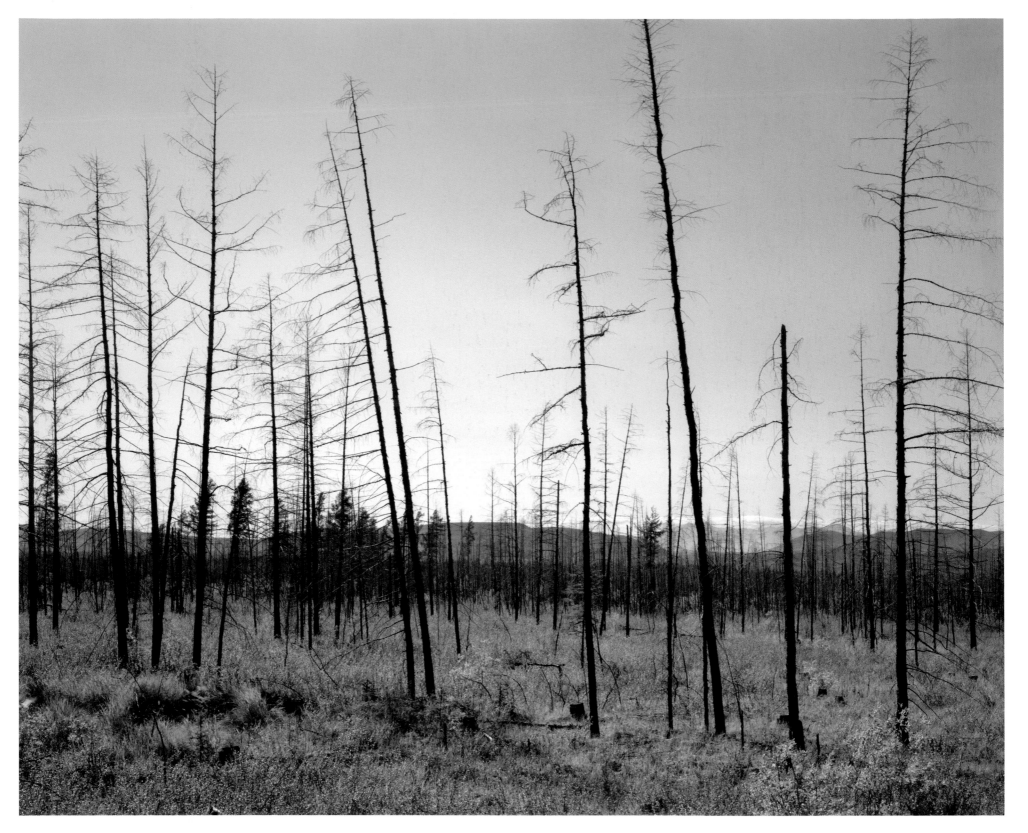

Untitled

GUILLAUME HERBAUT

(France, b. 1970)

Hiroshima, 2005

The name Hiroshima has haunted human memory for more than six decades, and remains a symbol of total destruction. At 8.15 a.m. on 6 August 1945, an atomic bomb was dropped on the city without any advance warning to the civilian population. Three days later, Nagasaki suffered the same fate, a second bomb obliterating the town. An estimated 140,000 people died in the two blasts or from their injuries. Some people – their bodies burned and their flesh singed raw – managed to survive despite the lack of medication. Not until the 1950s were they able to receive treatment, and many had to undergo numerous operations, so difficult was it for their bodies to recover from the radiation.

The tragedies of Hiroshima and Nagasaki put an end to the Second World War, but they also catapulted the world into a new era: humanity had created the means of its own annihilation. Guillaume Herbaut, whose work has taken him to many other scenes of terrible suffering (such as Auschwitz and Chernobyl), set out to show that sixty years after the nuclear attack on Japan, the bodies of the survivors are still battered and wounded and their heads still filled with the horror of their memories. Hiroshima has been completely rebuilt, but the survivors are a living reminder. These people, whose flesh will always bear the mark of their suffering, are known as the *hibakusha*, the survivors of the bomb. The aftermath has been both physical and psychological, for they are outcasts – isolated, condemned to silence, discriminated against in their private and professional lives, and constantly exposed to other people's fears that they might pass on diseases linked to radioactivity. Herbaut makes no attempt to hide the scars and ruined bodies that are still in pain sixty years later. This is his counterpoint to the most widely seen image of Hiroshima, the atomic mushroom cloud.

Watch found 150 metres from the hypocentre of the A bomb.

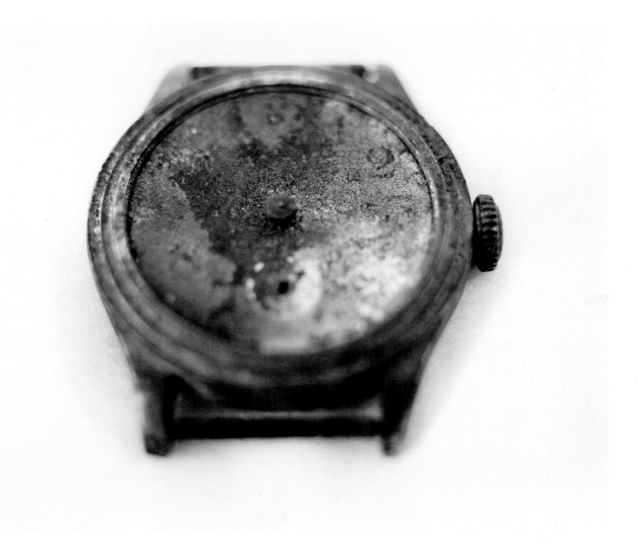

Shizuko Abe was eighteen when the bomb exploded. She was 1.5 kilometres away from the hypocentre
of the A bomb. Burned and disfigured, she has undergone eighteen surgical operations since then.

Opposite: Kuboura Hito was eighteen years old when the A bomb was dropped. He was working
at the railway station, 2.5 kilometres away from ground zero. His body was lacerated by thirty
pieces of glass and he was exposed to radiation.

ADAM BROOMBERG & OLIVER CHANARIN

(South Africa, b. 1970/UK, b. 1971)

The Red House, 2006

The Red House #1

A camera has the ability to isolate details. It will record only whatever is located within the frame. By standing at a distance, choosing different angles or using a particular type of lens, the photographer can expand the field of vision. Adam Broomberg and Oliver Chanarin did not, however, exploit these possibilities for the series called *The Red House*. Their approach was formal and neutral, and their aim was to present no visual information other than what was contained in the graffiti on the walls. These photographs could be described as reproductions rather than documentations, so rigorous is the discipline of their method. Each piece of graffiti was photographed individually and generally in close-up.

In this way, Broomberg and Chanarin focus the viewer's attention directly on their subject – the graffiti on the walls of the 'Red House'. That was the name of the building that housed the prison and torture centre of the Baath Party in Sulaymaniyah, in Iraqi Kurdistan, 330 kilometres from Baghdad. For many Kurdish prisoners, the walls of their cell were their only means of expression. The variety of graffiti shows the urge for creativity through drawing rather than writing. Here we find something very intimate, a window into thoughts and imagination, an escape route to the world of freedom. We can sense the survival instinct within these solitary, oppressed detainees who were looking for some constructive way of passing time.

Broomberg and Chanarin, who went to this prison in 2006, have chosen to isolate the graffiti from their surroundings. Stripped of context, these relics take precedence over the events that led to them. Whether figurative or abstract, acts of defiance or of pure creativity, what these drawings evoke above all is solitude, fear, boredom and endless waiting. They are a vivid expression of the suffering endured by human beings held captive in terrible conditions under Saddam Hussein's regime.

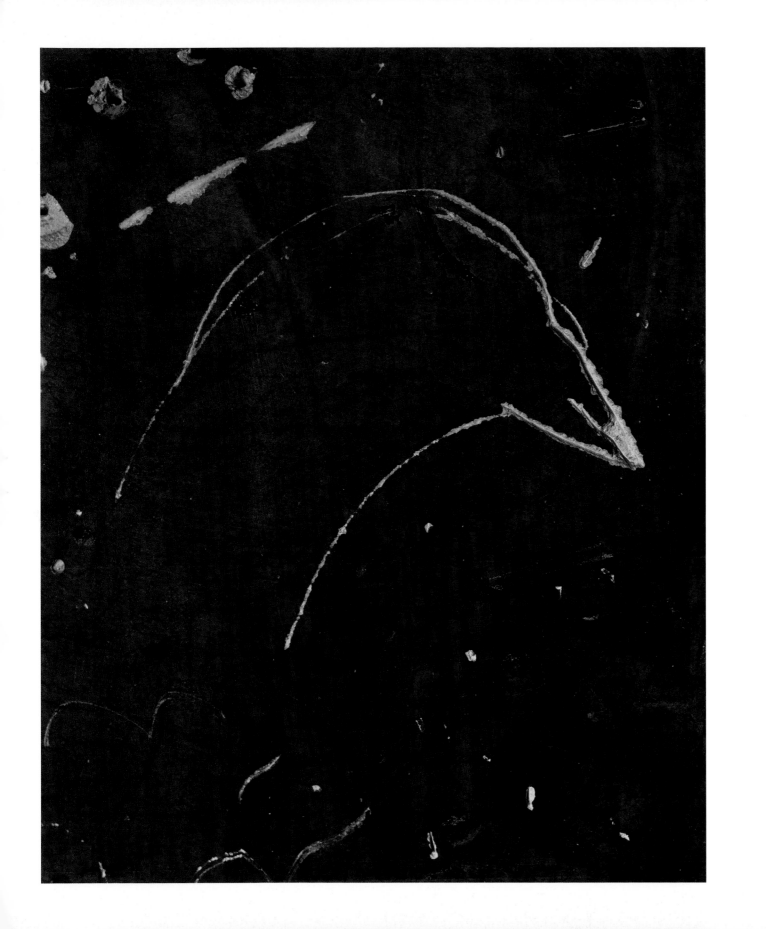

#19

#17

#7

#2

#24

#23

Opposite: The Red House #18

TARYN SIMON

(USA, b. 1975)

The Innocents, 2002

*T*he Innocents is a series of photographs documenting the stories of individuals who served time in prison for violent crimes they did not commit. Taryn Simon raises the question of photography's function as a credible eyewitness and arbiter of justice in legal proceedings.

The primary cause of wrongful conviction is mistaken identification. A victim or eyewitness identifies a suspected perpetrator through the law enforcement agency's use of photographs and line-ups. This procedure relies on the assumption of precise visual memory. However, through exposure to composite sketches, mugshots, Polaroids and line-ups, eyewitness memory can be influenced. In the history of these cases, photography offered the criminal justice system a tool for transforming innocent citizens into criminals. Photographs were used to assist officers in obtaining eyewitness identifications and aided prosecutors in securing convictions.

Simon photographed these men at sites that had a particular significance in their illegitimate conviction: the scene of misidentification, the scene of arrest, the scene of the crime or of the alibi. All of these locations hold contradictory meanings for the subjects. The scene of arrest marks the starting point of a reality based in fiction. The scene of the crime is at once arbitrary and crucial: this place, where they have never been, changed their lives forever. In these photographs Simon confronts photography's ability to blur truth and fiction – an ambiguity that can have severe, even fatal consequences.

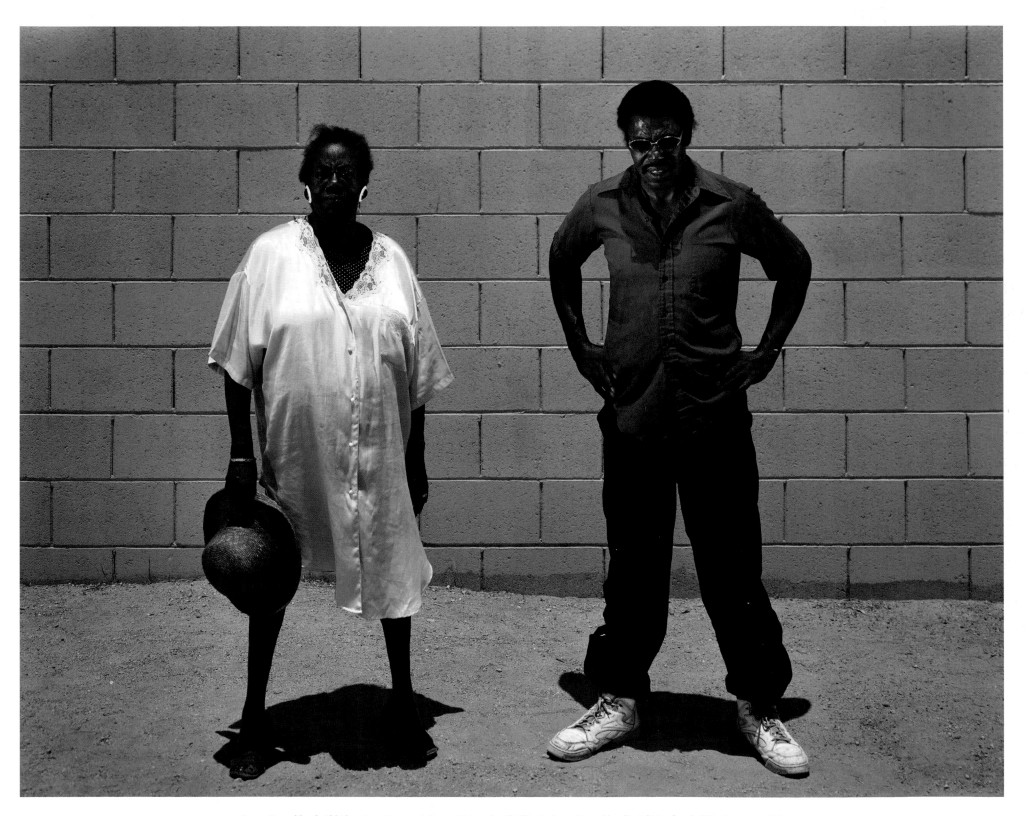

Larry Youngblood. Alibi location, Tucson, Arizona. Pictured with Alice Laitner, Youngblood's girlfriend and alibi witness at trial.
Served 8 years of a 10.5-year sentence for sexual assault, kidnapping and child molestation.

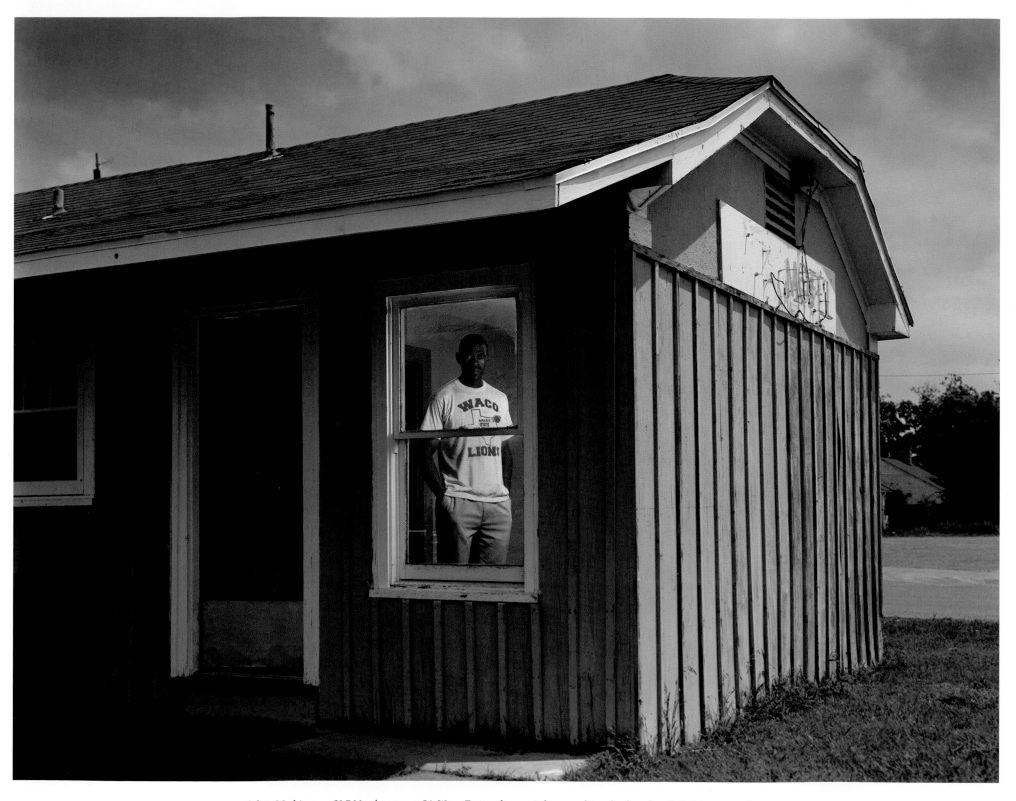

Calvin Washington. C&E Motel, room no. 24, Waco, Texas, where an informant claimed to have heard Washington confess.
Wrongfully accused, he served 13 years of a life sentence for murder.

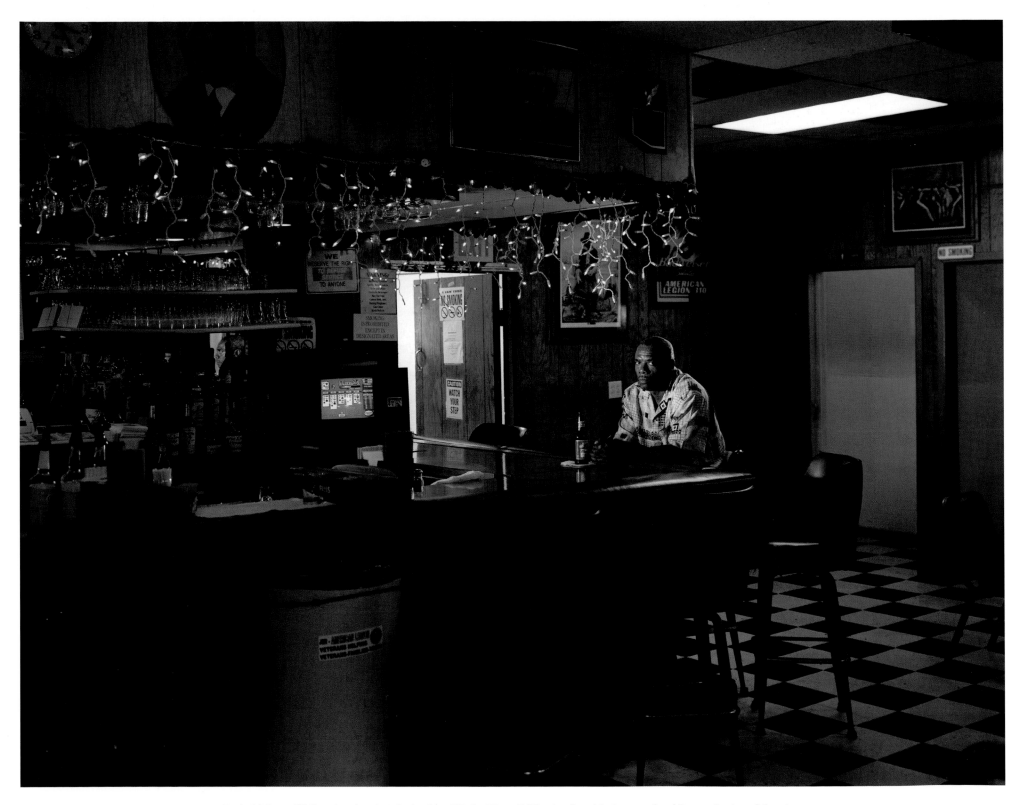

Frederick Daye. Alibi location, American Legion Post 310, San Diego, California, where 13 witnesses placed Daye at the time of the crime.
Served 10 years of a life sentence for rape, kidnapping and vehicle theft.

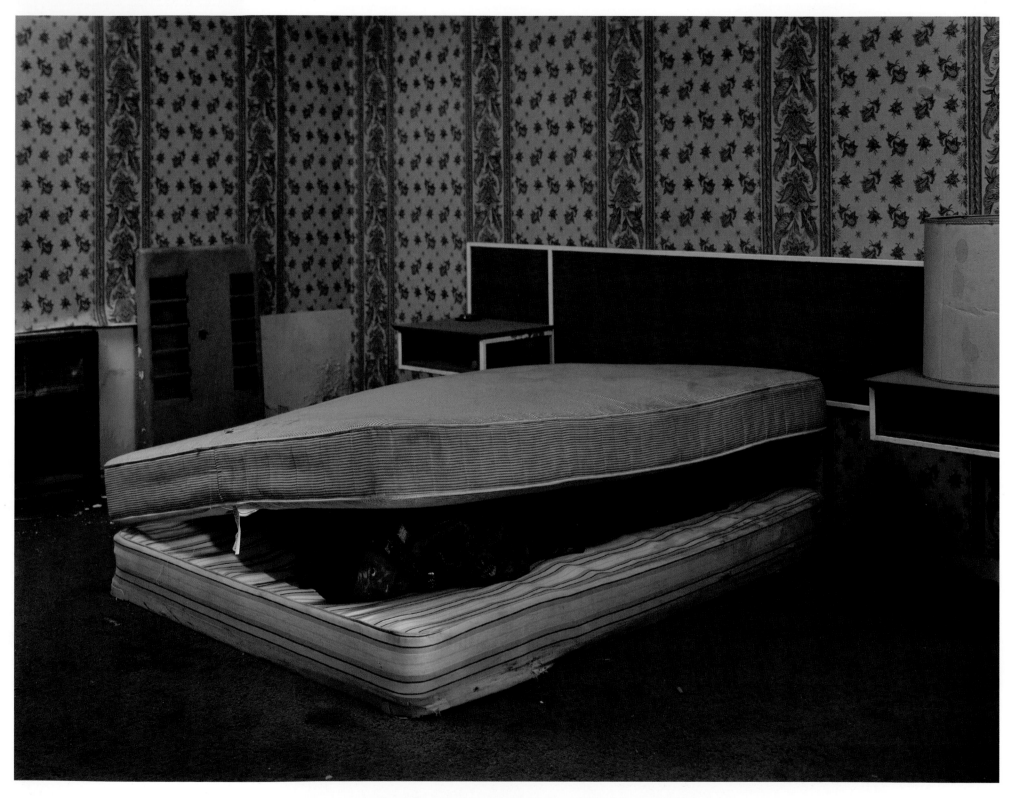

Larry Mayes. Scene of arrest, The Royal Inn, Gary, Indiana. Police found Mayes hiding beneath the mattress.
Served 18.5 years of an 80-year sentence for rape, robbery and unlawful deviate conduct.

Tim Durham. Skeet shooting, Tulsa, Oklahoma. Eleven alibi witnesses placed Durham at a skeet-shooting competition at the time of the crime. Served a sentence for robbery.

ASHLEY GILBERTSON

(Australia, b. 1978)

Bedrooms of the Fallen, 2009–10

The images that come to mind when we think of the death of a soldier are of ambushes, exploding grenades or gunfire. We also think of blood, a mutilated body, cries of pain. Ashley Gilbertson has recorded wars in Kosovo, Afghanistan and Iraq, and has photographed soldiers in action on the front lines. But then he felt a sudden need to tackle this same subject away from the scenes of combat, and so he began his series of bedrooms, a homage to the soldiers who have died in action.

At home, the bedroom is often a place of refuge. We put up pictures of our loved ones or of our heroes. We decorate it with ornaments and other items that remind us of important events. It is synonymous with home and security; when we close the door we can relax and rest. In this series, Gilbertson lets us into the private world of bedrooms belonging to young people who had just emerged from childhood and who are now dead, killed in battle when they had barely reached the age of twenty.

Our eyes wander through these interiors, which have been closed off ever since the soldiers went to war. Seven years after her death, Karina Lau's room has not been changed. Life is not far away, of course, but the closed door will not allow it to enter. Fixed in time, such places stand as memorials to the death of their young occupants. From now on, they are the reliquaries of those who will never return, and their families will nourish their memories of joy, of tenderness and pride through the small objects that are now their only remaining links with the lives of the fallen soldiers.

Marine Cpl Christopher G. Scherer, 21, was killed by a sniper on 21 July 2007 in Karmah, Iraq. He was from East Northport, New York. His bedroom was photographed in February 2009.

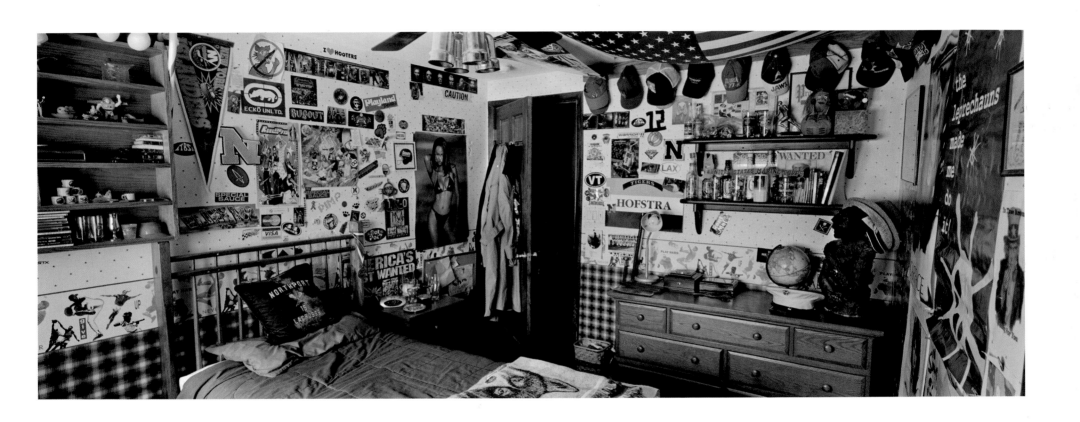

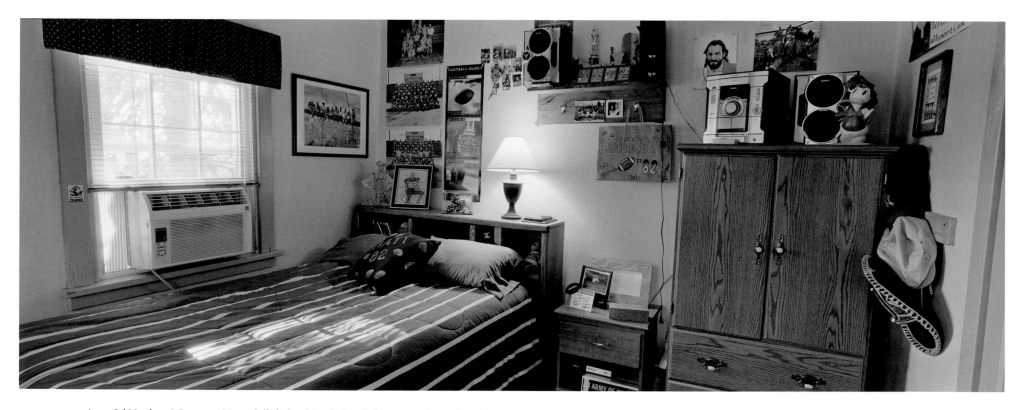

Army Cpl Matthew J. Emerson, 20, was killed when his vehicle rolled over on 18 September 2007 in Mosul, Iraq. He was from Grandview, Washington. His bedroom was photographed in February 2010.

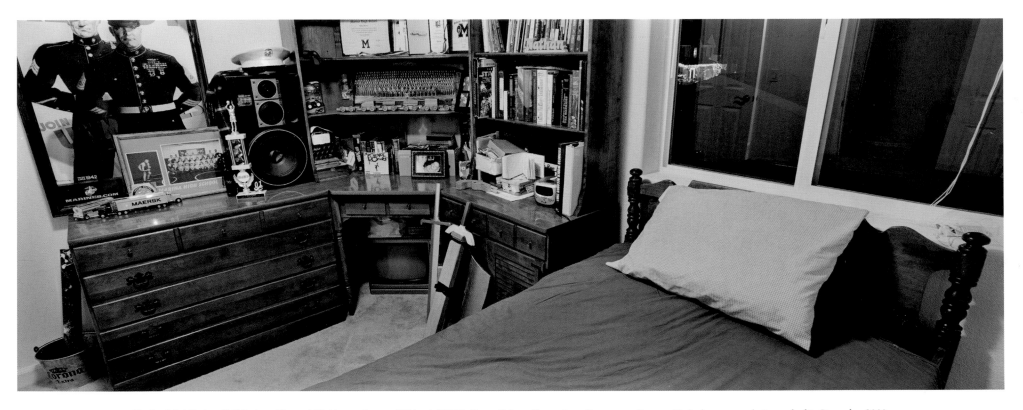

Marine LCpl Nathan D. Windsor, 20, was killed by a sniper on 13 March 2007 in Ramadi, Iraq. He was from Scappoose, Oregon. His bedroom was photographed in December 2009.

Overleaf: Army Pfc Karina S. Lau, 20, died when her helicopter was shot down by insurgents on 2 November 2003
in Fallujah, Iraq. She was from Livingston, California. Her bedroom was photographed in December 2009.

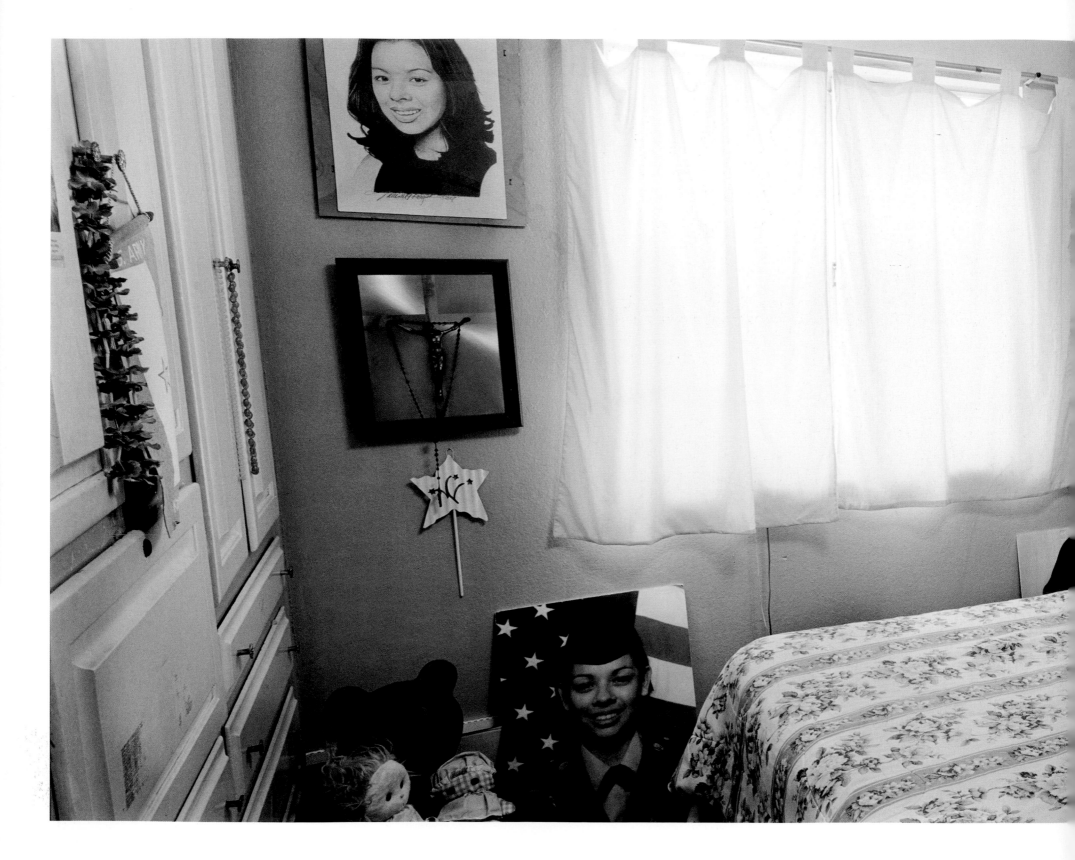

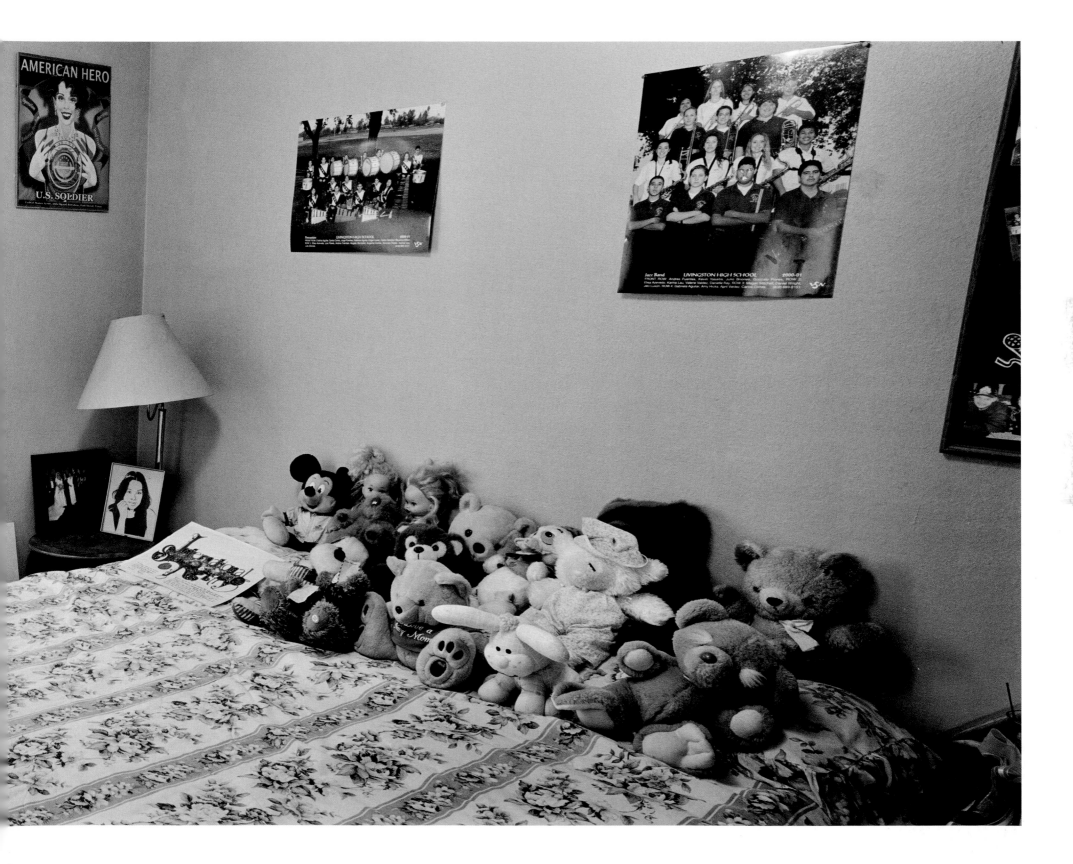

GUSTAVO GERMANO

(Argentina, b. 1964)

Ausencias, 2006

Omar Dario Amestoy and his brother Mario Alfredo on a trip to the country; Eduardo Raúl Germano, the eldest son, posing with his three brothers before they go on holiday; Orlando René Méndez, his wife Leticia Margarita Oliva and their daughter Laura at the home of their grandparents. Three photographs of happily family life, full of people who love one another. Viewers will find them strangely familiar; such pictures might be found in their own family albums.

The people photographed by Gustavo Germano were all affected by the extermination campaign carried out by Argentina's military dictatorship between 1976 and 1983. During this period, 30,000 people disappeared. Using photographs from family albums of thirty years ago, Germano photographed the families in the same places and under similar conditions, but without those who 'disappeared'. By thus bringing past and present together, Germano vividly expresses the pain of these families who are living with a big gap in their lives.

The experience of death is one of the most powerful motivating forces behind the creation of images: the image appears as a kind of response or reaction to the absence of a family member. Paradoxically, in Germano's photographs, it is through their absence from the second picture that the disappeared take on a physical form. While the absentees really are absent from these pictures, there have been dictatorships where the people in power did not hesitate to have propaganda images retouched, in order to – quite literally – remove the people they considered undesirable. The power of Germano's simple, direct portraits of missing loved ones lies in the fact that the pictures have an aura of complete authenticity and a strong emotional charge.

Top: Omar Dario Amestoy and Mario Alfredo Amestoy, 1975

Bottom: Mario Alfredo Amestoy, 2006

The Germano brothers, 1969

The Germano brothers, 2006

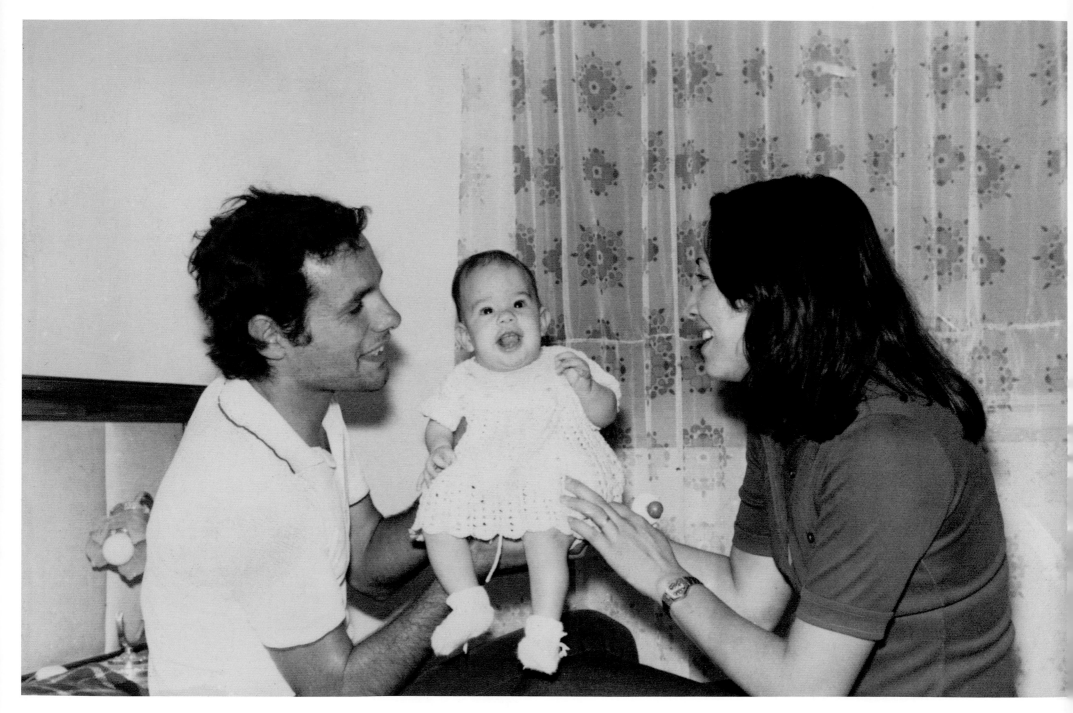

The Méndez family, 1976

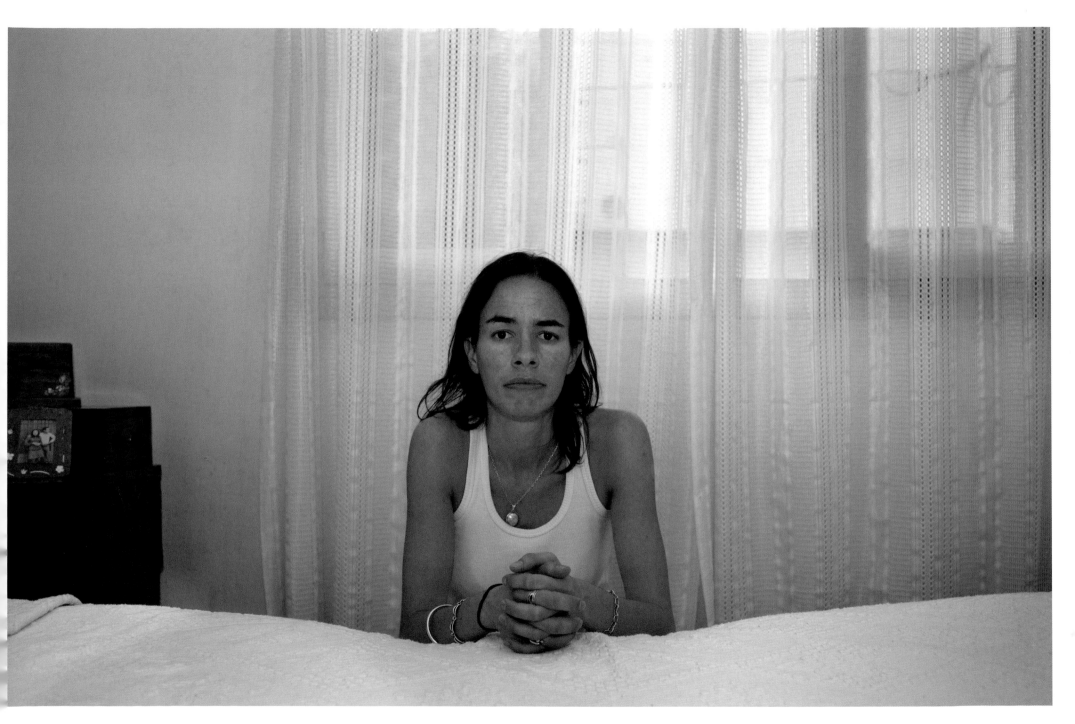

Laura Cecilia Méndez Oliva, 2006

CHRISTIAN SCHWAGER

(Switzerland, b. 1966)

My Lovely Bosnia: Blječeva, 2004

Untitled, Fall 2004

Between 10 August and 26 October 2004, 589 bodies were exhumed from three communal graves west of Potocari. In the Blječeva 1 grave, 132 bodies were recovered intact, 70 of which were identifiable. The victims came from detention camps set up in 1992. Of the 355 bodies exhumed from Blječeva 2 and 3, 55 were intact and 92 were identifiable. The bodies from these two communal graves had been taken from a first grave outside the village of Glogova, near Bratunac, and transferred to Blječeva in autumn 1995. As in other cases of double burial, the aim was to remove all traces of the war crimes committed against the almost 8,000 Bosnian Muslims by Serbian army units, following the UN abandonment of the 'protected zone' on 11 June 1995.

The Bosnian landscapes photographed by Christian Schwager look peaceful enough. They seem to invite us to walk through countryside that has never known any kind of disturbance. But in fact they are linked to terrible atrocities. Viewing these places more than ten years after the war, Schwager shows us pictures that run counter to the traditional images of war, which tend to focus on the dramatic. We live in a world that is saturated with images and news, but he has chosen a reflective style to tackle this painful subject – there are no visible traces of genocide, even though these places were the scenes of appalling massacres. Doubt begins to emerge as we gaze at these photographs and contaminates them one by one. The beauty of the landscapes gradually gives way to other mental images that depict the Balkans in the throes of war.

At a time when such horrors already seemed to have disappeared from Europe, once again there were killing fields, sieges and thousands of civilians massacred. The West, accustomed for more than forty years to seeing war unfold in distant, more 'exotic' lands, was shocked to see a whole region of Europe now devastated in the same way.

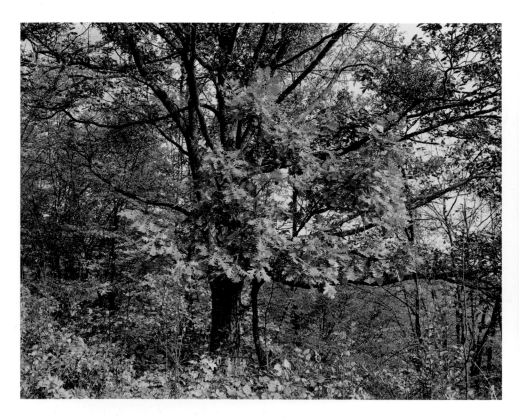

Untitled

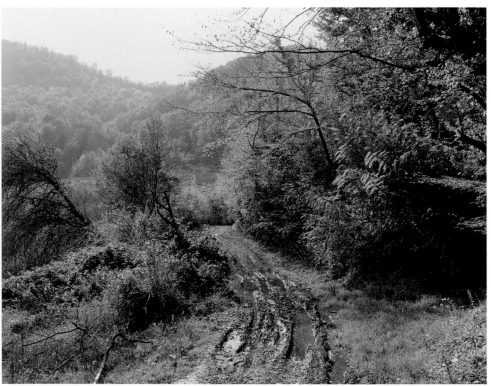

Untitled

Opposite: Untitled

PETER PÜNTENER

(Switzerland, b. 1958)

Totenklage, 2006

At the end of the Second World War, photographs showing piles of corpses in concentration camps came as a huge shock. These images, still engraved on the minds of those who saw them, were regarded as testimonies, and indeed the very concepts of 'atrocities' and 'war crimes' are connected to the expectation that proof will be supplied by photography. Peter Püntener's photographs of clothes and personal effects arranged on the ground provide a testimony of a similar kind.

Between 1992 and 1995, 200,000 people perished during the Bosnian war. Countless victims remain unidentified. Püntener went to a large hall at Sanski Most, in Bosnia and Herzegovina, where human remains are kept for identification. This place – the Krajina Identification Project (KIP) – is one of three identification centres run by the International Commission on Missing Persons (ICMP), created in 1996 to help the families of those who disappeared in the former Yugoslavia.

In keeping with the strict methods employed in these centres, Püntener adopts a rigid approach in his photographs: frontal views, no context, surgical precision in representing his subject matter. His pictures of clothes, shoes and other objects laid out to help families recognize the personal effects of their lost relatives, are in his eyes both evidence and an appeal for peace. These garments, all different, almost seem to move.

Untitled

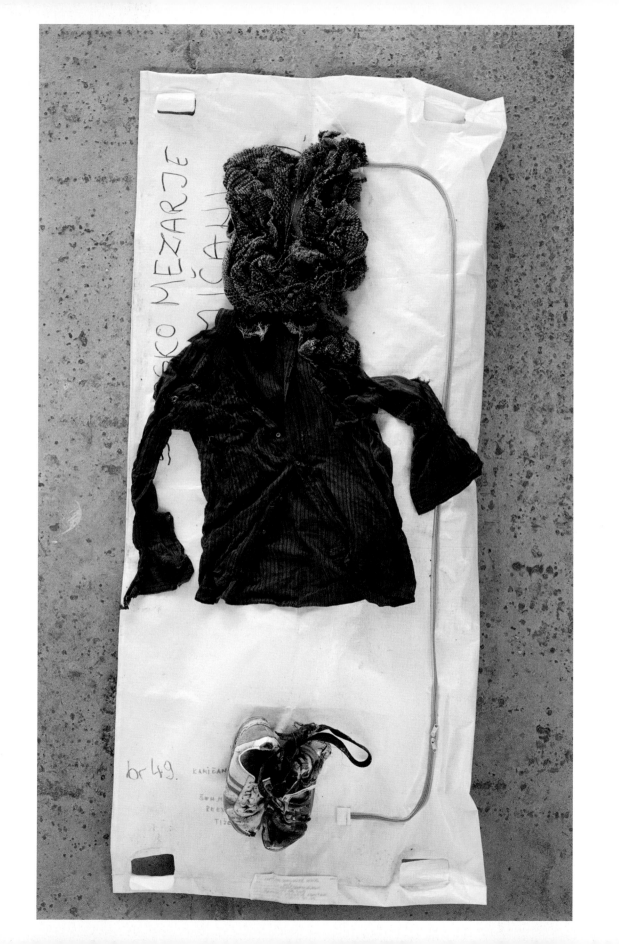

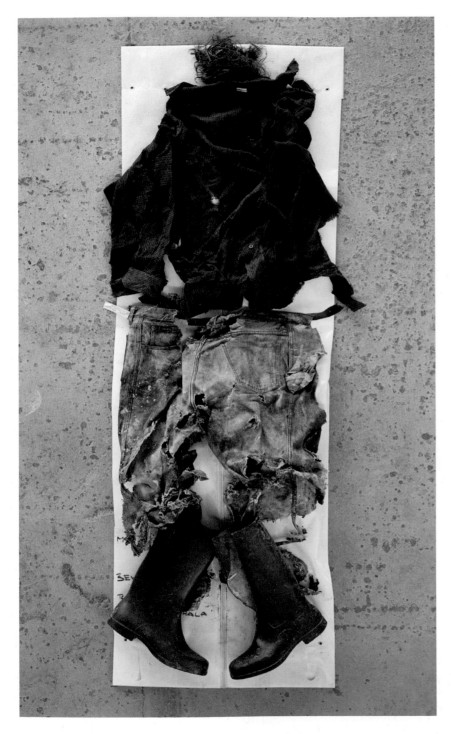

Untitled

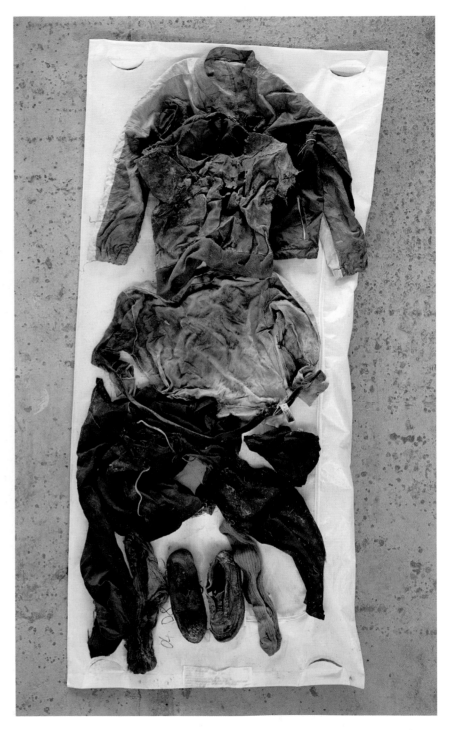

Untitled

Untitled

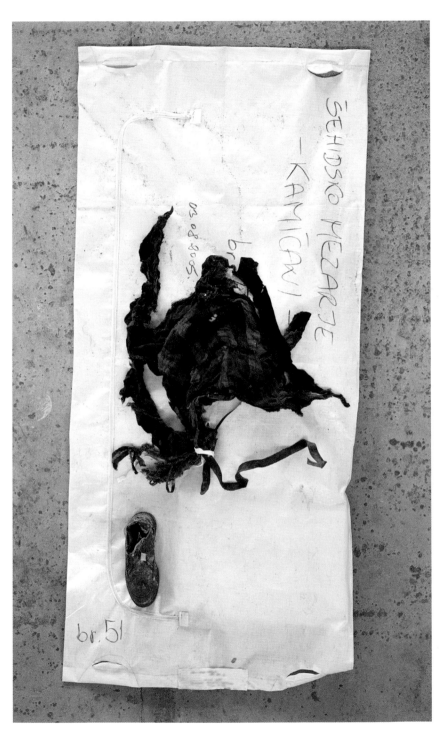

Untitled

GUY TILLIM
(South Africa, b. 1962)

Kunhinga Portraits, 2002–03

Photographed in a refugee camp in Kunhinga, in the province of Bié in Angola, these men, women and children are waiting for the civil war to come to an end. Refugees from regions where UNITA guerrillas recruited soldiers from the civilian population, they have walked for five days to reach the village of Kunhinga.

These images are a form of memorial: they bear witness to the recurrent conflicts and troubles across the continent of Africa. The people photographed by Guy Tillim have fled their homes and lands. They are waiting to return, but until that day comes they are trying to live their daily lives within a community dependent upon aid. A 'floating population', displaced by unrelenting war – the civil war in Angola ended after twenty-seven years of conflict in March 2002, a month after Tillim took these pictures – the refugees receive regular food in the camps, but must learn to rebuild a sense of family and community amid bleak living conditions.

Tillim's pictures concentrate on faces. By positioning his subjects at varying distances from the lens, sometimes very close up and sometimes far away, he breaks down the barrier between the subject and the viewer. The photographer gives back to his subjects something that they lost when they became refugees: their individuality and humanity.

Mateus Chitangenda, Fernando Chitala and Enoke Chisingi, 2002

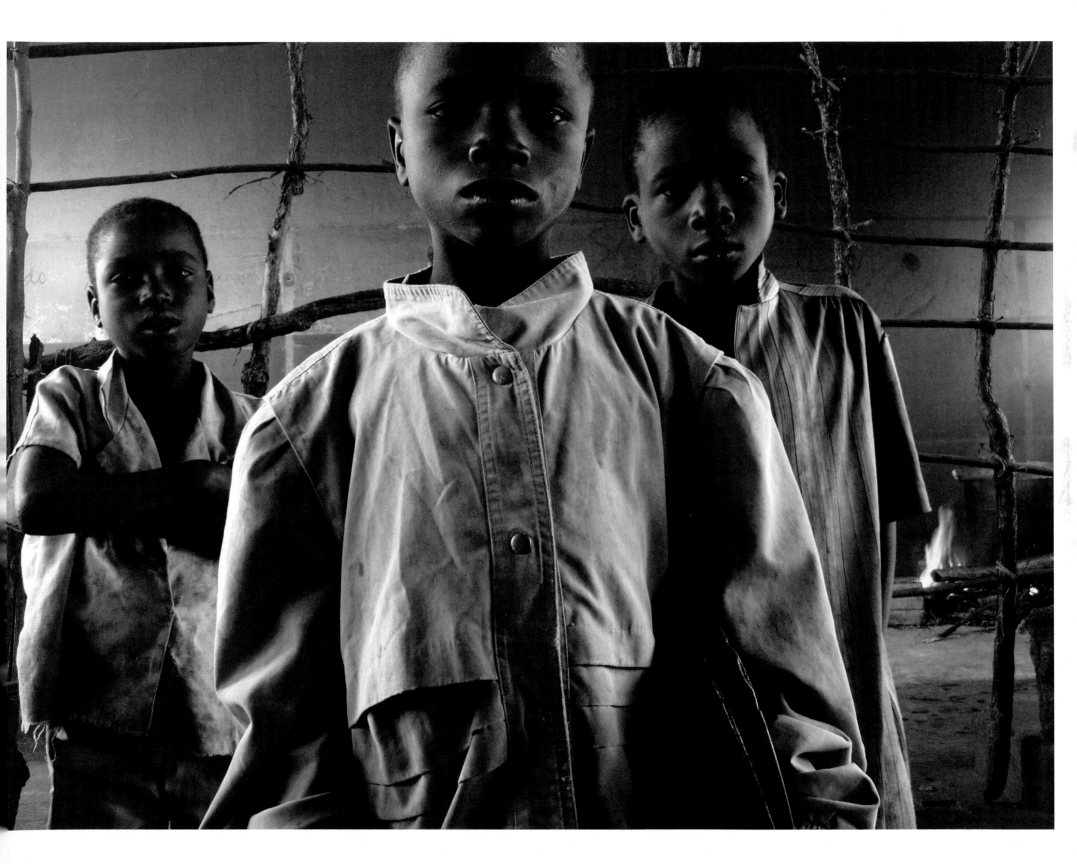

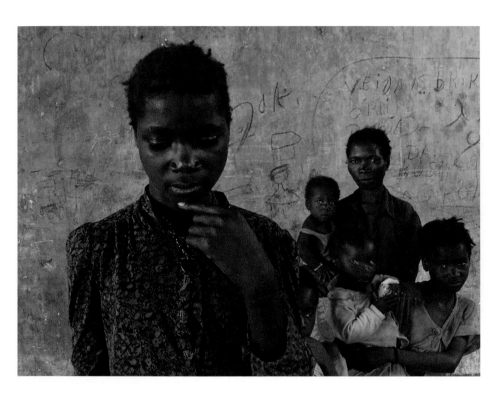

Fiorinda Ngoma, her mother Rosalia Nahamba (holding baby Filomena Lasinda)
and her sister Rosali Sindali, holding baby Guerra, 2002

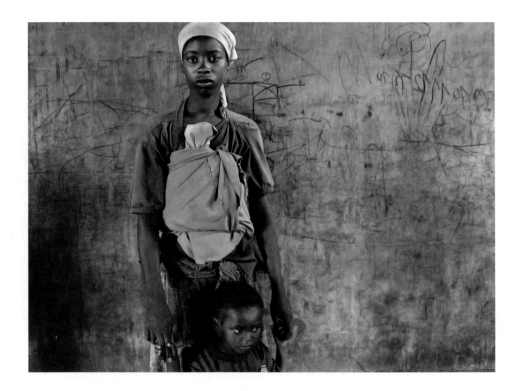

Refugees, Kunhinga IV, 2003

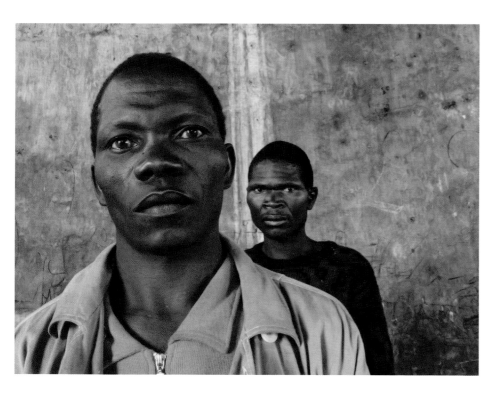

Refugees, Kunhinga I, 2003

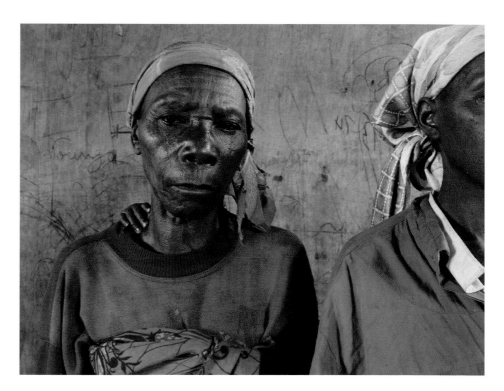

Albertina Natatu and Amelia Catembo, 2002

ROBERT POLIDORI

(Canada, b. 1951)

After the Flood, 2005–06

Symbolic of the end of all things, natural disasters have always been depicted in the arts. Flood myths in particular have recurred across many cultures. In 2005, Hurricane Katrina inflicted catastrophic damage on the southeastern US. The world's media were swamped by images of devastated land, water up to the roofs, abandoned cars, fallen trees, homes floating like rafts, and displaced people. Robert Polidori was one of those who came to photograph New Orleans after the hurricane.

Human beings are absent from Polidori's images – a purposely vivid metaphor – but the homes and interiors he depicts are nonetheless a vivid reflection of the people who once lived there. Watching a disaster occurring in a distant country can feel like a shared experience, but what does it mean to see chaos of this magnitude in one of the richest countries in the world? Polidori takes his time: he works with a large-format camera to obtain a wealth of detail, which he accentuates with the dimensions of his prints, and he prefers long exposure times in order to avoid the need for artificial light. This technique is the opposite of that of the photojournalist, who works by getting inside the event, almost like conducting a commando operation. Polidori rejects this kind of immediacy.

The purpose of documentary photography is not only to offer an image of the world but also to shape it. In painting, the representation of disasters is often linked to the concept of the sublime. Polidori's photographs, however, create an effect comparable to that of great fiction. The amount of detail invites viewers to contemplate the destruction in silence, reminding them of the fragility of human life and moving them to experience for themselves the fear of annihilation, as in a great myth.

5000 Cartier Avenue, New Orleans, Louisiana, 2005

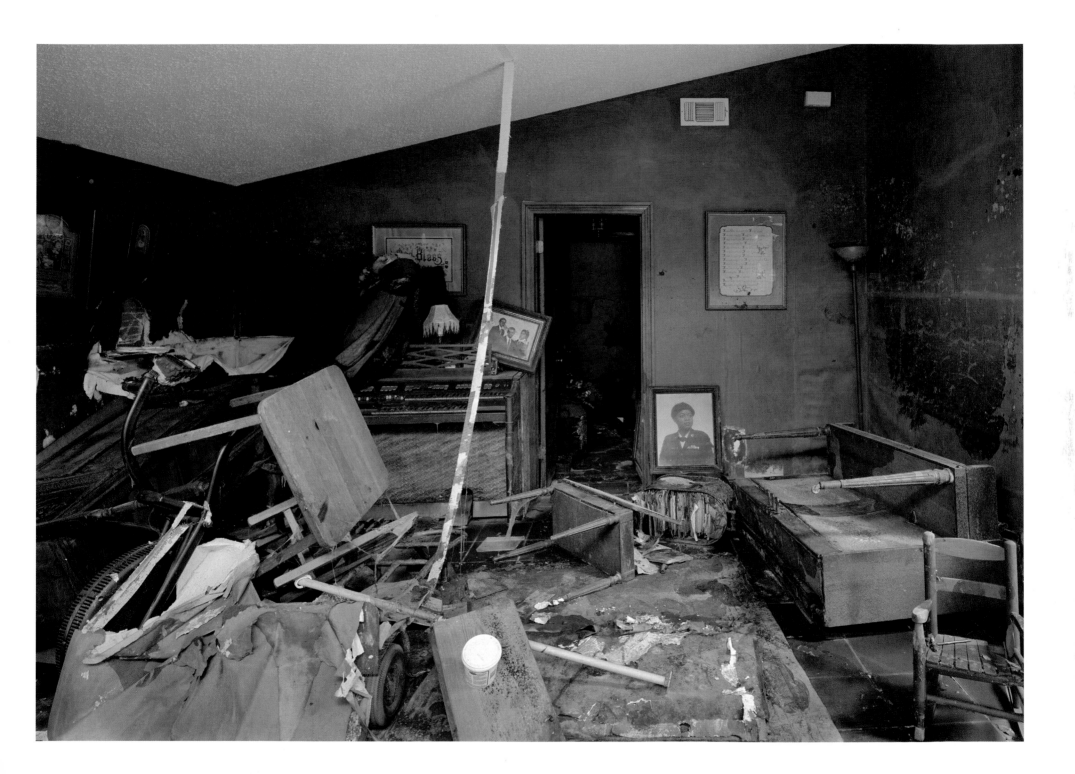

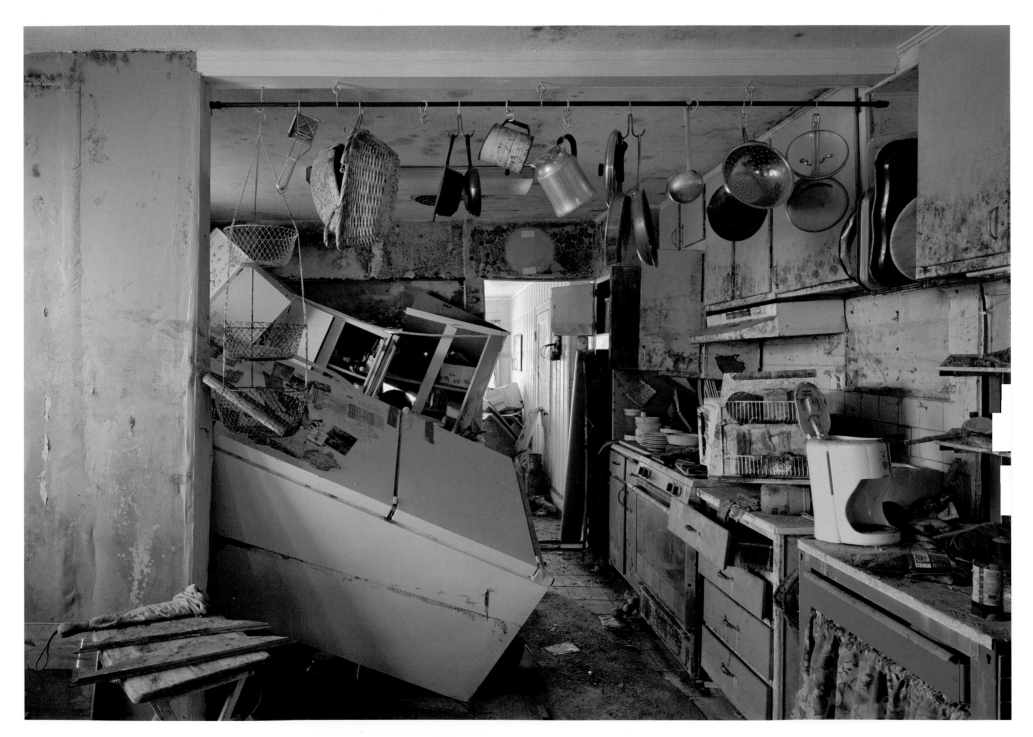

5417 Marigny Street, New Orleans, 2005

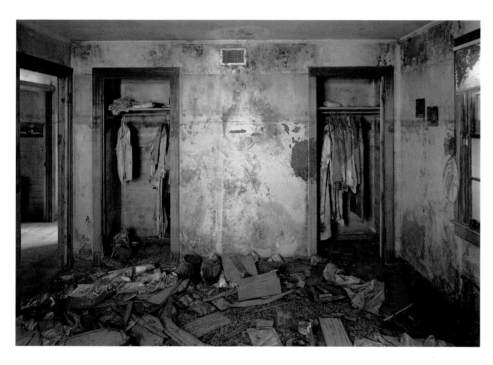

5020 Warrington Street, New Orleans, March 2005

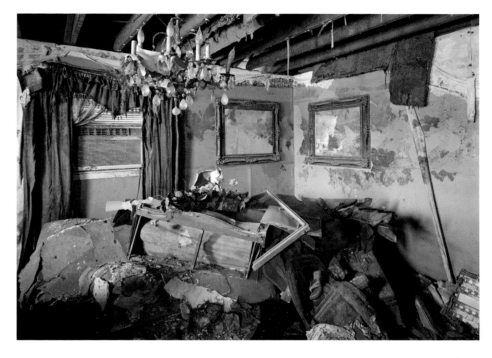

2520 Deslondes, New Orleans, March 2005

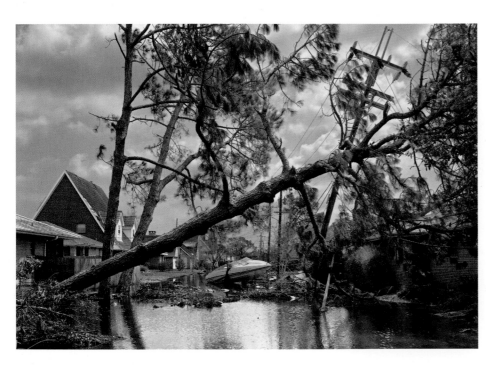

Bellaire Drive, New Orleans, September 2005

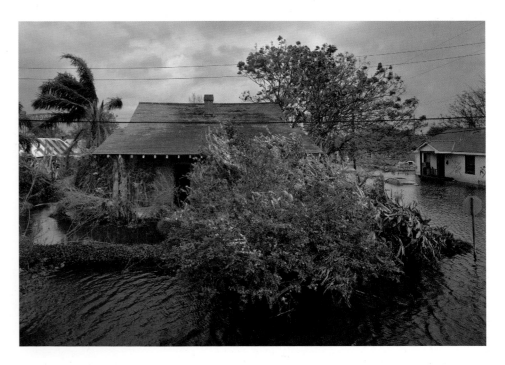

View from St Claude Avenue Bridge, New Orleans, September 2005

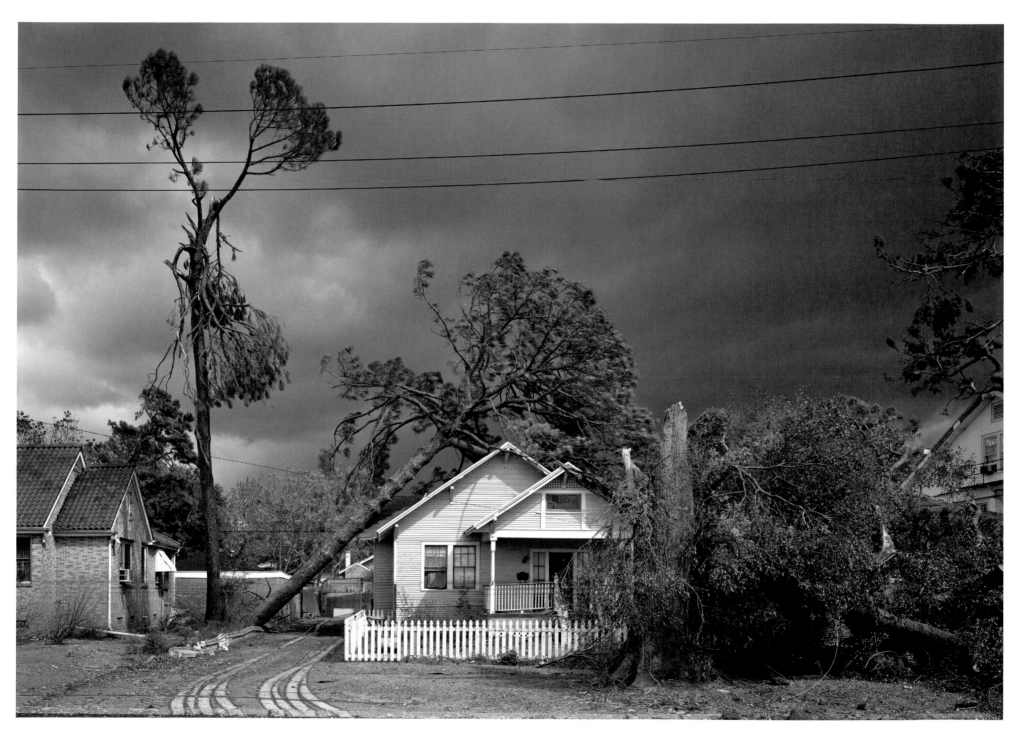

5979 West End Boulevard, New Orleans, September 2005

SUZANNE OPTON

(USA, b. 1950)

Soldier, 2004–05

Suzanne Opton's approach to taking portraits of American soldiers returning from Iraq is both unexpected and unsettling: she asked them to lay their heads on a table. Apart from enemy prisoners of war, we never see soldiers depicted in this manner, heads bowed, positioned as if they are wounded, dead or vanquished. The result is the exact opposite of military iconography. Courage, determination and self-confidence have given way to fragility, vulnerability and human weakness. Stripped of all their military trappings, these soldiers, who were in training at Fort Drum in New York before returning to Iraq or Afghanistan, all agreed to pose in this way, revealing the human beings behind the mask.

During the Second World War, the US conscripts who left to fight in Europe or in the Pacific posed with calm assurance and even pride, with their families gathered around them, promoting a cause that no one doubted. No such attitude can be seen in Suzanne Opton's soldiers. Their eyes seem glazed, as if they are no longer part of this world. Lost in thought, they seem incapable of overcoming their doubts and scruples, the guilt that threatens to overwhelm them. Whatever traumas they have suffered are psychological (we know that none of them were wounded). The captions accompanying the photos are brief: just the name and the number of days of active service. The rest is for the viewers to interpret. Only the soldiers' faces can be seen – and it is the eyes that attract our immediate attention. Does photography have the capacity to see into the soul of the subject, as has often been suggested? Can we say that these people look serene, shocked, calm, exhausted, impassive or traumatized? What are the thoughts that are really going through their minds as they lie in this position? Opton has made her own intent clear: 'In making these portraits of soldiers, I simply wanted to look into the face of someone who'd seen something *unforgettable*.'

Soldier: L. Jefferson.
Length of Service: undisclosed.
2005

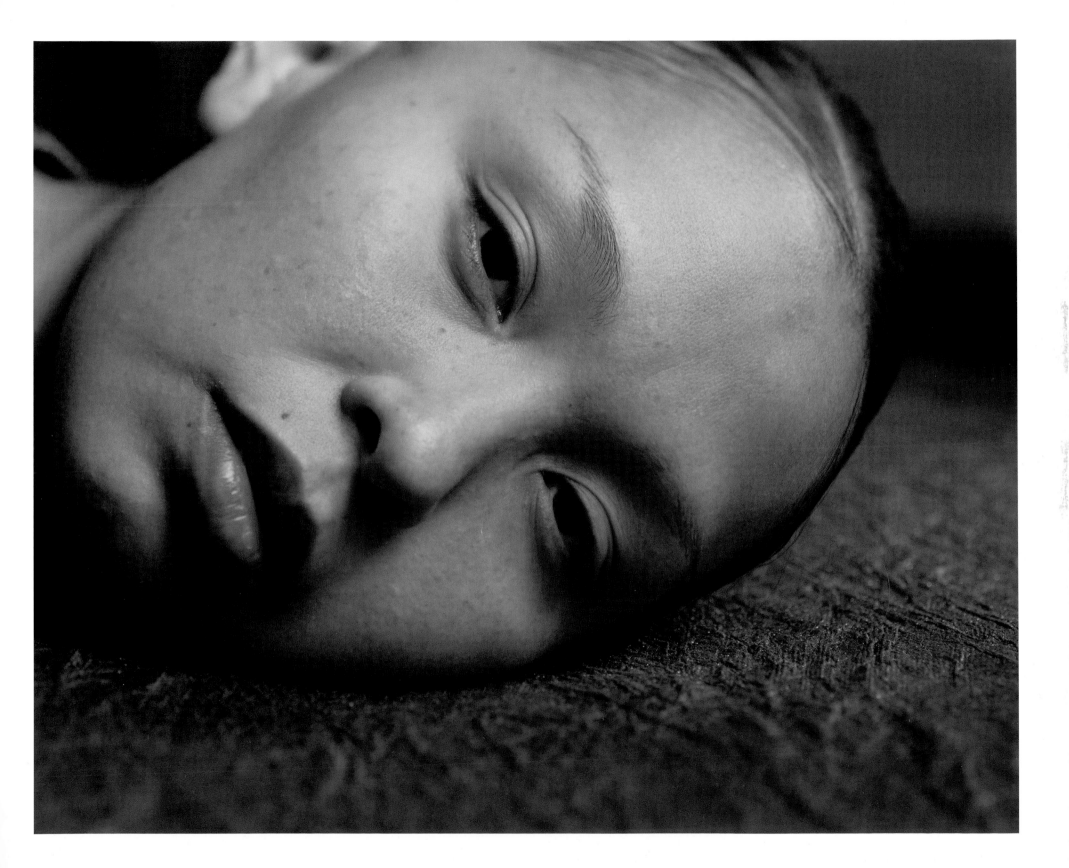

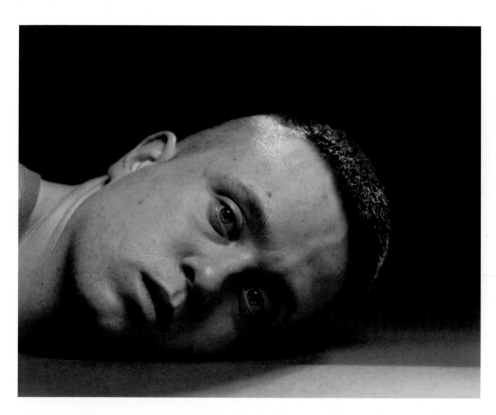

Soldier: Bruno. 355 days in Iraq. 2004

Soldier: Claxton. 120 days in Afghanistan. 2004

Opposite: Soldier: H. Jefferson. Length of Service: undisclosed. 2005

HENK WILDSCHUT
(The Netherlands, b. 1967)

Shelters, 2006–09

San Clemente, Spain,
September 2007

When the French town of Calais is mentioned in the press, it is often in connection with illegal migrants wishing to travel to the UK. In 2005 Henk Wildschut decided to tackle this subject so prominent in the media. Since then he has travelled thousands of kilometres across Europe to photograph migrant shelters. Boxes, plastic sheets and blankets are just some of the building materials used to construct a roof attached to trees or bushes. Wildschut admits to being fascinated by the creativity behind these makeshift structures. In fact, his photographic series resembles a typology study.

Some shelters are square or rectangular, others are round. There is a certain harmony to be sensed, insofar as each of these structures has the same purpose – to protect its occupants from the cold and the rain, or from police intrusion. By isolating his subjects, Wildschut encourages the viewer's eye to compare shapes, materials and colours, which vary according to the ethnic origin of the builders. With this serial approach, he succeeds in sharpening our curiosity. He sees no need to use his work to dramatize a situation that is dramatic enough already. In one case, his own photography was used for the very purpose it depicted (Calais, see p. 117) – a reproduction of an image was 'recycled' and used as an actual shelter.

The migrants arrive in Europe, often having covered vast distances, hoping for a better life. Some are successful, but others remain in their makeshift shelters for long periods. What these pictures show us above all is the survival instinct shared by these people who live hidden away in the depths of the forest.

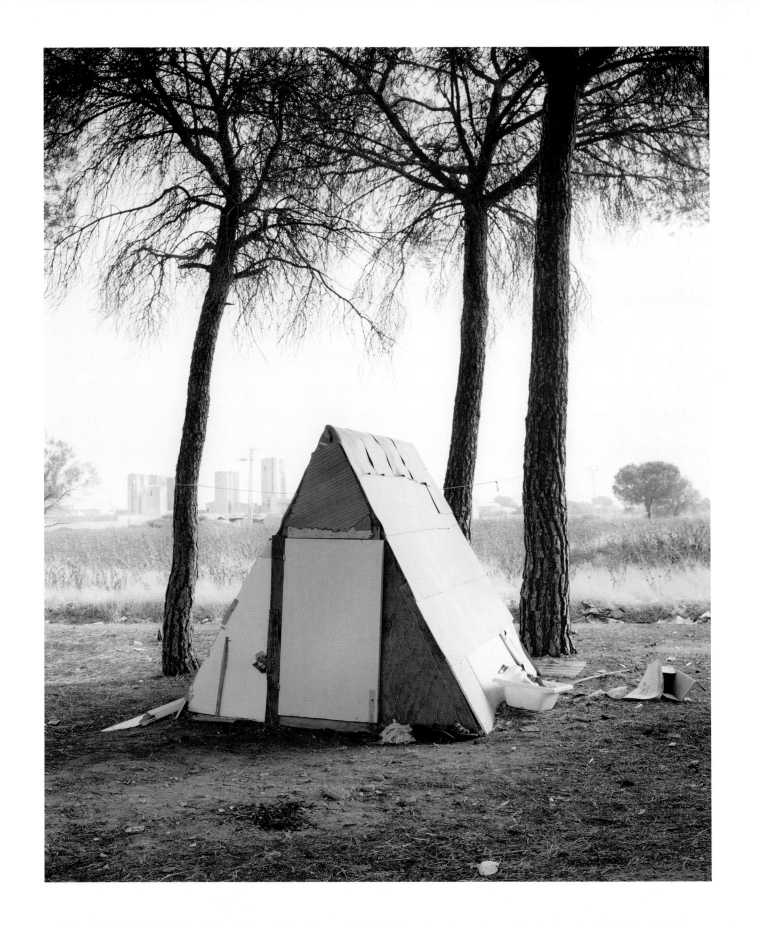

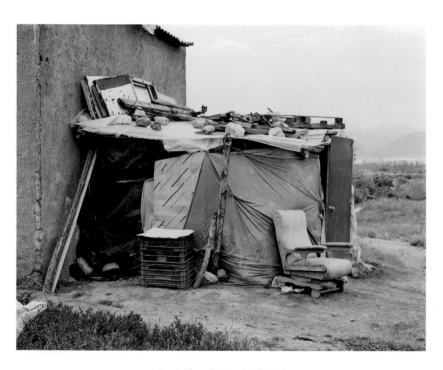

San Isidoro, Spain, April 2007

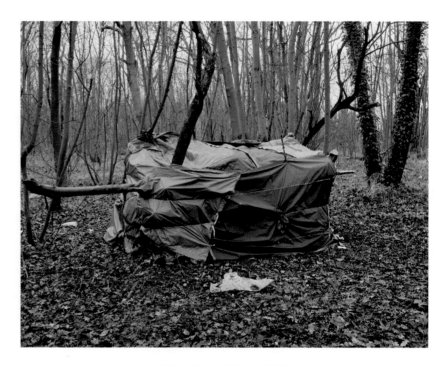

Calais, France, February 2006

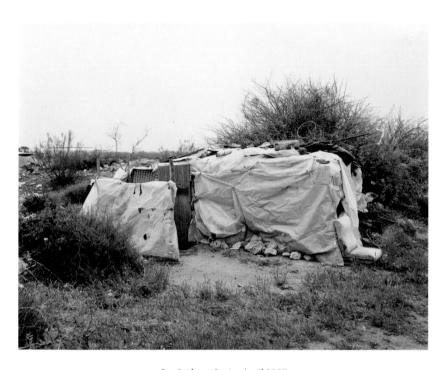

San Isidoro, Spain, April 2007

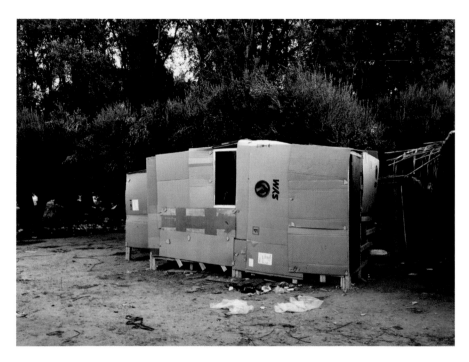

Patra, Greece, November 2008

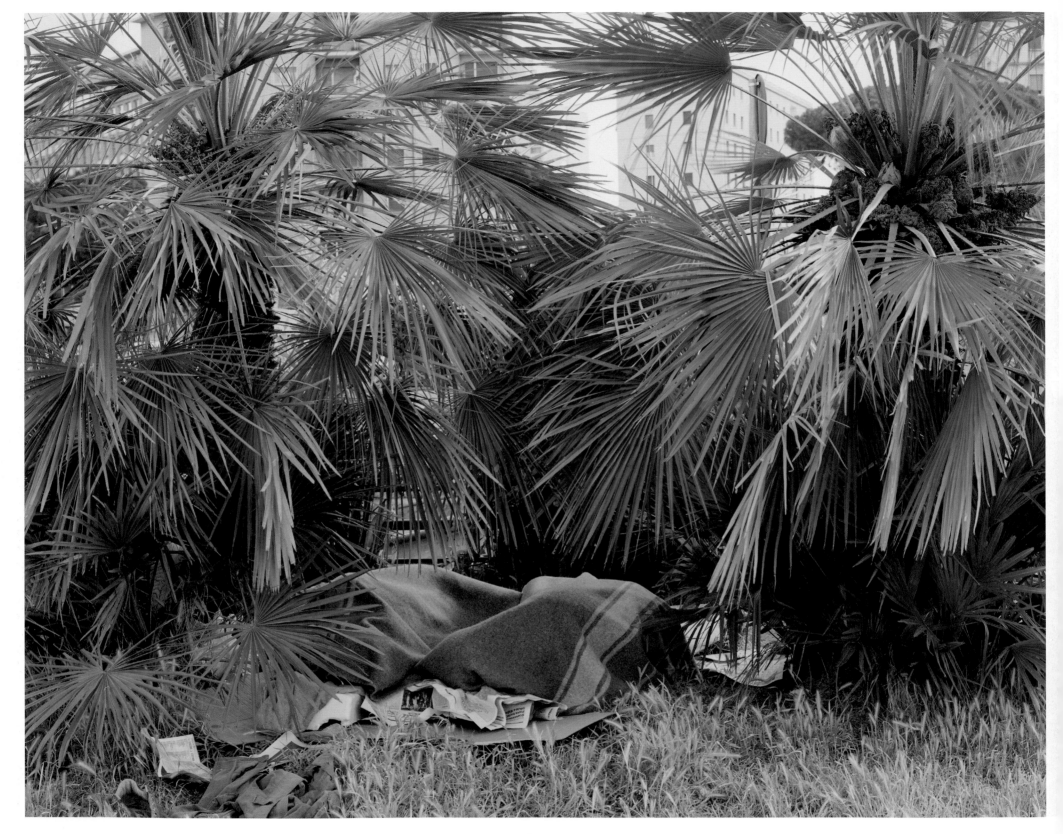

Rome, Italy, May 2008

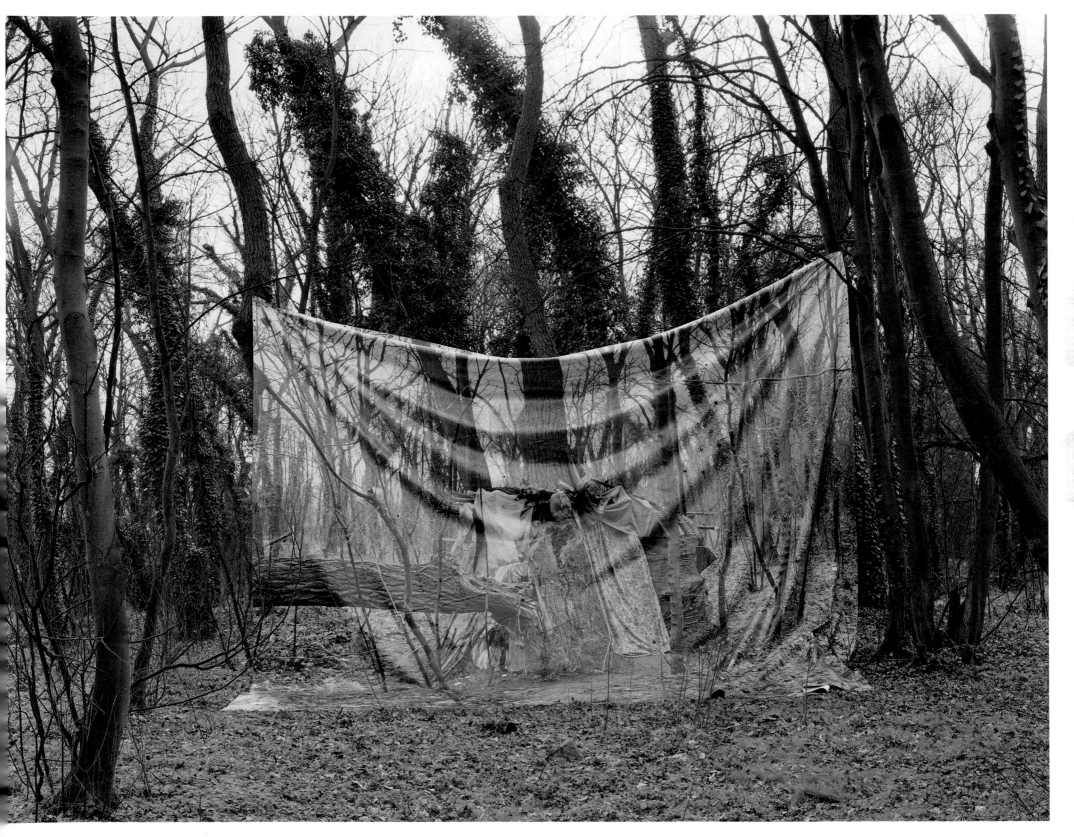

Calais, France, 2009

SUZANNE OPTON

(USA, b. 1950)

Citizen, 2007

Continuing her exploration of the war initiated by the United States, Suzanne Opton went to Jordan to meet Iraqi refugees. Using the same procedure as in her *Soldier* series (see p. 108) – i.e. photographing her subjects in a horizontal position – she studied the faces of individuals who had left their families and country behind. The camera invites the viewer to come close, but in these photos the intimacy seems almost excessive. By giving the names of the subjects and their occupations, she seeks to involve the viewer more than would be the case with anonymous portraits. What remains unknown, however, is the terrible experiences these people have undergone. They have fled their homeland, experienced danger, and perhaps been shadowed by death. Now they have sought a refuge where they might live in safety. Opton describes them as citizens, but they have lost their basic rights. What do their faces tell us? What emerges from their expressions: memories, terror, sadness or calm? Once more, it is left to the viewer to come up with their own interpretation.

The tact with which Opton handles a subject as delicate as that of the Iraq war is admirable. Rather than denounce the conflict openly, she has opted for discretion. In photographing these men and women, whether American or Iraqi, soldiers or refugees, she has sought to express an inner life that is open to all sorts of questions. Perhaps the subjects had not expected to pose for the camera lying down, but they agreed to play the game her way and in doing so showed their vulnerability. With these two series, Opton shows how withdrawal into the self can also present a strikingly eloquent image.

Citizen: Yada Barazanji, writer, mother of three.

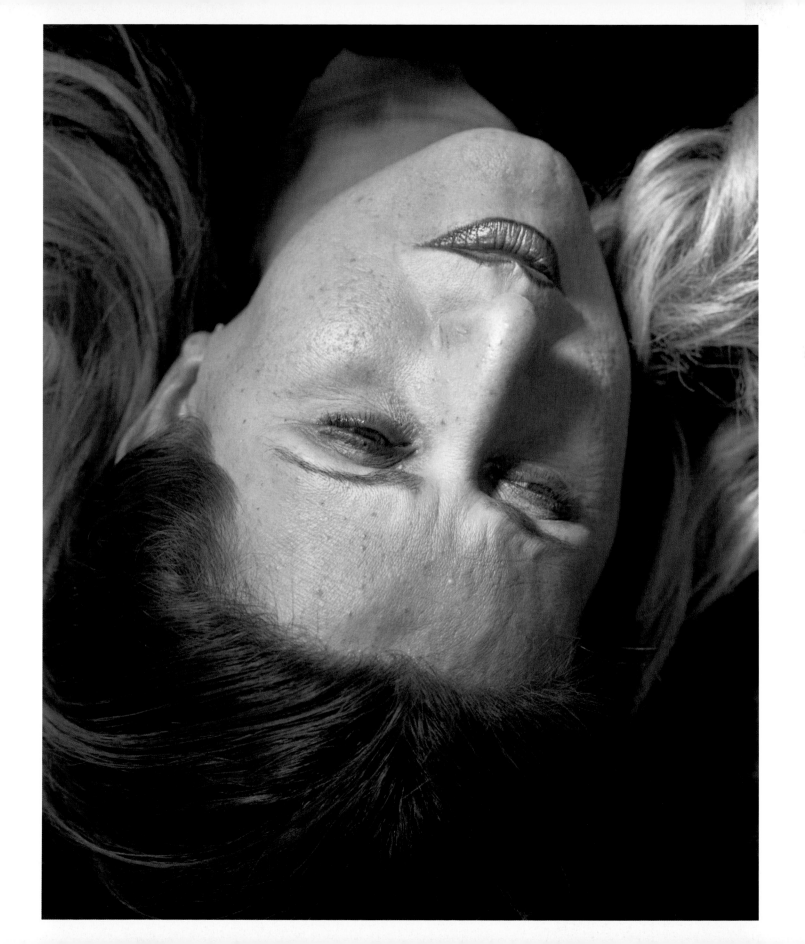

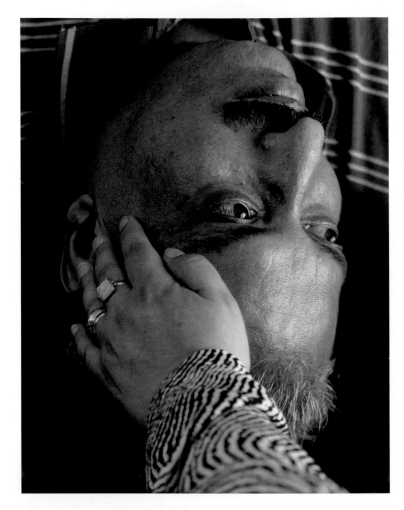

Citizen: Thabit al-Falahi, doctor, father of four.

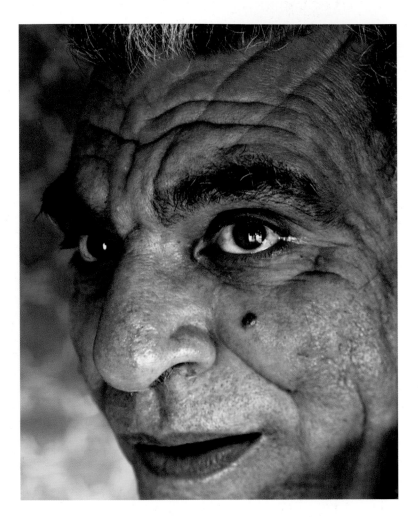

Citizen: Ghazwan al-Mukhtar, businessman, father of two.

Opposite: Citizen: Sabah Yalda, engineer, father of two.

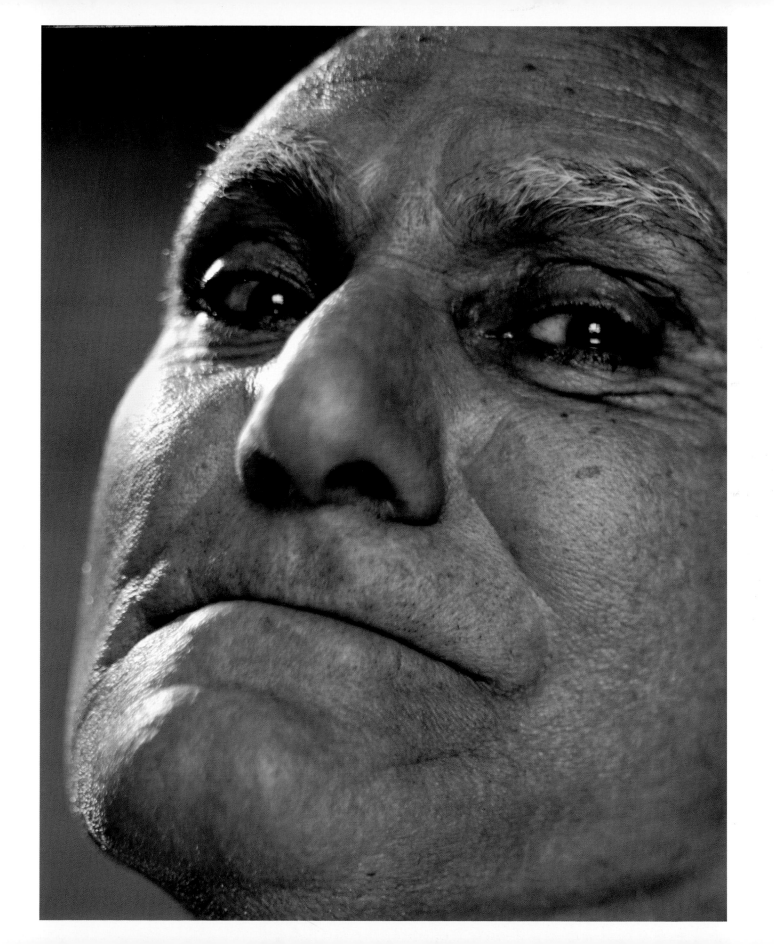

MAZIAR MORADI

(Germany, b. 1975)

1979, 2007

Untitled

The year 1979 was a fateful one for Maziar Moradi's homeland of Iran. The Pahlavi dynasty was overthrown and replaced by the Islamic Republic. The revolution started a new era that was marked by outbreaks of violence, and just a year and a half after Ayatollah Khomeini's ascent to power, Iraq declared war on Iran. This turbulent period in Iran's history was the inspiration for Moradi's photography. He knew that some members of his family had lived through the revolution and the war with profound repercussions for themselves, and he asked them to re-enact their roles so that he could record their story.

The question we ask when confronted with Moradi's photos is whether they are reproductions of reality or fictional constructs. He says that he is reliving scenes experienced by his family. Different people are shown in public or private places, in the daytime or at night. We are plunged into a cinematic world. How were these characters directed, given that they themselves lived out these scenes? This calculated blurring of reality and fiction suggests a critical view of the so-called objectivity of documentary photography; the fiction allows the relationship between image and reality to be explored.

Shot in Iran, the series *1979* focuses on people, not political events. Nevertheless, the latter are never very far below the surface. Moradi's stagings are based on memories, but we do not know whether these have been transformed by time or have remained intact. In truth, it doesn't matter. The images are suffused with tension and the viewers are invited to immerse themselves in these pictures, even if they are the product of the photographer's imagination.

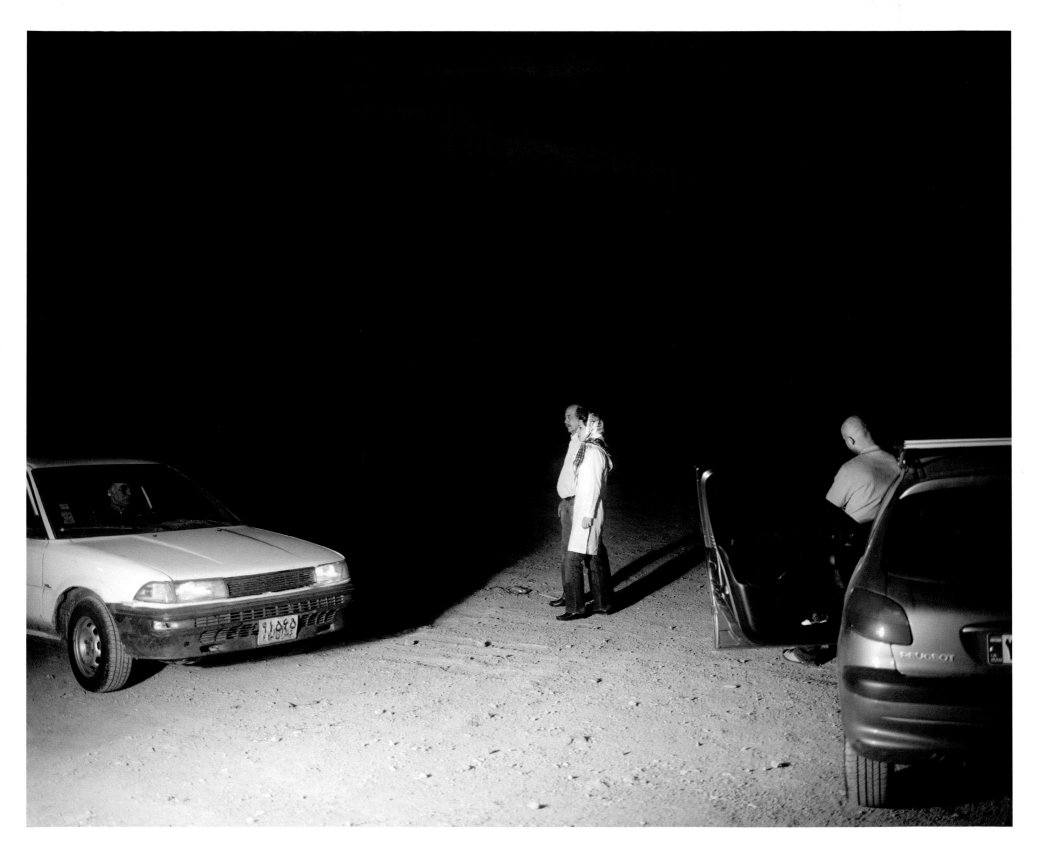

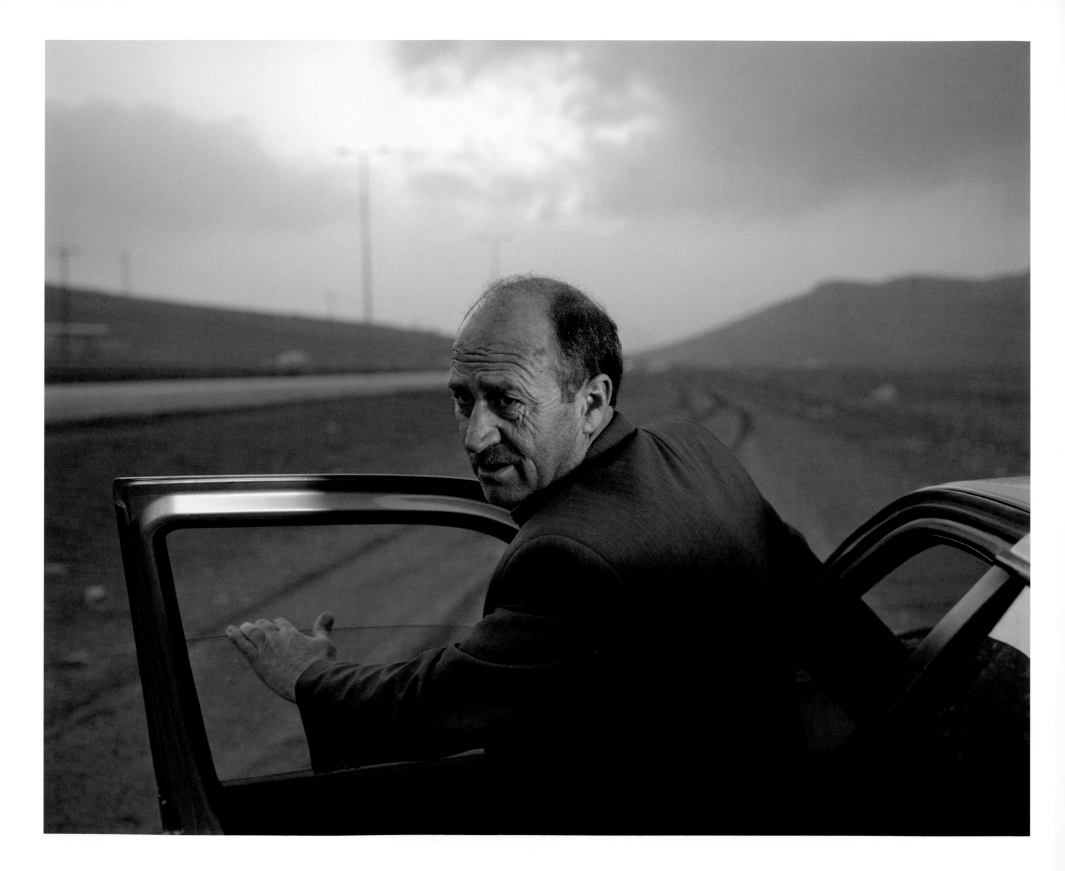

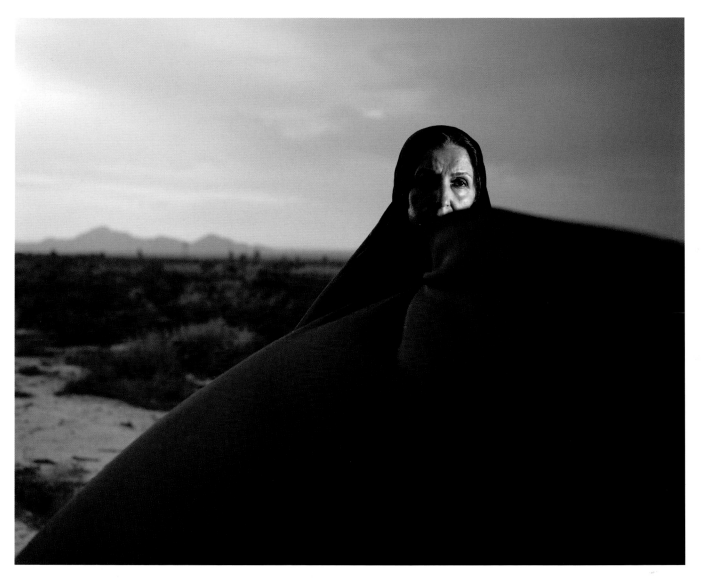

Untitled

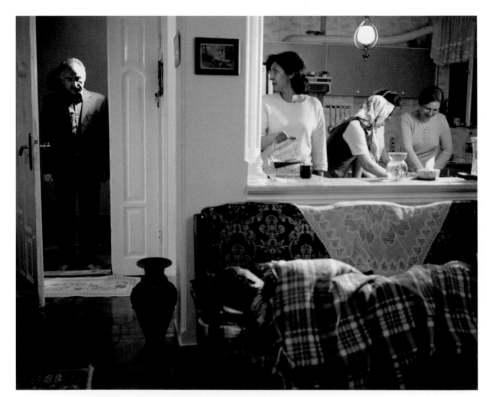

Untitled

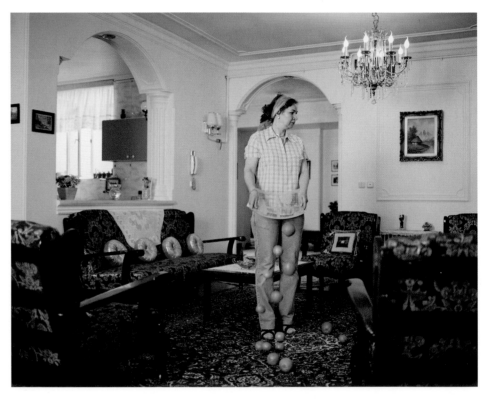

Untitled

Opposite: Untitled

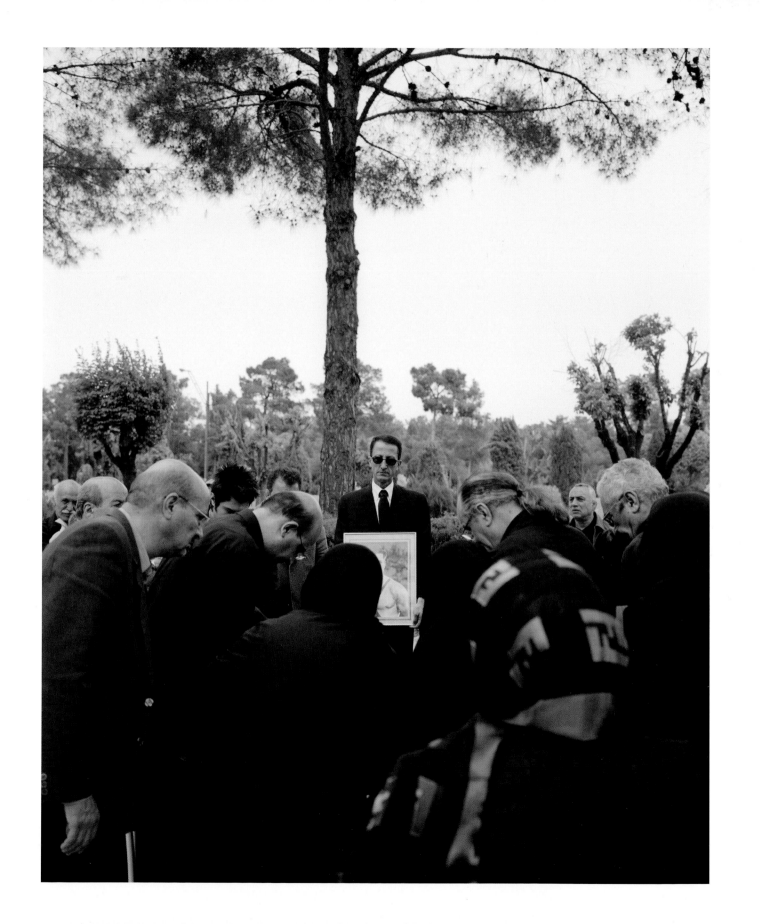

RAPHAËL DALLAPORTA

(France, b. 1980)

Domestic Slavery, 2006

A Paris apartment block, an unobtrusive house in the suburbs, calm and peaceful locations – and yet over the course of months and often years, some terrible events took place there. No one seemed to notice until the Committee Against Modern Slavery (CCEM) intervened. One case was brought to their attention, and suddenly a heartbreaking story was revealed concerning people whose very existence had been kept secret from the world.

The series *Domestic Slavery* by Raphaël Dallaporta shows the ordinary-looking façades behind which these secret servants were exploited. Dallaporta has chosen to stay detached from the victims of abuse. He turns his camera solely on the houses where these young foreign women and their tormentors lived and sticks to a rigidly formal approach. Just like a crime scene investigator, he begins by examining the exterior. There is nothing to be seen apart from the windows, but even when these are open, they give no hint of the horrors within. Thus Dallaporta uses apparently harmless images – you might think you were leafing through a catalogue of properties for sale – to convey the general indifference of passers-by, neighbours, our whole society which closes its eyes to such human dramas. Only the texts, written by Ondine Millot, take us into the real world of the victims. These texts are repetitive, telling similar stories and creating a haunting contrast with the anonymity of the façades: the words tell of servitude, isolation and abuse. There is a powerful tension between the images, which give not the slightest indication of the truth, and the words recounting the horror stories of these modern-day slaves.

AINA

Aina's boss gave her a list of words – 'yes, thank you, hello, goodbye'. These were the only words that Aina, then aged eighteen, had the right to say.

Her day began at 6 a.m.: preparing breakfast for the family's two children, then ironing, vacuuming, doing the laundry, washing up, gardening and cooking. Her day ended at midnight. Aina ate the family's leftover food from a separate plate; she slept on the tiles of the bathroom floor. Aina left Tananarive, the capital of Madagascar, on a promise: 'A job, money to send back to my family, the chance to continue with my studies.' Held prisoner for two years, she was beaten, threatened and never paid.

A neighbour finally noticed this 'young, thin girl who didn't speak' in the garden. She gave her some cream for her hands, which were cracked from the hard work, and called the CCEM. Today, Aina works as a nurse near Paris; her employers were given a six-month suspended prison sentence and fined €4,500.

SALMA

She tells her story as if apologizing for it. 'For me, leaving for France was an unhoped-for chance I had to take.' Even if it meant leaving Morocco and her family aged just seventeen; even if, almost immediately, in the small apartment in the Parisian *banlieue* where she arrived in September 1998, her new boss threatened, mistreated and insulted her every day; even if she wasn't paid any of her promised salary; even if she wasn't signed up for 'the good French school' she had been promised. Salma survived 'by praying'. Each day, she hoped that 'things would work out'. Each day, she had to scrub the apartment from top to bottom: vacuum, wipe the dust off every centimetre of every surface, wipe down the floor in the toilet, the walls and the floor of the bathroom, hand-wash the clothes and iron them. Then, 'completely empty the kitchen cupboards and clean them, lift up all the cushions in the living room and turn them over to air, lift and beat the mattresses and beds and clean all the windows in the apartment.' Her boss was obsessed by cleanliness and was never satisfied. Salma also prepared meals and looked after her boss's two children, twin boys aged ten.

The boss would often have hysterical fits, such as the one the day in March 2001 when she threw Salma out. Taken in by a social services shelter, she slowly began putting her life back together, and eventually decided to take her boss to court. Today, Salma has found a job as a cashier in the Paris region; the case against her employer has yet to come to court.

ANGHA

The apartment was huge, situated on one of the most beautiful avenues of Paris's 16th arrondissement; its owners were extremely rich. The man, CEO of a number of Saudi gas and oil companies, spent his time on business trips; the wife didn't work. She spent her time moving between Saudi Arabia, the UK, Spain and France, where the couple owned several properties, and acted as absolute monarch with her army of household staff. 'I have so many people working for me in Saudi Arabia and all over Europe that I sometimes forget their names,' she told the police. In October 2002, Angha, forty-two, had been part of the 'staff' for two years – and locked in the Paris apartment for five months. Recruited in Goa, India, the holder of a domestic worker diploma, she applied to a recruitment agency to work in a family. She then followed the family as they moved around. Once she arrived in Paris she received no pay for her domestic tasks, which she carried out every day from 7.30 a.m. until 2 in the morning. Her passport was confiscated and another employee was given the task of watching her and locking her in every evening. Every day her boss beat her. 'She hit me with different objects, such as shoes; she pulled my hair and pushed me down the stairs. She broke my nose,' Angha remembers. In October 2002, Angha no longer had a choice. Taking advantage of a moment alone she rolled up some sheets, tied them together, knotted them around the edge of the balcony and managed to escape through a window on the third floor. The police officers who picked her up found her body covered in wounds and bruises.

With the help of the CCEM, Angha was able to return to India, as she wished, and see her mother and sisters again.

DANA POPA

(Romania, b. 1977)

not Natasha, 2006

Abused, raped, kidnapped, sold and exploited: the young women in Dana Popa's photographs have suffered almost unimaginable violations of body and soul. However, these images do not show them in captivity – Popa photographed these former victims of sex trafficking back at home in Moldova. They are overwhelmed by silence and shame; even their bodies seem awkward. Human trafficking became rife in Eastern Europe after the fall of communism and still operates across multiple countries. Popa chose to portray women who had succeeded in escaping from the traffickers and she does this sensitively and discreetly. With the help of one of the reintegration programmes set up by the Moldovan wing of the International Organization for Migration (IOM), these young people – at what ought to be a carefree age – learn to cope with the violence they have experienced and to build new lives.

Traditionally, the caption for a photograph is neutral and objective: a date, a place, a name. Popa adds additional details gleaned from interviews with the subjects. The victims are not anonymous and their accounts give enough information to allow the viewer to imagine the horrors they have endured. Suddenly everything is overturned: the facts of identity and age of each subject, along with the fragments of their stories, evoke a sense of indignation in the viewer, and the intense suffering of these women becomes palpable.

Elena, twenty-three years old, August 2006.
'Why do you have to dig up my life again?'

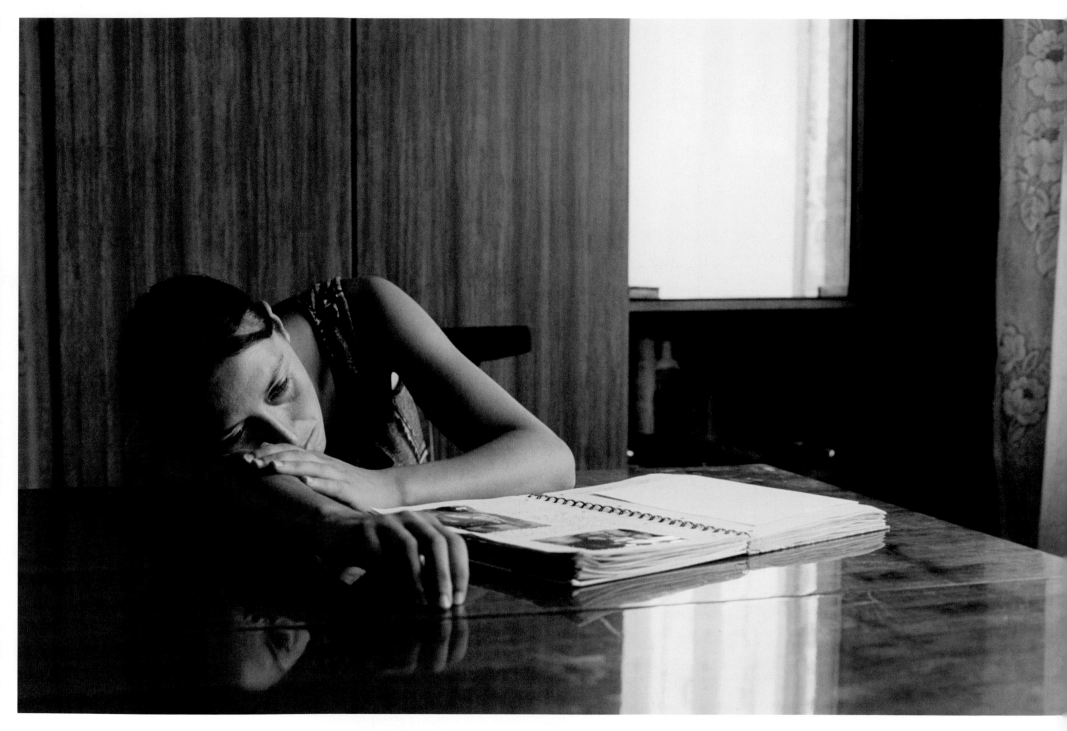

Olea, twenty-three years old.
'My husband's family in Romania forced me to work as a prostitute. The Romanian social services took my
three-month-old baby daughter away. I only recently regained the right to bring her up as her mother.'

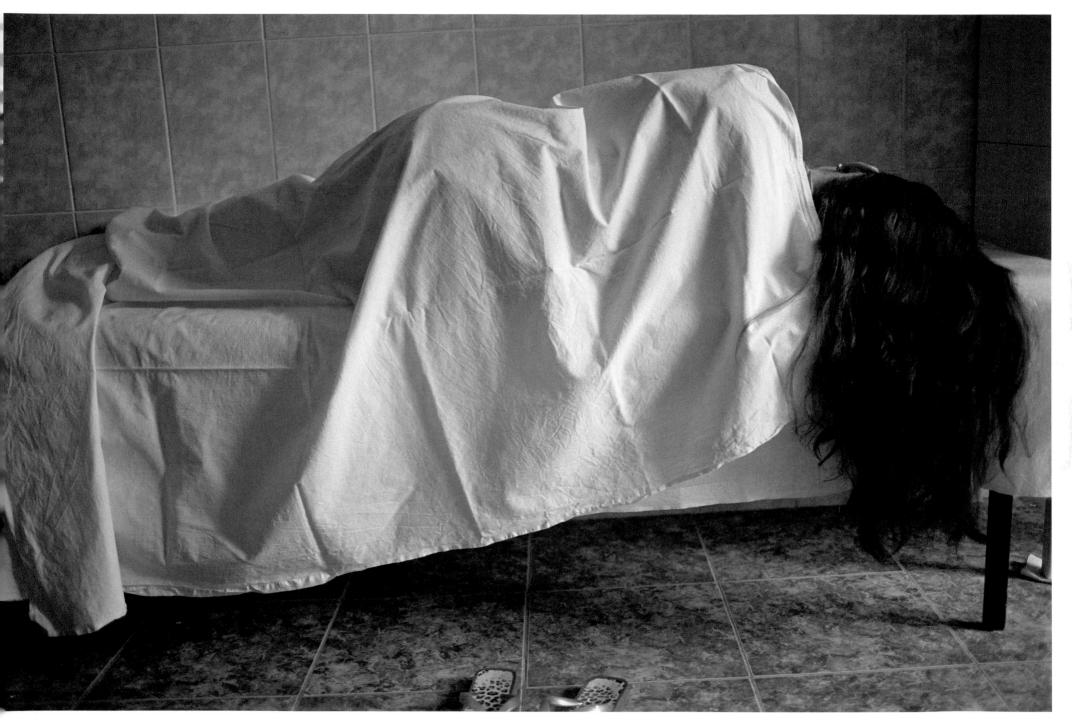

Dalia, twenty years old.
Moments before a gynaecological examination, at the International Organization for Migration,
Chișinău, Moldova. Dalia was trafficked to Turkey and forced into prostitution for three months.

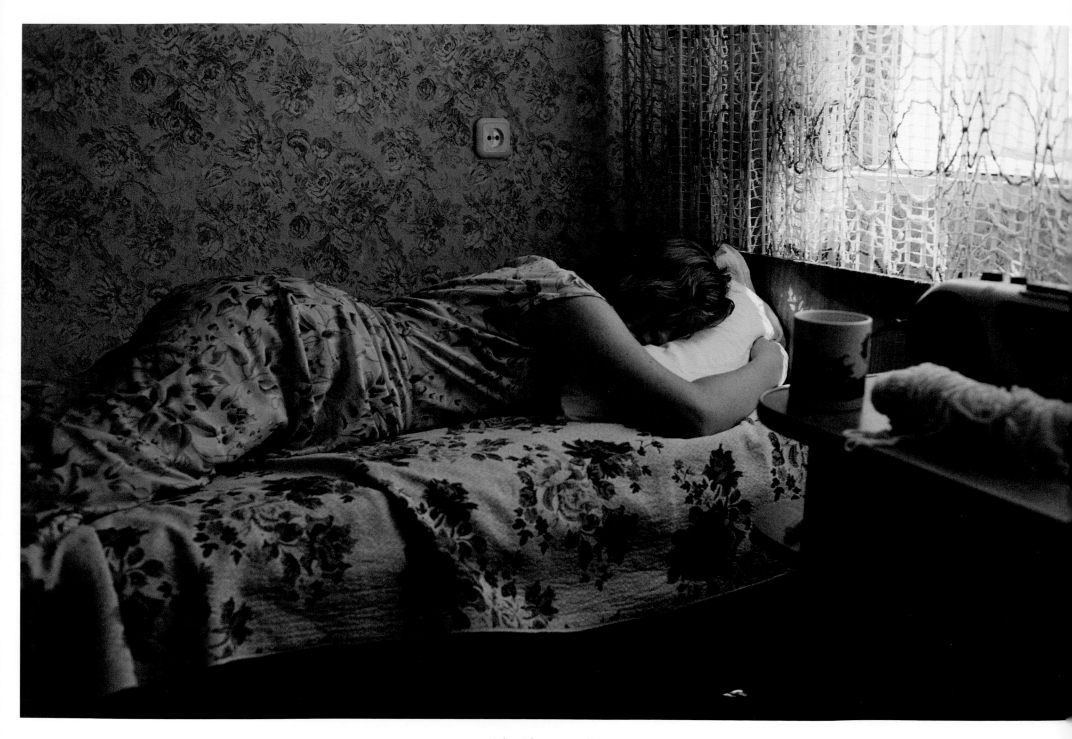

Nadia, eighteen years old.
'My mother sold me... I would never prosecute my mother...'

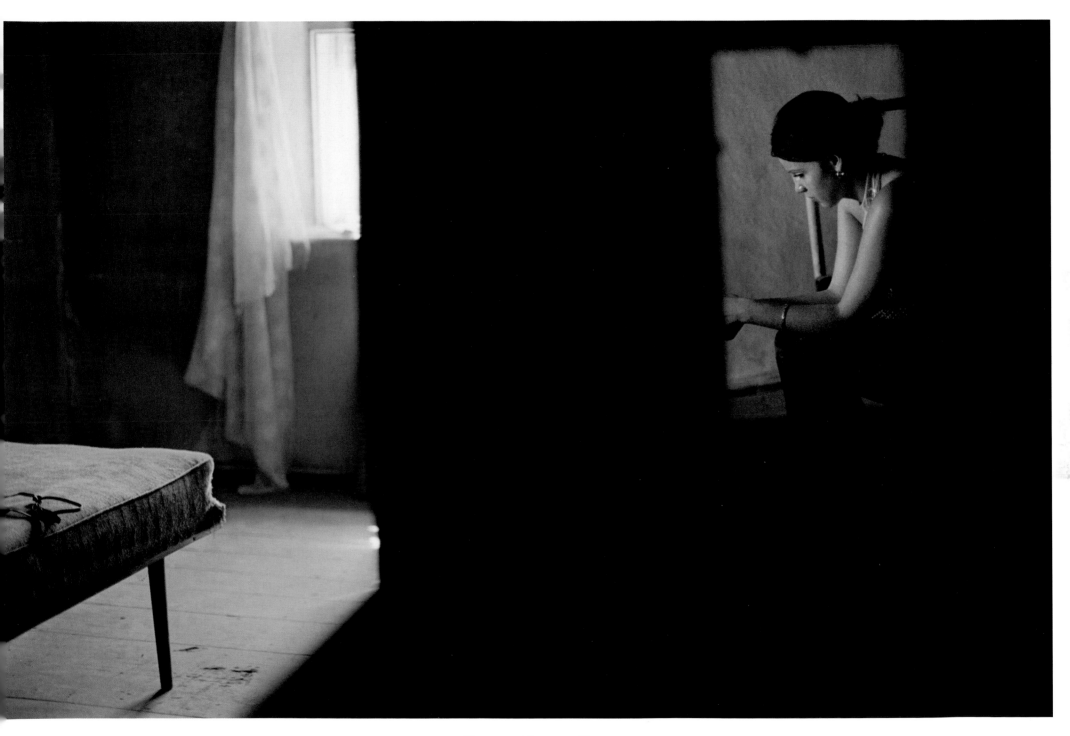

Elena, twenty-three years old.
'I thought I would work merely as a vendor at the market in Moscow, for $200 a month...
Instead, I got sold and resold to pimps until a client set me free...'

SHAI KREMER

(Israel, b. 1974)

Infected Landscape, 2007

In the 19th century, during the Crimean War and the American Civil War, photographers questioned what they ought to depict. Army camps, the urban landscape under wartime conditions and military equipment became the first subjects of war photography. However, it was not long before their lens was turned on much more distressing themes, including the dead. Since then, newspapers have continued to publish images of battle and wounded and suffering victims.

Shai Kremer has worked for ten years in one of the planet's most photographed conflict zones – Israel and Palestine. This conflict has been the focus of media attention for more years than anyone cares to remember, while other wars have received little coverage. An arena for endless conflicts, occupied since ancient times by different peoples – in Kremer's eyes Israel has been 'infected' by the virus of war. To prove his point, his landscapes trace the military movements of the past as well as the present.

He depicts a place that was kept secret until recently – a military base used to train Israeli soldiers – but he has kept his photographs devoid of human presence, in order to make us think in wider terms of the manner in which this land has been occupied. The pasteboard sets that previously served as part of the training ground have now given way to a realistic modern town with a mosque, kasbah, hospital, central square, streets and houses. Not a detail is missing at the Tze'elim base, a reproduction of an Arab town in the Negev Desert. Although Kremer shows no manoeuvres or military exercises in this setting, whose sole purpose is to sharpen the soldiers' reactions in preparation for fighting in the streets, the viewer nevertheless has no difficulty imagining the sound of gunfire. These virtual war games are part and parcel of the real world.

Street, 'Chicago' Ground Force Training Zone

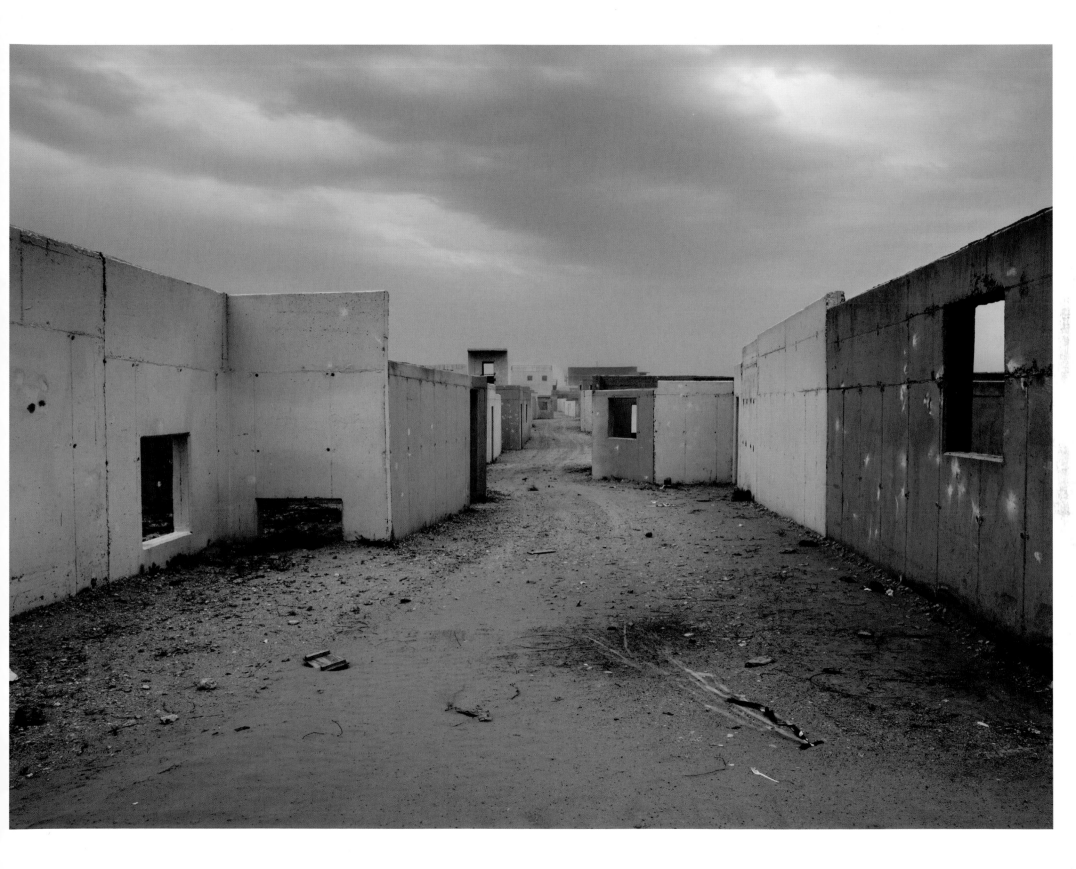

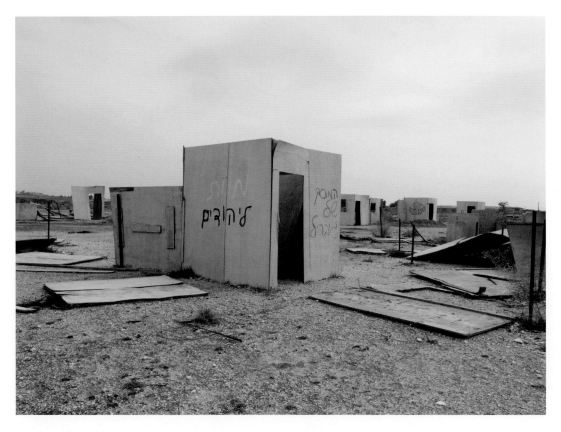

Graffiti, former Ground Force Training Zone, next to Tze'elim

Opposite: Mosque and nursery, former Ground Force Training Zone
Overleaf: Urban Warfare Training Center (panorama), Tze'elim

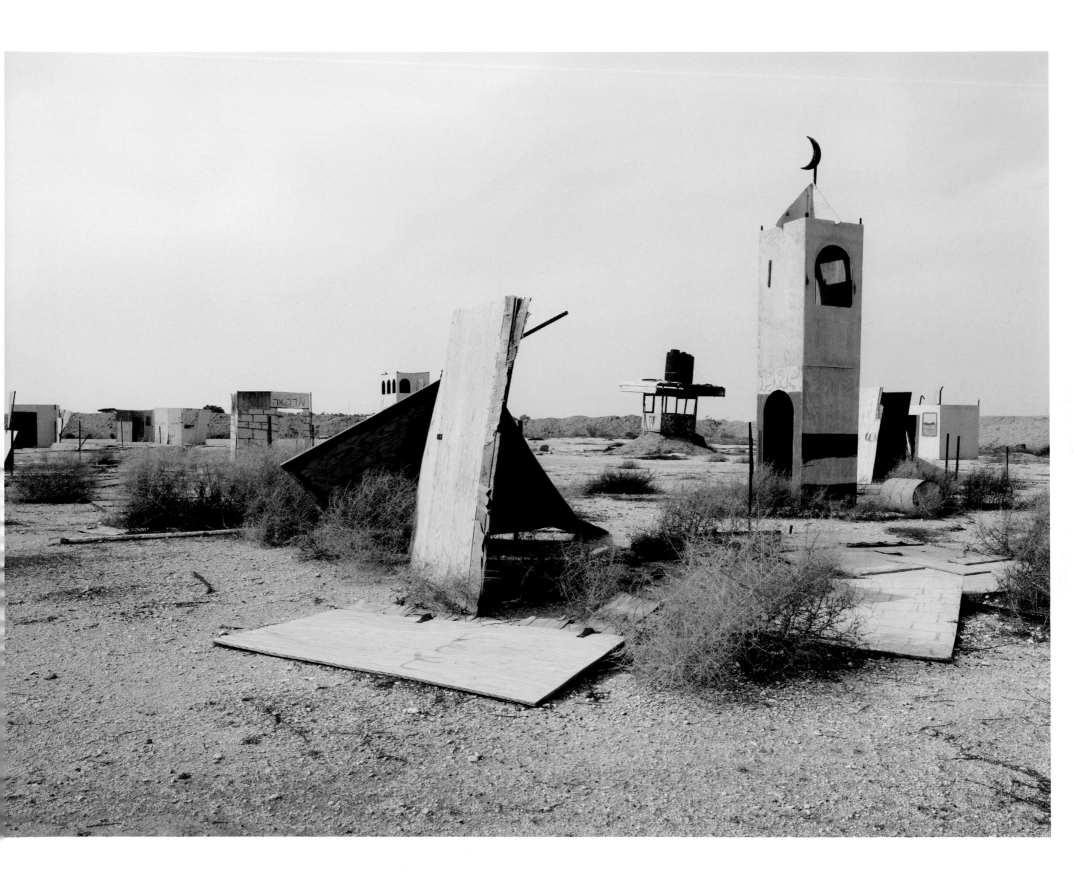

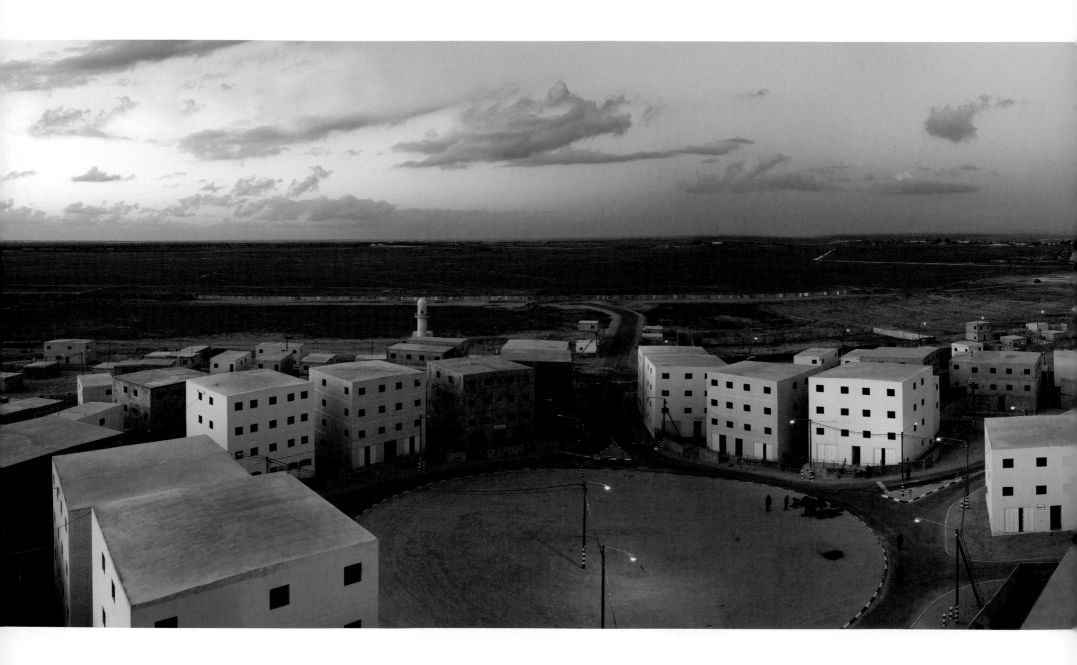

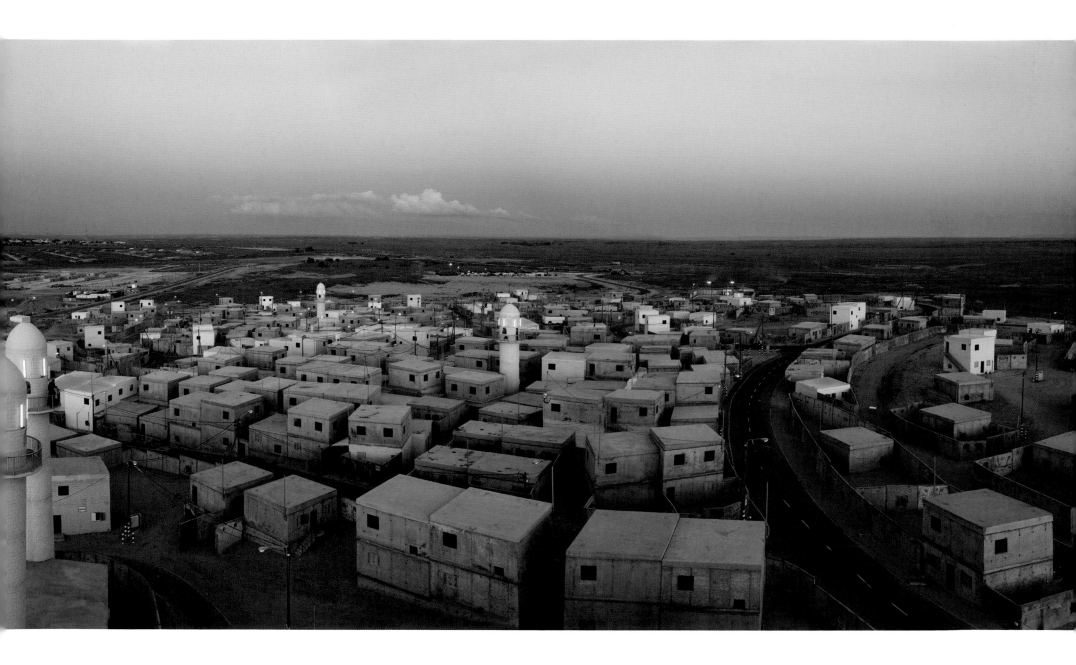

JIM NAUGHTEN

(UK, b. 1969)

Re-enactors, 2009

Little boys love to dress up as knights or soldiers, ready to go into battle; the props and costume allow them to take on a new identity within seconds. Is there anyone who hasn't played some kind of war game in the school playground? Chasing the enemy, finding places to hide or shelter, such are the games that generation after generation of children have enjoyed. Even toy soldiers have not yet lost their attraction. This is unquestionably the world of play that Jim Naughten evokes with his series of photographs. Nonetheless, these are not people that you will see in the street. Adults very rarely take on a different identity. And so the fascination of these pictures becomes all the greater for those of us who no longer indulge in this kind of role-play.

What happens, then, when 20,000 adults come together to re-enact battle scenes from the First or Second World Wars? Naughten loved the experience of standing side by side with his 'childhood toys', now grown to adult size. Here the present is banished. Only the past – albeit an idealized past – is glorified. The subjects, isolated from any context, like toy soldiers themselves, are dressed up as different types of character: Nazi officer, Red Army soldier, American GI, Red Cross nurse. Men, women and children don the guises of the heroes of yesteryear, and retain no hint of their true identities. This legion of soldiers brings history to life, just like the cinema. What is the source of this endless fascination with war and all its authoritarian trappings? Have we still not exorcized our old demons? Is the process of stepping out of our own identities and into someone else's inevitable in a society in which our appearance is determined by our own decisions?

Second World War German
forces ambushed

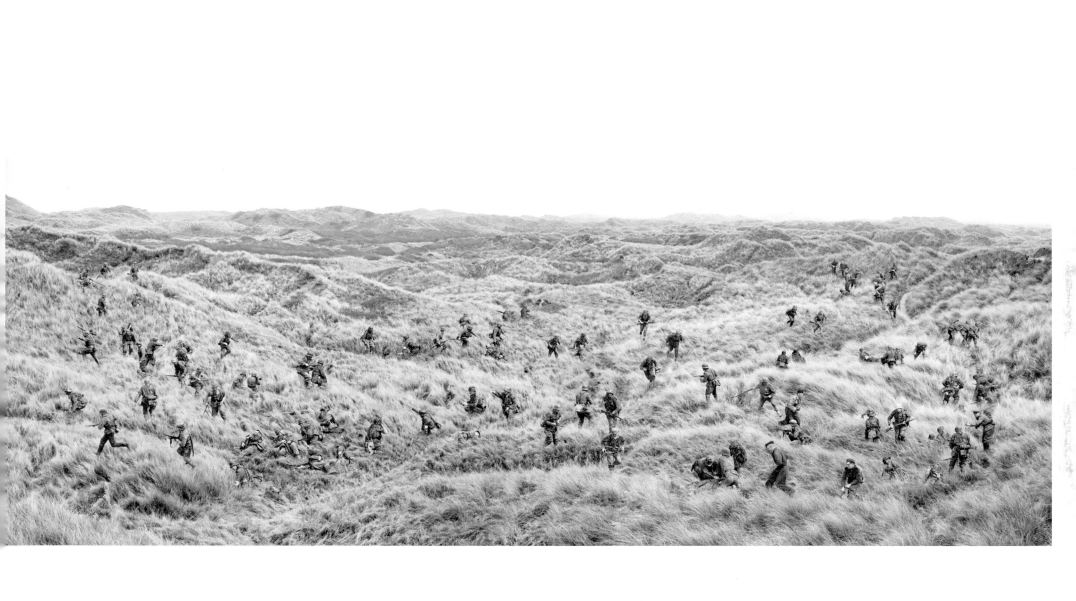

Soviet soldier with telogreika uniform

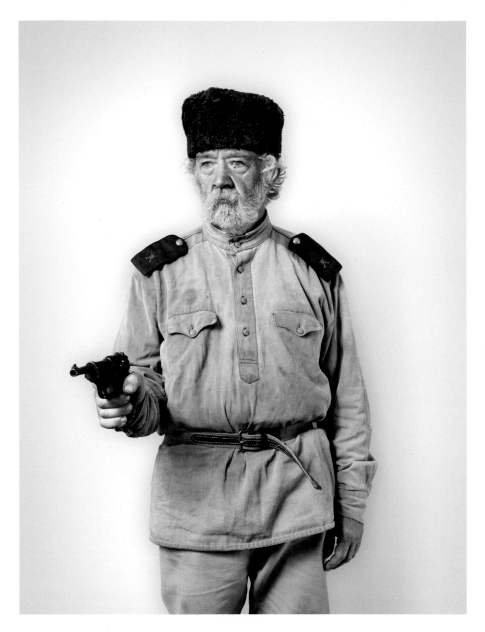

Soviet Cossack

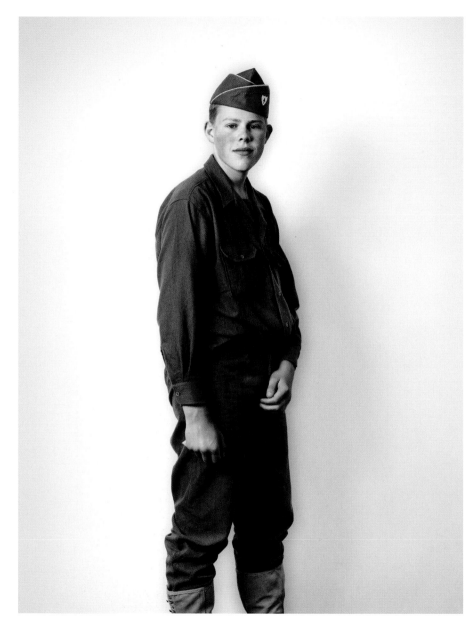

US infantryman

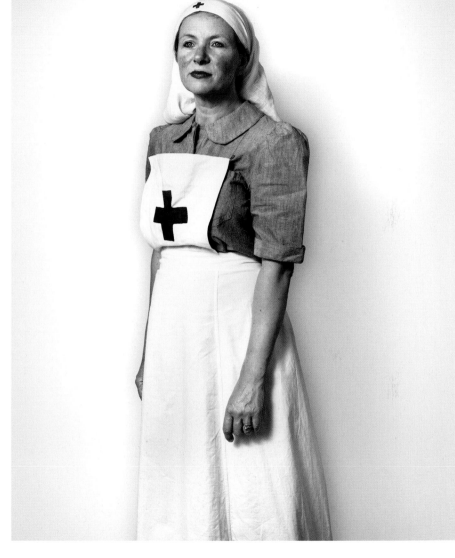

Red Cross nurse

SIMON NORFOLK

(Nigeria, b. 1963)

Scenes From a Liberated Baghdad, 2003

Devastated cities, landscapes devoid of people – these have been the scenes depicted in recent times by photographers who have ventured into arenas of war. Undoubtedly, these images go back to the tradition of the landscape rather than to black-and-white war photography that captures people in motion. The war is presented in carefully composed images, taken with a view camera, using exposure times that last several minutes. And when exhibited, these prints are monumental, resembling large-format paintings. Simon Norfolk's works belong to this genre. They offer an alternative to the images relayed every minute of every day by international news agencies, and their power resides in their beauty.

Photographers working at the heart of war try to provide a record of its horrors. But how should scenes of death, bloodshed, displaced populations and genocide be handled? Should they be transfigured or stylized? Norfolk's method is close to that of 19th-century photographers, who had to work slowly because of the size and complexity of their equipment. He says that he has been influenced by 17th- and 18th-century painters and their taste for ruined landscapes. Just like landscape painting – a genre more contemplative than narrative – his work presents carefully structured images, almost as it were in slow motion, where the violence of war has been sublimated.

The war in Iraq may have received the most intensive coverage in the history of journalism. Although the images sent back by reporters accompanying the US forces were streamed live to TV screens, websites, newspapers and magazines, none of them could really bring home the reality of this war. The pictures taken by professionals on the ground all ended up looking alike. Norfolk was not concerned, however, with simply recording the facts. He wanted to convey a different view. He arrived in Baghdad ten days after the US army had toppled the statue of Saddam Hussein and discovered a place plunged into darkness, set ablaze by looters, left in ruins. By making the dramatic scenes so aesthetically pleasing, Norfolk creates a distinct feeling of unease in the viewer.

The Ministry of Planning,
Baghdad, 19–27 April 2003

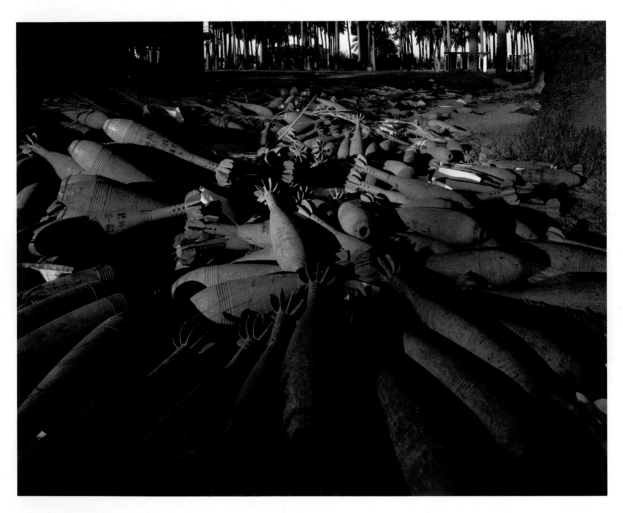

Abandoned mortar shells in a date grove in Atifya, northern Baghdad, 19–27 April 2003

Opposite: Street corner where five boys were killed. US soldiers came to destroy an Iraqi tank that had been left behind. They threw in an incendiary grenade and left. People came to watch the burning tank and when its ammunition exploded, five more were killed. Street 60, Mechanical City, Dora. Baghdad, 19–27 April 2003

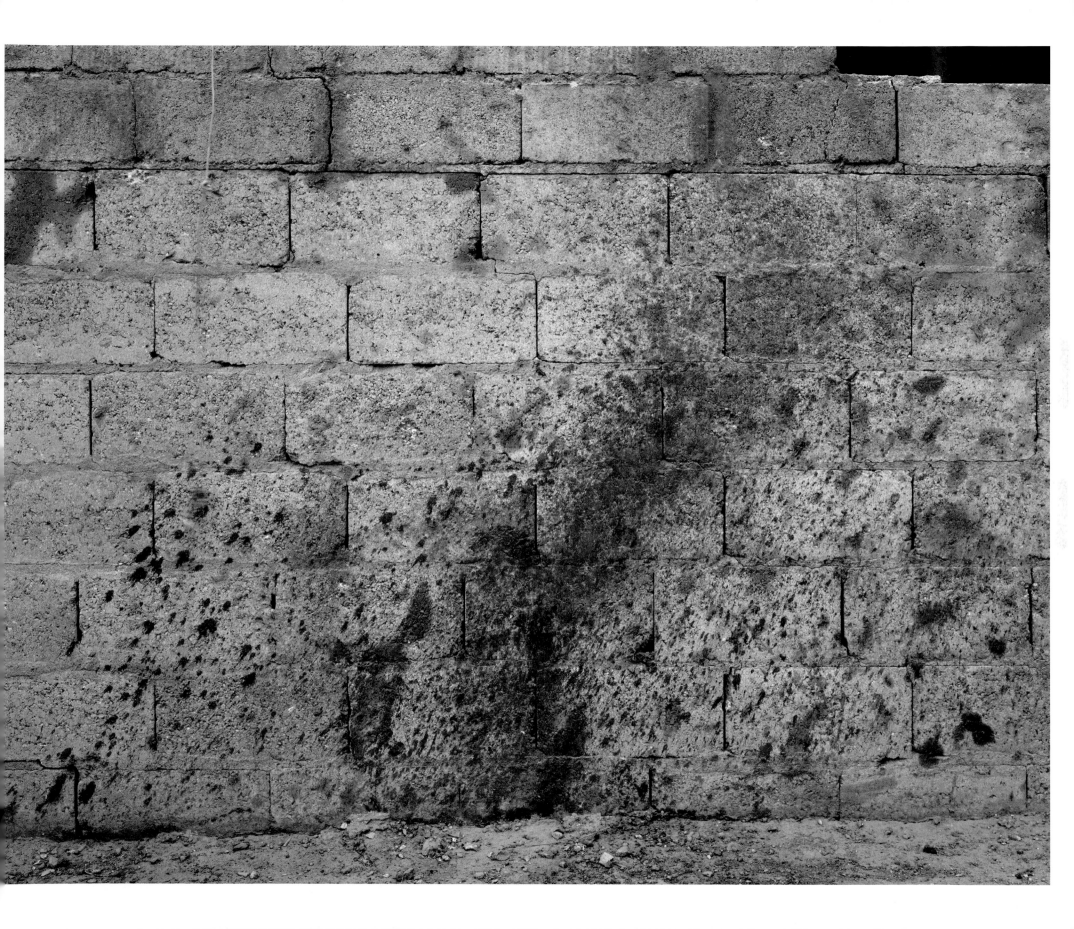

JUUL HONDIUS

(The Netherlands, b. 1970)

Factions, 2002–09

The work of Juul Hondius is concerned with fiction based on facts. While his photographs closely resemble those that fill the press – images of illegal immigrants, asylum seekers, refugees – they are in fact the result of careful staging. This creates a disconcerting sense of déjà vu. Newspapers have an unquenchable appetite for illustrations of this kind to accompany sensationalist articles, so we assume that we are looking at real-life events, but here every image has been deliberately orchestrated by the photographer, down to the smallest detail: direction, casting, choice of location, lighting.

Hondius is inspired by media imagery. Working from mental images – those lodged in our collective memory – he reconstructs an atmosphere rather than any particular event. None of his images really tells us anything, and neither are the places or the people specific. Although they evoke the ideas of wandering and travel, the pictures are situated within a no-man's-land that is timeless and unplaceable. All of the elements that make up the iconography of migration are present. The work therefore subtly recalls images of refugees flooding into Western countries. With these stylized scenes, Hondius criticizes the stereotypical images that fill the media. He demonstrates that photographs are deceptive and often distort reality. By borrowing from the codes of journalism and advertising imagery – carefully arranged lighting and composition, an intriguing atmosphere – Hondius creates what could be called a new iconography of the present day.

The aesthetic beauty of his images is seductive, but something seems false. They haunt us and make us confront ourselves and our superficial response to media images that often seem interchangeable.

Busfront #1, 2006

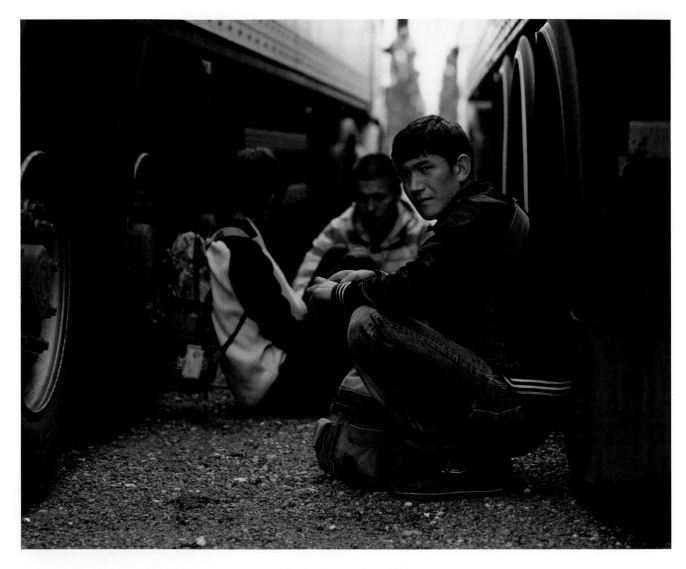

Wheels of fortune, Paris, 2009

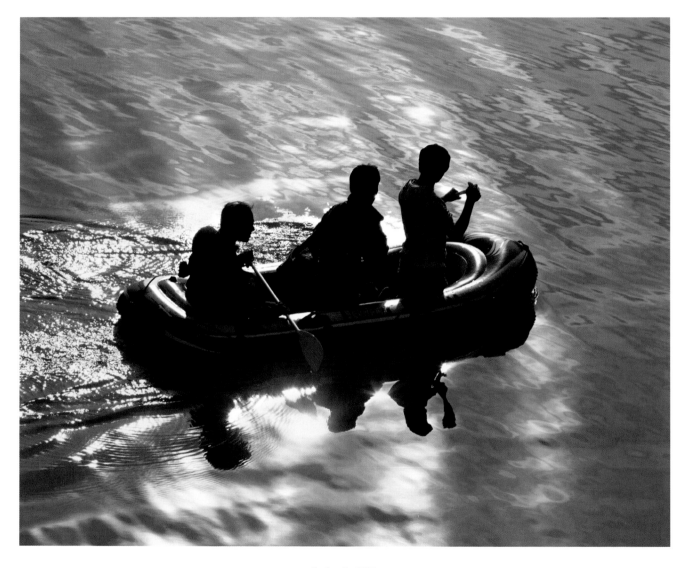

Seahawk, 2009

Motion, 2002

Maboge, 2003

Opposite: Calais, 2009

LÉA EOUZAN
(France, b. 1980)

Histoire(s) contemporaine(s), 2006–08

The 21st century has seen the emergence of a phenomenon known as the 'museumification' of memorial sites; it might even be called the 'spectacularization' of these places. For instance, Auschwitz (Oświęcim) – symbol of all the 20th-century internment, concentration and extermination camps of Europe – is now a museum. It is there for 'consumption', complete with bar, cafeteria and shop. But are visitors to Auschwitz just ordinary tourists? What are their thoughts when they see the watch towers, bunkers and death chambers of this concentration camp?

For several years now, Léa Eouzan has been developing her own approach to memory and its preservation. She is not seeking some new angle on the Holocaust, and she has no desire to create a commemorative work. The object of her attention is the way in which history is manipulated and prepared for consumption. And so at Auschwitz she focuses on the facilities designed for tourists rather than on the remains of the camp itself. Her series of photographs questions the phenomenon of the heritage industry that turns such sites as this one into museums. Does Auschwitz now look more like a film set than a place of contemplation? Eouzan denounces the excesses of the tourist industry. Her images are deliberately banal and create a distancing effect, very unlike the photographs that show Auschwitz in the mist and snow. She has no desire to arouse emotion or create a spectacle; yet the viewer feels a certain tension when confronted with these images of a place that represents the unbearable.

Car park, Auschwitz Museum,
Oświęcim, March 2006

In front of the Auschwitz Museum, Oświęcim, March 2006

Hotel sign, IG Farben labour camp, Monowice, June 2008

Opposite: Observation bunker, IG Farben labour camp, Monowice, June 2008

RAPHAËL DALLAPORTA

(France, b. 1980)

Antipersonnel, 2004

Raphaël Dallaporta's series *Antipersonnel* is fascinating and repulsive at the same time. His pictures of antipersonnel mines, photographed in a studio and reproduced life-size, bring together a number of different varieties. Covering fifty years of conflict, they are striking for their diverse range of shapes, materials and colours. We can even perceive a certain kind of beauty in them. Tom Ridgeway's captions, inspired by military manuals, give details of dimensions, weight, country of origin, method and scale of destruction. The effect is disturbing. Initially viewers are intrigued by these objects stripped of their context, but then they find themselves unable to blot out the terrible damage that these explosives can cause.

As in his series *Domestic Slavery* (see p. 128), Dallaporta photographs his subjects frontally, as if compiling an inventory of these weapons whose aim is to injure, mutilate and kill. But it is left to the viewers to imagine the consequences, because the photographer does not turn his camera on the victims. His perspective makes us look solely at the variety of mines, with their almost seductive aesthetic beauty. All of them, however, have the same function: to destroy the enemy in motion. Although humans play no part in Dallaporta's photographs, it is the story of their lives – and their deaths – that permeates his work.

Antipersonnel Directional Fragmentation Mine

M-18.A1
USA

The 'Claymore' directional fragmentation mine releases 700 steel balls when detonated by a hand-turned dynamo, a tripwire or, when used with the 'Matrix' system, remotely using a laptop computer. (Multiple Claymores can also be linked together using a detonator cord.) A 1966 Department of the Army field manual states that 'the number of ways in which the Claymore may be employed is limited only by the imagination of the user'. In September 2002 (the most recent available statistics), Claymores made up 403,096 of the 10,404,148 landmines stockpiled by the USA.

w: 35 l: 210 h: 125 W: 1.58kg

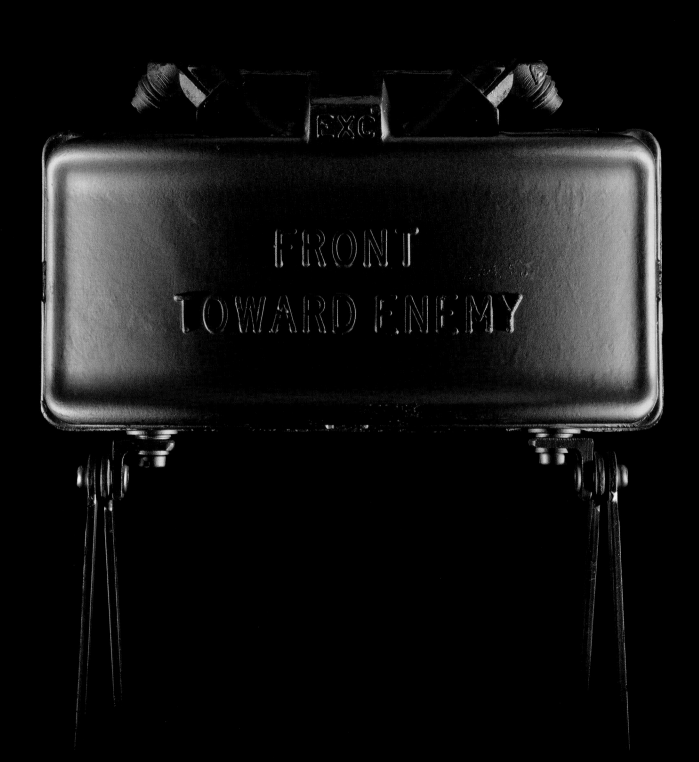

Cluster Bomb

F-1
France

An Ogre F1 155mm shell, containing 63 dual-purpose
bomblets, each weighing 244g, can be fired up to 35km.
Each shell leaves a footprint of 10,000–18,000m², depending
on range. Until 1998, the Ogre F1 was manufactured by
Versailles-based Giat Industries (now Nexter); recently,
the French government admitted that its signing of the
Dublin cluster-munitions treaty would mean that its
Ogre F1 stockpile would have to be destroyed.

l: 45 h: 90 W: 244g

Antipersonnel
Blast Mine

GMMI-43
Germany

Used by Nazi forces during the Second World War,
this antipersonnel mine's glass construction and chemical
fuse render it undetectable. Glass fragments, which enter the
body after the mine is triggered by pressure on the interior
glass plate, are also undetectable to X-rays. In 2004, Colombian
government sources said that homemade glass mines were
being used by guerrilla forces in the country.

d: 85 h: 30 W: 1.2kg

Antipersonnel
Blast Mine

SB-33
Italy

A scatterable blast mine, the SB-33 is resilient, completely
waterproof and its 35g explosive charge will result in the
traumatic amputation of the detonating limb. The SB-33AR
version of the mine contains an anti-handling mechanism,
but once laid is indistinguishable from the SB-33.
The mine is no longer in production but was used
in Iraq, Afghanistan and the Falkland Islands.

w: 85 h: 30 W: 140g

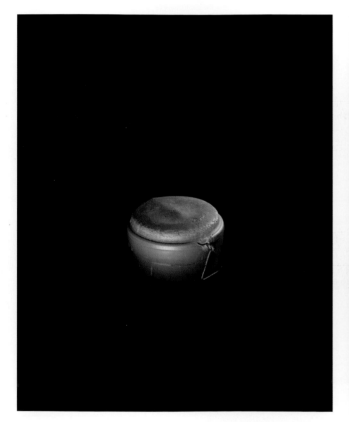

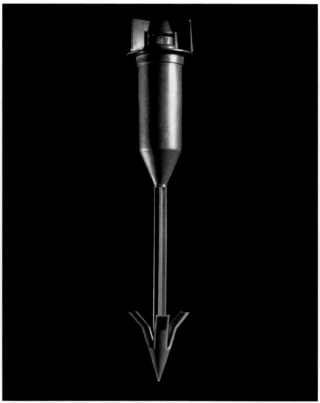

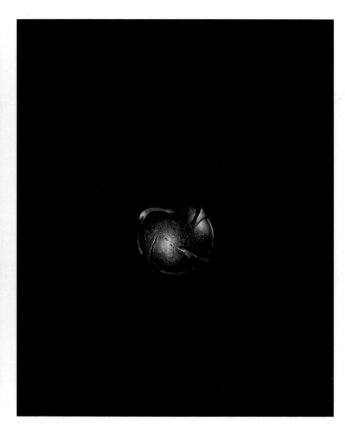

Antipersonnel
Blast Mine

TYPE-72
China

Type-72 blast mines are said to make up 100 million of China's
110 million antipersonnel landmine stockpiles (Chinese
officials claim that this figure is exaggerated). Manufactured
by China North Industries Corporation (NORINCO), Type-72s
are reportedly priced at US$3 each. The Type-72B includes an
anti-handling mechanism that makes it impossible to neutralize
or disarm – if the mine is moved more than 8 degrees from the
horizontal it will explode, amputating the limb that actioned it.

d: 78 h: 38 W: 150g

Antipersonnel
Blast Mine

MI.AP.DV-61
France

Designed for use in Algeria, the MI.AP.DV-61 antipersonnel
blast mine is provided with an integral stake that stops
it being displaced in sandy, desert conditions. It can be detonated
by either footfall pressure or a tripwire. Before France banned
the production of AP mines, MI.AP.DV-61s were manufactured
by ALSETEX in Mulhouse, France.

d: 35 h: 270 W: 125g

Cluster Bomb

BLU-26.B
USA

Each BLU-26.B submunition is armed by centrifugal force
after its release from a CBU-24.B bomb. The 670 submunitions
in each bomb explode on impact with the ground, each releasing
600 razor-sharp steel shards. It is estimated that at the end
of the US 1964–1973 bombing campaign of Laos over 9 million
BLU-26 submunitions were left on the ground. Unexploded
BLU-26.Bs cannot be disarmed.

d: 60 W: 400g

SARAH PICKERING

(UK, b. 1972)

Explosion, 2004–05

Fuel Air Explosion, 2005

Sarah Pickering's series of photographs is enigmatic. Does she want to show us a catalogue of terror with her pictures of explosions? The variety and serial nature of the images forces us to think, and the fact that the explosions are deprived of context – they take place in a no-man's-land somewhere in the English countryside – reinforces the mystery. There is a certain formal beauty in the phenomenon of the explosion. We are all fascinated by firework displays. But the blast and its flames also evoke other feelings – we think above all of the circumstances associated with dramatic events, generally revolving around violent death.

Pickering created this series at a training centre for police and army instructors. The explosions bring a degree of drama and tension to the military exercises, but they are simulations – fictions. And so Pickering was in fact working with a faked reality, a construct, despite taking a documentary approach.

In this digital era of virtual realities, the armed forces can prepare themselves for all kinds of dangerous situations, but although the explosions look realistic, they are only an illusion. Pickering's pictures are such that they allude to the whole history of warfare. The use of napalm, for instance, evokes conflicts such as the Vietnam war. Her interest lies in the form of violence represented by the explosion and in the references it calls to mind – whether from history or cinema, a medium that revels in the fascination that explosions exercise on all of us.

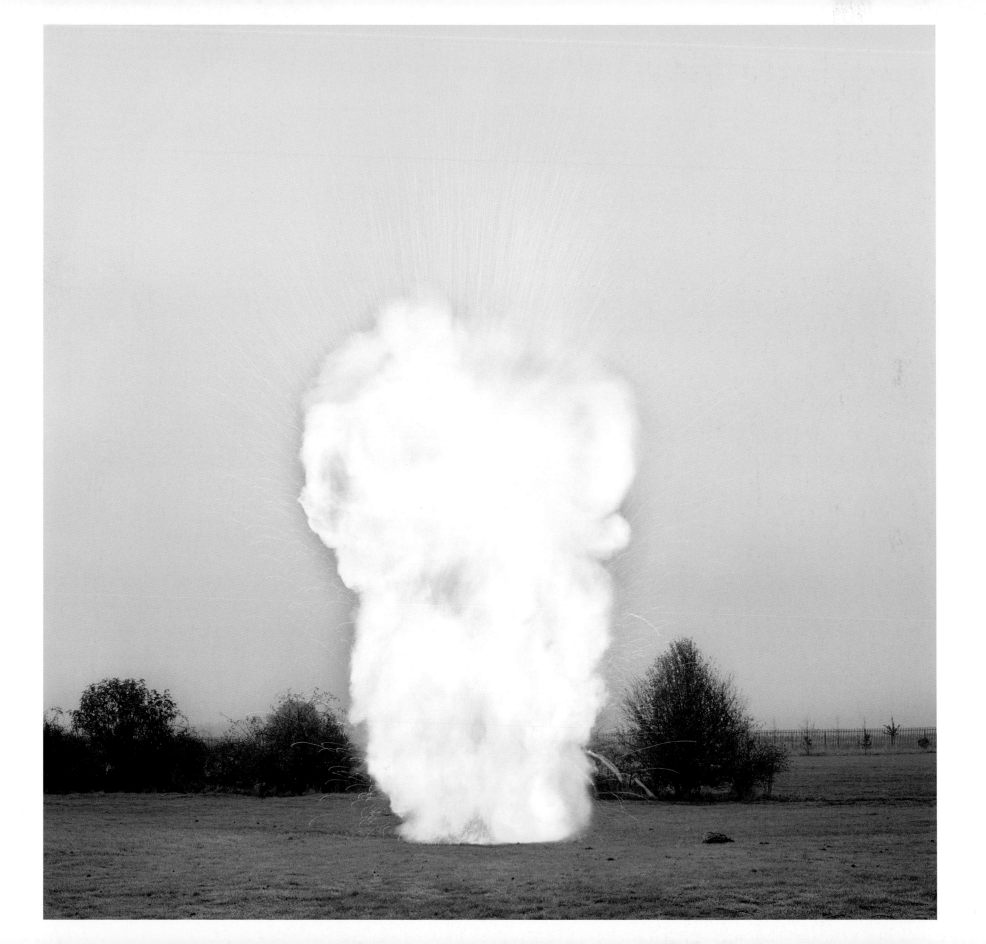

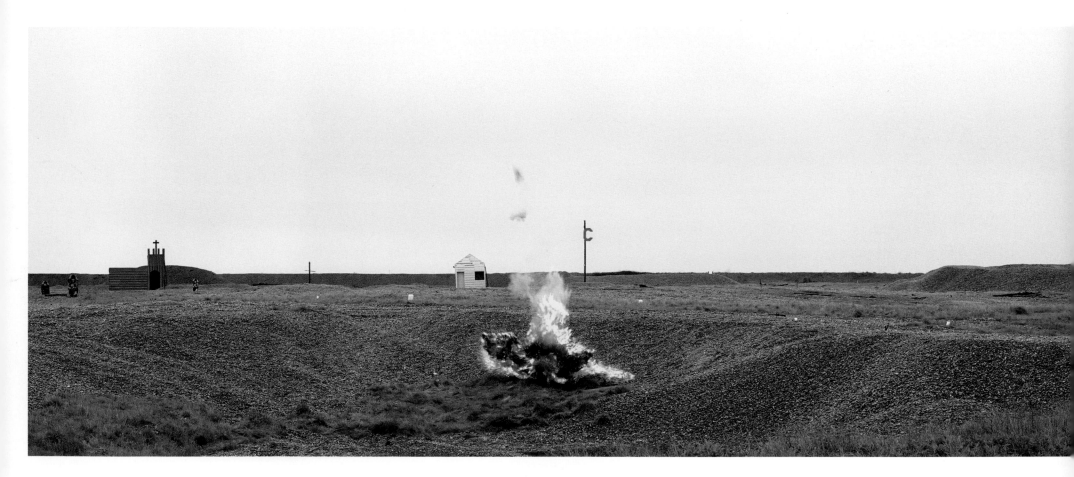

Large Maroon, 2005

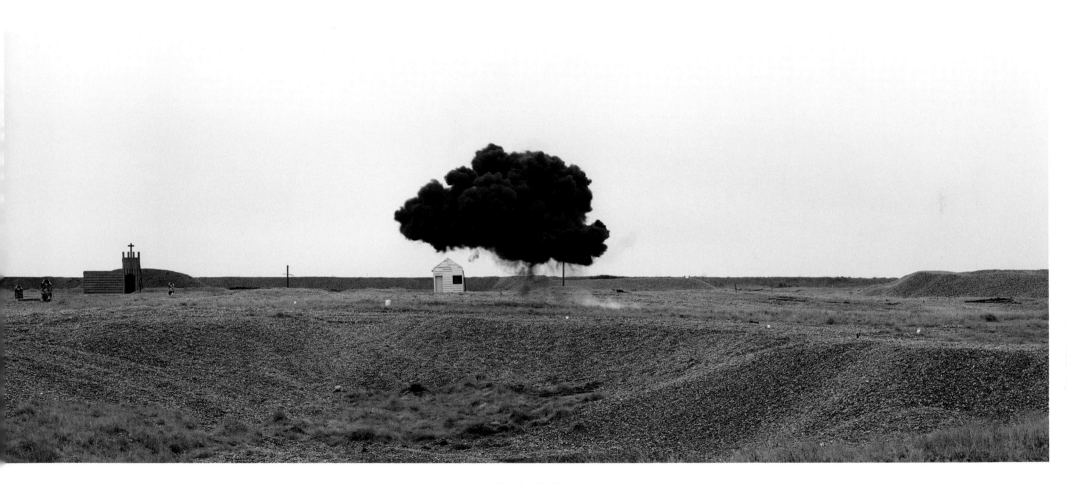

Napalm, 2005

CHRISTOPH SCHÜTZ
(Switzerland, b. 1964)

Gaza 0109, 2009

Untitled

Misty landscapes drawing our gaze towards the line of the horizon. Fields stretching as far as the eye can see, devoid of human presence, of any tension. Accompanying each of these images, a caption that describes a scene of conflict on the Gaza Strip in Palestine. But a closer look at these photographs soon reveals that the landscapes do not correspond to the image we normally have of Gaza. Neither the light nor the vegetation nor the contours belong to this region of the Middle East. The photographer is Swiss, and it is in Switzerland that he created this series. So what is the link between the peaceful countryside of misty Switzerland and the scenes of war in a region thousands of miles away?

Christoph Schütz created this series between December 2008 and January 2009, when war was raging on the Gaza Strip. Every day, the media were publishing pictures taken on the spot, but these only showed one side of the war. The Israeli army imposed rigid restrictions on journalists; the main purpose of the pictures they permitted was to justify Israel's invasion. On the Palestinian side, the war was depicted in a totally different manner: the images showed massive destruction, especially of people's houses, and the dead bodies of civilians. The image of a little Palestinian girl being buried by her father came as a shock when published in the Western press.

Schütz set out to provide a counterpoint to all these images by adopting a detached approach, as a contrast to what the media were showing and telling us. His photographs contain no action, and they make no attempt to convey drama of any kind. Only the captions direct the viewers, who have already been bombarded with so many images of the war; the words simply allow them to use their own imagination. With this gulf between image and text, Schütz focuses on the way we are influenced by the media. The information in the captions emphasizes the emptiness of the image to the extent that one contradicts the other.

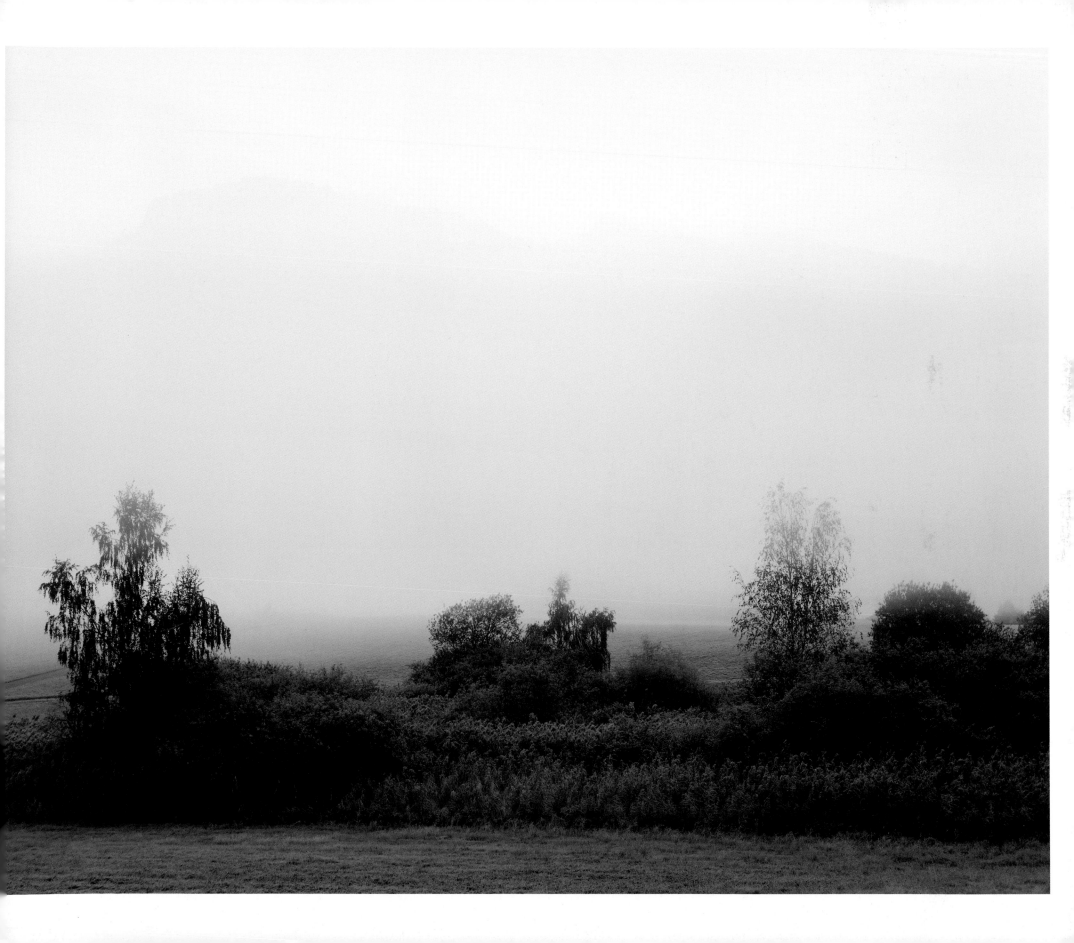

A Palestinian in the Gaza Strip reads a pamphlet dropped by an Israeli plane, announcing further bombardments.

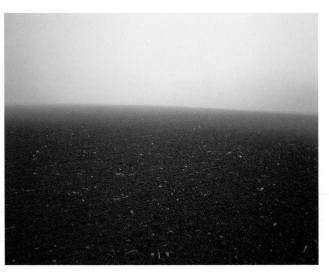

Since Saturday the Gaza Strip has been dominated by panic and chaos, following the Israeli aerial attacks.

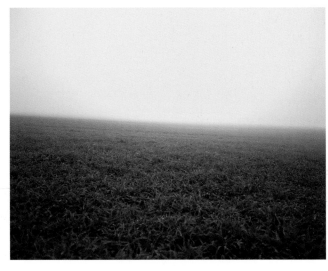

Thousands of Israeli soldiers marching gradually into the Palestinian areas.

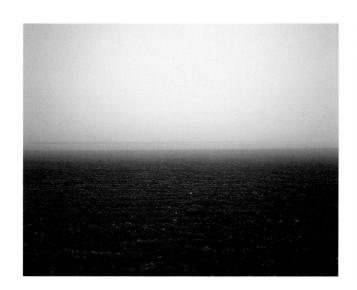

Palestinian men bury the body of four-year-old Lama Haman
in a cemetery on the northern Gaza Strip.

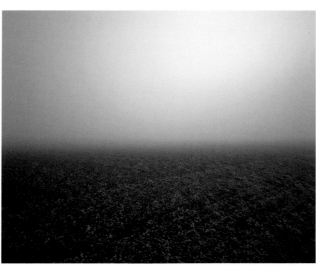

UN Secretary-General Ban Ki-moon travels to the Near East.
His objective: mediations.

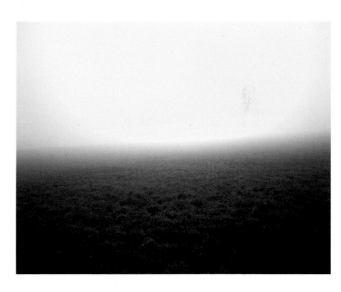

Israeli soldiers fight on even after nightfall.

SUSAN E. EVANS

(USA, b. 1966)

The Story, 2001

No event has ever received such intense media coverage as the 9/11 attacks on the World Trade Center in New York, which made front-page news all over the world. Television screens were swamped with images in endless repetition. The photographs chosen by newspapers for their front pages were visually strong but all extremely similar: a fireball bursting from a tower, clouds of smoke filling the blue skies of Manhattan, the shells of the collapsed towers, people fleeing the streets of Lower Manhattan, rescue workers amid the rubble. These scenes were repeated in every newspaper. The city was the focus of immense media attention, with both professional and amateur photographers capturing the public shock and panic, but the press tended to reproduce similar pictures day after day.

The images of 9/11 were so widely seen that they remain imprinted on our minds a decade after the event. Their visual impact was reinforced by repetition and by the uniformity of the press coverage. Susan E. Evans summons these collective visual memories, but the images themselves have disappeared. All she offers are brief captions, a few words printed on a plain black background. It is left to the viewers to recreate the images from their own memories.

In the absence of images and the presence of words, Evans tells a story already known to everyone, questioning the omnipresence of images in our society as well as their use in the media. The collection of front pages that the artist places before us encapsulates the standardization of media iconography even at a time when there was a huge number of photographers in New York. It may have been the most photographed event in the history of photojournalism, but the homogenized media treatment reduced our visual memory of 9/11 to the sense of having seen the same few images in a loop. Evans's series is a comment on the uniformity of press photography, where an image is chosen for symbolic value rather than for information.

Untitled

Impact, Flight 175

South Tower giving way

Skyline and smoke from Brooklyn

Ash covered workers crossing
Brooklyn Bridge

Firemen and dogs searching rubble

Girl holding flag and burning candle

Crane lifting debris amidst smoke

Dawn skyline from Brooklyn
September 12, 2001

Weeping woman holding
photo of her husband

Stigmata:
Their Origin, Purpose and Power

PASCAL VRTIČKA

Swiss Center for Affective Sciences, University of Geneva

Some of the photographs depicted in this book were initially presented during an exhibition at the International Red Cross Museum in Geneva, Switzerland, under the title 'Stigmata'. The aim of this exhibition was to show human suffering indirectly through images displaying the aftermath of chaos rather than chaos itself. In accordance with the primary interpretation of the word 'stigma', denoting in the Roman Catholic faith bodily marks corresponding to the crucifixion wounds of Jesus, the photographs symbolically represent scars left by different forms of physical and psychological violence against humans. However, such scars are only the final result of a very subtle process having its seeds in the early branding of a person or group of people with a negative and mostly ignoble trait, a process also known as stigmatization. In this respect, 'stigmata' refer to marks of social disgrace or infamy, which are the fundamental underlying causes of sexual, racial, ethnic, religious or any other kind of discrimination.

One of the major topics in modern neuroscience is the question whether such processes like discrimination or stigmatization happen automatically and unconsciously or whether we consciously perceive and are thus able to voluntarily regulate them. Thanks to recent technical developments – particularly based on functional magnetic resonance imaging (fMRI) – we can now look inside the human brain at work and try to elucidate how and where stigmata are created and assimilated. The first intriguing insights into these processes are outlined in the following paragraphs.

WHY THE HUMAN BRAIN CREATES STIGMATA

Stigmata are the result of a categorization process that happens within the human brain while we navigate through the social world. Thanks to social category representations such as 'pretty girl', 'Asian man', or 'Muslim woman', we can more quickly access relevant information about the people we interact with. Unfortunately, this categorization process may readily trigger stereotypes based on the relatively basic cues that we use to deduce these social representations, such as appearance, gender, age, religion or race. And that is precisely how stigmata are created. If a certain social category is paired with a negative stereotype of any kind, a new stigma arises. Once activated, such a stigma can be very powerful and strongly influence how we perceive and treat so-called 'stigma possessors'.

A POSSIBLE PURPOSE OF STIGMATA

From an evolutionary perspective, stigmatization might be considered somewhat adaptive. Its behavioural consequence is to avoid or reject a human being with deviant physical or psychological traits because such a person may be dangerous, disagreeable or ill. This is the reason why our reactions to stigmata are usually paired with negative or adverse emotions. The latter originate from emotional brain regions processing signals of fear, anger or disgust, which are located deep inside the mammalian brain. Let us call them 'negative emotion regions'. There might even be some degree of genetic influence in our reactions to certain stigmata, predisposing activity in some negative emotion regions to represent particular stigmata more negatively than others.

CONSCIOUS OR UNCONSCIOUS PROCESSING OF STIGMATA

Two recent fMRI studies have shown that the negative emotion regions respond to (particularly social) stigmata in a very predetermined fashion. As soon as participants were exposed to images of social 'stigma possessors' (homeless people or drug addicts), activity in their brain related to fear and disgust increased, even if they processed such information unconsciously. Our own research group has extended these findings by showing that the negative emotion regions do not only display automatic increased activity to pictures of already well-established social stigmata, but also to newly acquired marks; in our case hostile social behaviour. In addition, activity in the prefrontal cortex that is normally present when we are making social or moral judgments about other people has been found to show exactly the inverse pattern, being least activated when exposed to the strongest social 'stigma possessors'. Altogether, these findings imply that we automatically derive judgments about social stigmata not only by associating them with negative emotions, but even by attributing less social and moral value to their possessors. This is rather bad news, implying that we are completely at the mercy of the power of stigmata.

Luckily, this is not entirely true, because activity in the human brain relating to social stigmata has been found to display some additional and rather intriguing properties. First, some studies revealed that the degree to which the social stigmata are associated with fear and disgust varies considerably between different people. This is probably because associations between social categories and negative stereotypes are to some degree learned, and not simply genetically determined negative emotional responses. Consequently, it might be possible to overcome even the strongest social stigma by repeatedly associating it with positive values, or in other words, by unlearning its automatic negative associations. Second, recent findings in social neuroscience suggest that we can, and normally do, cognitively regulate our emotional responses to stigmata. This has been shown in several different ways: on the one hand, activity in negative emotion regions has been found to depend on the amount of time somebody has to perceive a stigma: the shorter the exposure time, the more negative emotion activity was observed. On the other hand, activity in the negative emotion regions has been found to be influenced by the focus of attention: the more consciously stigmata are perceived, the lower the observed negative emotion activity. And finally, when people are instructed to consciously down-regulate their emotional reactions to various types of negative scenes, activity in the negative emotion regions normally shows a strong modulation or decrease. Taken together, these findings imply that when we are given enough time or when our attention is directed explicitly towards our emotional reactions to stigmata, we tend to automatically re-evaluate them, thereby changing our thoughts and most likely also our actions.

THE ESSENCE OF STIGMATA

Recent fMRI evidence suggests that stigmata arise due to the aim of our brain to speed up and thus simplify the processing of social information. Such simplification may be adaptive from an evolutionary perspective, because it helps us to avoid human beings with deviant physical or psychological traits. Even though emotional reactions to stigmata may occur rather automatically and unconsciously, they are subject to learning and voluntary control, and can thus be actively regulated.

To conclude, we could try to derive a solution for successfully dealing with stigmata so as not to be slaves to their intrinsic power. The best way would be to navigate mindfully through our social environment and to be attentive to our immediate reactions during encounters with other people. By simply observing our negative feelings towards a stigma possessor, our brain is already prompted to think twice, starting to adjust activity within the negative emotion regions. If we can then add some effort to consciously re-evaluate our negative feelings and even turn them into positive ones, there is a real chance that one day at least some stigmata will cease to exist.

References

Harris L.T., Fiske S.T., 'Dehumanizing the lowest of the low: neuro-imaging responses to extreme out-groups', *Psychological Science* 2006, Oct 17 (10)

Krendl A.C., Macrae C.N., Kelley W.M., Fugelsang J.A., Heatherton T.F., 'The good, the bad, and the ugly: An fMRI investigation of the functional anatomic correlates of stigma', *Social Neuroscience*, 2006 (1)

Vrtička P., Andersson F. & Vuilleumier P., 'Friend or Foe: The social context of past encounters with faces modulates their subsequent neural traces in the brain', *Social Neuroscience*, 2009 4 (5)

Vrtička P., Andersson F. & Vuilleumier P., 'Effects of emotion regulation strategy on brain responses to the valence and social content of visual scenes', *Neuropsychologia*, 2011

The Emotional Impact of Photographic Exhibitions

GERALDINE COPPIN & DAVID SANDER

Swiss Center for Affective Sciences, University of Geneva

One of the most striking effects in film editing, the Kuleshov effect is named after the Russian film-maker Lev Kuleshov who discovered in the 1920s that the emotion attributed by the spectator to a character who is not very expressive depends largely on the images that have come before. For instance, the same face will be interpreted as expressing sadness

if preceded by a funeral scene, but as expressing joy if preceded by a scene of children playing around. This effect demonstrates the power of context in our interpretation of the images we perceive. Apart from the context, the way in which we interpret an image also depends on our knowledge, beliefs, aims, desires and values. The photographs chosen here have the power to make us feel the suffering of others deeply. They touch us, they strike us and they move us. Such images are typically described as having 'impact'. However, more often than not, images presented out of context do not have a shocking content as such. The photographs do not 'speak for themselves' – their content is not in itself upsetting and does not throw us into turmoil, faced with an intolerable image that makes us avert our eyes. Most of the time the picture lets us imagine very stressful events; but rather than showing the pain, it implies it. The subtlety of what is suggested leaves room for contextual and cognitive interpretation. As spectators, we have to deduce the meaning of the situation represented and its consequences. Some of these photographs have a real symbolic value by reason of their ability to reveal and sum up particular circumstances. Drawn into empathy with the characters and the situation represented as experienced by those characters, we are affected by the scene.

Given the fairly implicit nature of the message communicated by photographs, it does not seem to follow necessarily that they should be able to engender intense emotions. All the more so, because the impact of these images may still affect us after we have finished a book or visited an exhibition. How can one explain such a gap between what is portrayed in the image (a scene that is not intrinsically emotional) and its strong emotional impact?

According to appraisal theories of emotion, we constantly identify what is relevant to us in a given context, consciously or unconsciously. From the perspective of these theories, emotion is triggered by our interpretation of a significant situation or event, whether it be real, remembered or imagined. We can assume that the traces of past violent acts presented in these photographs will particularly lend themselves to the interpretation made possible by cognitive appraisal.

If we accept the idea that only events that are significant for a particular person are likely to trigger an emotion in him or her, our experience of being moved by the pictures in an exhibition is explained by their capacity to touch our very own concerns, knowledge,

beliefs, goals and values, and not just those of the characters in the photographs. The images that touch us point to relevant concerns in our lives. Consequently, in order to understand why some photographs have an emotional impact on us, we need to understand something about the appraisals we make of the events recounted in the pictures. Does the event represented in the photograph affect us directly? What are the implications of this event? How well are we able to deal with it? What meaning does this event have for our personal convictions, and in terms of social norms and values? The results of these appraisals allow us to predict the nature and intensity of the emotion that will be triggered by the photograph, or, more generally, by a particular event. These appraisals are always subjective and thus dependent not only on the context but on the perceptions and inferences that a particular person makes about a particular situation.

Since we feel concerned about some issues more than others, we will be more affected by certain images in an exhibition, precisely depending on their capacity to confront us with things that are important to us. There are differences in the way in which a single item will be appraised by two different people and those two people will not necessarily be affected by the same exhibits. But although the appraisal of each photograph is subjective, there tends to be a sort of agreement among viewers that some have a greater impact than others. This inter-individual agreement suggests the sharing of knowledge, beliefs, aims, desires and values among individuals while still allowing for possible inter-cultural differences in the emotions triggered by the images.

Accordingly, to say that a photograph like this possesses an inherent emotional character would mean neglecting the importance of the person looking at it, and the internal processes that take place during that time. When an emotion occurs, a complex set of cognitive responses is triggered. The cognitive process at work in the earliest stages of an emotion involves a focusing of the attention, fixing on the emotional elements in the situation. Some emotional elements seem to be particularly effective at attracting attention. Studies have shown that emotional facial expressions showing fear or disgust, but also other kinds of images, such as a baby's face, are particularly powerful and capture the attention very rapidly, automatically and unconsciously. The direction of a person's gaze is the most important indication of the place his or her attention is going to; and it is interesting to note that

the time spent observing a given object and the way in which the eyes explore a visual scene are behavioural indicators often used in the psychology of emotion.

This attentional bias induced by emotion has consequences for the encoding of emotional events in memory. In general, emotional information enjoys a special status in memory when it comes to the acquisition, retention and memory of life experiences. It seems that emotional events, whether positive or negative, root themselves in memory more than emotionally neutral events. Again, researchers have observed that memories having to do with emotional events are richer; they contain more sensory details (visual and auditory details in particular) and contextual information than memories of non-emotional events. Thus, if you feel particularly touched by a particular photograph or a particular visual object, you will be better able to remember at what point you looked at it. The time and the place of an emotional event are in fact an integral part of the memory. What is more, the long-term consolidation of the memories will be particularly strong in the case of visual objects that have affected you. On the other hand, the memory of emotional events also has the characteristic of focusing on the central details of the situation and neglecting the surrounding events that do not have a direct relation to the emotional situation. For example, you would be less able to remember what the people in the background were like when you were looking at an image in an exhibition that caused an emotional response.

Influencing our attention, our memory, but also our choices, decisions and moral judgments, the emotions triggered by photographs, museum exhibits or life events thus ensure a central coordination of different brain systems that underlies our individual and social behaviour. We are prompted to seek out objects likely to subtly stimulate the processes of cognitive appraisal in us that result in the triggering of emotions. Looking for such objects is surely one of our essential motivations for visiting exhibitions such as 'Stigmata'.

Reference

Sander, D. & Scherer, K. R. (eds), *The Oxford Companion to Emotion and the Affective Sciences*, Oxford University Press, New York, Oxford, 2009

The Dead Die Once, the Disappeared Every Day

SANDRA SUNIER

Exhibitions and Publications, International Red Cross and Red Crescent Museum, Geneva

The dead die once, the disappeared every day
Ernesto Sabato, Argentinian writer

The photographs in this book, featured also in the 'Stigmata' exhibition, let us discover the work of young photographers who systematically distance themselves from the direct imagery of events. They all examine various situations of human suffering, but after the event. This suffering can be caused by the loss of a loved one, psychological after-effects of war or other physical violence, the contamination of landscapes that have been theatres of war, and the occasional destructiveness of nature itself. The photographs make us think about the way in which these impressions remain stamped on the people and landscapes.

The idea of 'trace' refers back to the past; in the words of the philosopher Jacques Derrida, it is 'the abiding presence of a residue'. The trace establishes itself in space and time and appears as a meeting point between past and present, where the past affects the present and where the present signals the past. With these photographs, it is the after-effects that evoke a humanitarian response. Like these photographers, the humanitarian workers often operate in the shadow of events. Responding to human suffering when it is not in the glare of the media is a challenge for humanitarian organizations. Emotion, evoked by what is direct, spurs the generosity of individuals when it comes to fundraising, and emergency humanitarian action provides a media 'return on investment' that reassures the donors. However, the response to change, and adapting to the challenges presented by social discrimination, movements of populations and armed violence and its after-effects, involves long-term and not very visible intervention. Just as photojournalists have seen their profession radically changed by the advent of the digital camera,

which makes it possible for anyone to broadcast images of human suffering in real time around the world, humanitarian organizations find themselves constrained by the media spotlight on disasters.

The question of the trace brings up not only the relationship with the past, but also the relationship with the individual's body and identity and the after-effects that can remain with them, as some of the photographs show. This, of course, is also the field of humanitarian work. Let us look at three photographers and three kinds of humanitarian action.

THE SEARCH FOR THE DISAPPEARED AND THE IDENTIFICATION OF THE DEAD

The search for disappeared persons is one of the typical activities of the Red Cross. The massacres and movements of population during the conflict in Bosnia and Herzegovina caused thousands of disappearances. The peaceful landscapes in *My Lovely Bosnia* by Christian Schwager implicitly refer to these tragedies, questioning the beauty of nature after the war. Today the Red Cross is still searching for disappeared persons and identifying the dead. Re-establishing family contacts or certifying deaths are indispensable elements in the reconstruction of people's lives.

PSYCHOLOGICAL SUPPORT TO VICTIMS OF DISCRIMINATION

Dana Popa in *not Natasha* shows the fate of young Moldavian women who had been kidnapped for the sex trade, on returning home. According to the International Organization for Migration (IOM), human trafficking is 'the most threatening form of irregular migration because of its increasing size and complexity, and due to the fact that it involves arms, drugs and prostitution'. Besides emergency assistance, the humanitarian organizations provide long-term psychological care. They thus help these women to integrate back into society and begin a new life.

PREVENTION OF NATURAL DISASTERS

The traces left by Hurricane Katrina, which struck New Orleans in 2005, are made visible in Robert Polidori's work. He shows how the environment sustains wounds that can have a devastating effect on the populations who live there. The poorest in New Orleans were trapped by the deluge because they did not have the necessary means of transport to leave the city or because they were waiting to get their monthly cheque. Preparing people to deal with imminent natural disasters, installing early-warning systems and revitalizing natural defences reduce the risks substantially. In partnership with local authorities and volunteers, the humanitarian organizations are in the business of prevention.

Without necessarily involving emergency action or spectacular images, humanitarian work, like the photographs in this exhibition, deals with human pain. The photographers and humanitarian workers bear witness to the intensity and the complexity of suffering, each in their own way. They remind us of aspects of society in which more is needed than just concern with immediate problems.

References

Paola Baril, 'Moldavie : migrations, traite des êtres humains et action humanitaire', in *Humanitaire* no.11, 2004

Rony Brauman, René Backmann, *Les médias et l'humanitaire*, Victoires, 1998

Christian Caujolle, 'Mort et résurrection du photojournalisme', in *Le Monde diplomatique*, 2005

Pierre Delayin, *Les mots de Jacques Derrida*, Idixa, 2004–2009

Mike Davis, 'Katrina', in *Le Monde diplomatique*, 2005

Lucia Iglesias, Casey Walther, 'L'insoutenable poids de l'absence', in *Courrier de l'UNESCO*, no. 9, 2008

Christian Schwager, *My Lovely Bosnia*, Patrick Frey, 2007

Thoughts on the Term 'Victim'

FRANCESCA PRESCENDI & MARC KOLAKOWSKI

Swiss Center for Affective Sciences, University of Geneva

'Never has so much attention been paid to the sufferings of others', states Guillaume Erner in a book that defines our society as a 'society of victims'.

'Victims' are people who experience mobbing at work, an earthquake, a road accident, sexual violence, a physical assault, and so on. All these people – because of the fact that they experience a situation causing them suffering – may be grouped together into the heterogeneous category of victims. On the other hand, an athlete who suffers during his sporting performance cannot be regarded as a victim. His suffering is something he takes on willingly; it is not imposed by somebody else. The suffering of the victim, by contrast, involves the idea of injustice and involuntary imposition on an innocent party and elicits a feeling of compassion and empathy in the wider society.

Sociologists and historians have shown that attention paid to the victim grows in step with the democratization of society. A key event leading to the modern concept of the victim was the French Revolution, which turned the hierarchical order of society upside down and put forward notions of brotherhood, solidarity and equality. Closer to our time, other key events have been, for example, the Marxist movement, the student protests of 1968 and the re-evaluation of the Holocaust.

While it is fascinating to trace the concept of 'victim' through modern and contemporary history, its earlier history allows us to understand how it emerged.

In Latin, 'victima' is a word belonging to religious terminology, and refers to an animal killed in honour of the gods. In the religious concepts of the Romans, the victim is a prestigious animal or human – the gods would not appreciate a gift imperfect and impure. 'Victima' is also used in a metaphorical or figurative sense outside the religious context. Cicero, for example, calls someone who was killed for political reasons a victima of the republic. Two centuries later, Tertullian sometimes calls the prostitutes given over to public enjoyment victims. The meaning of this term in a secular context does not seem to differ much from the meaning we attribute to the word 'victim' today.

In moving from the religious to the secular sphere, the term victim has therefore lost its connotations of prestige and consent. The only aspect that links the two spheres is the idea of undergoing one's fate: just as the religious victim falls under the sacrificial knife, so the secular victim is overtaken by the event that they experience.

When Christians developed their own religious language, they were faced with the issue of traditional sacrificial terminology. With the first authors to write in Latin, we find 'victima' used to refer to Christ or the martyrs. It continues to mean the figure at the moment of being killed as a sacrifice.

The term victim seems not to have been used early in modern languages. In French, for example, its first occurrence seems to be in the year 1485 in a sacrificial context; in 1552, it is used metaphorically (indicating the heart of an 'immolated' lover) ; since 1604, it is attested definitively in secular usage referring to persons killed or injured as a result of accidents or war, as well as those undergoing injustices. The dictionary entry 'victim' is indicative of the lack of importance of the term: 'victim' appears in one dictionary from 1690 complete with its religious and secular usage, but it is not given in any other from the 17th century.

The sporadic appearance of the term victim in the older dictionaries may indeed indicate the rarity of the usage in literature or conversation from the Middle Ages to the second half of the 18th century. The term victim appears once more in its religious and secular meanings, and, as stated earlier, the application of the term is extended from the exclusively cultic area (having to do with sacrifice) to a wider domain by metaphorization. In his *Manuel lexique*, the Abbé Prévost tells us that:

'Victim is used in a figurative sense of anything that perishes or suffers on the occasion of something, or by the violence of some power.'

This definition ends with a concept that is very significant for the rest of our lexicographic exploration: power. Indeed, both in times of the Revolution, when the people rose against the monarch, and under the Terror, when bloody executions became almost an everyday occurrence, the victim seemed to be in the grip of a power – individual or collective – that came to be identified more and more with the executioner.

While revolutionary propaganda resorted constantly to the word (and the idea) of sacrifice, its enemies, condemned to the scaffold, came to be referred to by the term victim. In fact, the *Complément du Dictionnaire de l'Académie française*, in its 1862 edition, tells us that victim 'has been used of persons condemned by revolutionary tribunals'. But the author of the article does not stop there and reports several expressions that were current at the time, and which can be usefully quoted here:

|| 'Victim's hair, Coiffure. Hairstyle recalling the appearance of condemned persons mounting the scaffold, and which became fashionable in some circles during the reaction following the 9th Thermidor. || Bal des victimes (Victims' ball), Ball to which one could only be admitted if one proved that one had a victim in one's family. || Victim's cutlet (cooking), one cooked between two other cutlets which are sacrificed by putting them on the coals, so that the juice of the two victims goes to the one in the middle.'

Thus the movement of reaction following the death of Robespierre was a key moment for the devel-

opment of various phrases using the term victim – but does that really imply a re-evaluation of the concept?

A quick review of literary and documentary sources at the beginning of the 19th century, as well as a reading of the definitive article on the topic by Ronald Schechter, allows us to identify a great many of these expressions (victim cut, victim belt and others, generally referring to fashions) as stemming from the Bal des victimes. Held at former places of execution or even in freshly decorated cemeteries, this ball is thought to have been a commemoration in dance of the victims of the Terror. Once inside, people greeted each other by a head movement reminiscent of decapitation, the idea of which was reinforced by a red thread worn around the neck. People wore a victim's cut, which meant the hair shaved at the back of the neck, which condemned persons were subjected to so the blade of the guillotine could cut cleanly. Victim's bands meant ribbons around the back, modelled on the bonds preventing the making of gestures on the scaffold. Through a whole series of accessories having to do with a real aesthetic of the victim, people attempted to recapture in a mood of derision and irony the painful image of those 'sacrificed' on the altar of the Revolution. Although there is no reason to believe that these frenzied dances ever existed, this does not at all weaken the idea that a new concept of the victim evolved between the Terror and the rise of Napoleon. What is important to us here is less the foundation in reality than the literary development of this representation of the victim. The gap between the Terror and the legendary Bal des victimes seems to be have been the period of time required for a notion rather uncommon and rarely invoked until then to become part of the collective imagination. The 19th century added a great deal to the usage of the term and made it common, in literature and elsewhere. In the meantime, there was a change of referent: people no longer spoke of victims metaphorically on the basis of ancient or exotic sacrifice; they were now invoking the memory of bloody episodes much less distant in time.

References

G. Erner, *La société des victimes*, La découverte, Paris, 2006.

Ch. Lamarre, 'Victime, victimes, essai sur les usages d'un mot', in B. Garnot (ed.), *Les victimes, des oubliées de l'histoire? Actes du colloque de Dijon, 7 et 8 octobre 1999*, Presses universitaires de Rennes, 2000

Tert. Cult femin. 12, 1: *Aud quid minus habent infelicissimae illae publicarum libidinum victimae?*

Dictionnaire de l'ancienne langue française et de tous les dialectes du IX au XVe s. de Frederic Gedefroy, tome 7, Paris, 1892, Emile Bouillons ed.

Trésor de la langue française, Edition du centre national de la recherche scientifique, Paris, 1994.

Dictionnaire universel d'Antoine Furetière, SNL, Le Robert, Paris 1978 (first ed. 1690).

Dictionnaire du français classique, Larousse, Paris 1992, dirigé par C. Kannas.

Manuel lexique, ou Dictionnaire portatif des mots français dont la signification n'est pas familière à tout le monde, Paris, 1750.

Complément du Dictionnaire de l'Académie française, Firmin Didot, Paris, 1862

R. Schechter, 'Gothic Thermidor: The *Bals des victimes*, the Fantastic, and the Production of Historical Knowledge in Post-Terror France' in *Representations* n° 61, University of California Press, 1998.

Memory on the Skin: the Chequered History of the Term 'Stigma'

AGNES ANNA NAGY & FRANCESCA PRESCENDI

Swiss Center for Affective Sciences, University of Geneva

In today's medical terminology, 'stigma' means a wound or a scar; in law, it is a stain on one's reputation. Metaphorically, in everyday speech, a stigma is the physical or mental sign of a past event that has not been dealt with; it is a painful reminder of irreducible 'otherness'.

'Stigma' (plural stigmata) is originally a Greek word (later also used in Latin) which means a bite or sting (from a snake, for example) as well as the effect that results from it, a mark on the skin, including one caused by a tattoo or branding with a hot iron. Tattooing for aesthetic or ritual reasons was not practised in the Greek and Roman world. It rather belonged to peoples considered 'savages', such as the Thracians, who lived on the edge of civilization. In Greece and Rome, tattoos (and therefore stigmata) were made on the forehead of slaves who had committed an offence. The letters were to indicate the crime committed: for example, the 'men of three letters' (*trium litterarum homines*) were branded with three letters to indicate that they were runaway slaves (*fug*, abbreviation for *fugitivus*) or thieves (*fur*, meaning 'thief'); others were marked by a letter k, which indicated that they were liars (*calumniator* with a 'k') . In general, 'stigmatized' people were sarcastically known as men of letters (*litterati*). Such a mark was considered a disgrace: one tried to cover it with one's hair or to wear a headband over it. Freed men even submitted to medical treatments to remove the brand.

Paul the Apostle was the first to claim proudly to be marked by stigmata: 'From henceforth let no man trouble me; for I bear in my body the marks (stigmata) of Jesus' (Galatians 6:17). Several explanations have been proposed for this statement in the two millennia since it was written. Some favour the idea of purely spiritual, invisible stigmata; others suggest it was a tattoo of the name of Jesus on the apostle's skin. The most common view saw these marks as due to ill-treatment to which Paul was subjected because of his faith (whiplashes or blows from sticks, stoning, and so on). At the same time, we must not ignore the fact that, when Paul speaks of the stigmata of Jesus borne on his body, it is to distance himself from those who find circumcision necessary for all Christians. For Paul, the only 'glorious' physical marks are those of suffering undergone for Christ's sake.

For more than a millennium, the term 'stigmata' has retained this meaning in both Western and Eastern Christendom. However, since the 13th century, a new and more specific meaning has emerged in the West: with Francis of Assisi (1224), stigmata became the marks of the Crucifixion that appear miraculously on the bodies of some chosen saints. The number of these 'stigmatized' persons is not known. Some authors, such as A. Imbert-Gourbeyre, estimate that there were more than 350. P. Adnès, more cautiously, avoids giving a number, since 'each case needs to be examined individually'. In any case, the number of stories of stigmatization is no doubt much higher than the number attested by fact. The Catholic Church has always been cautious and has never issued any decree about the nature of stigmatization in general, even if one of its representatives occasionally expressed an opinion for or against in a particular case. For the mass of believers the appearance of stigmata was an unambiguous sign not only of divine grace but also of the holiness of the person receiving them (consider the cult surrounding Padre Pio); for the Church, however, there is not a necessary or intrinsic relationship between stigmatization and holiness. It should be noted that the stigmata of the Passion in all cases follow the mental representation made of it by the subject, which is inspired by the tradition of Western iconography: nails in the palms of the hands and the feet, a wound in the left side, and often – though not always – whip marks on the back, marks of thorns on the forehead and of the cross on one shoulder. According to Pierre Vercelletto, the appearance of miraculous stigmata in the 13th century precisely coincides with the point where mystical compassion for the crucified Christ and adoration of his sacred humanity became important in Western Christianity, which until then had focused more on the risen Christ in glory and majesty.

The terms 'stigmata' and 'stigmatization' are thus invested with a specifically religious, Christian meaning. They recall suffering, but redemptive and glorious suffering. The 'stigmatized' are special people, marked by the sign of Christ, often the objects of popular devotion. At the same time, these same persons often have to deal with doubts about their sincerity (are they frauds?) or even their mental health (neurotic hysteria, crucifixion complex, religious obsessions, and so on).

In a possibly more sinister context, physicians, jurists and even philosophers have at various times in the past tried to pinpoint stigmata – in the sense of physical marks of certain personality traits or behaviours deserving punishment; visible signs by which dangerous individuals, madmen, criminals or simply 'inferior' types might be detected.

In the 1970s, the American sociologist Erving Goffman used 'stigmata' and 'stigmatization' as technical terms in his account of human relations. For him, the stigmatized person in his interactions with others exhibits an attribute, a stigma, that disqualifies him. The stigmatization derives from the gap between what he is in reality and what he should be according to others. Stigmata are numerous and varied. Goffman arranges these stigmata into two different categories: *visible* stigmata (physical attributes and personality traits directly apparent in social contact) and *invisible* ones (personality traits that are harder to detect).

The history of the term 'stigma' since antiquity shows a spiral development. First stigmata were a mark of shame put on slaves and criminals. Then marks of suffering were proudly owned by the Christians of antiquity as signs of glory that brought them close to the tortured and crucified Christ. From the Middle

Ages, stigmata have attained a transcendental dimension: they are considered to be of divine origin and are exclusive to a few chosen people having a special relationship with Christ. In the Age of Reason, these claimed miracles were often dismissed as tricks, or the physical expression of mental disorder. Since then 'stigma' has become a pejorative term again, used in a pseudo-scientific way to describe claimed physical signs identifying individuals with 'deviant' tendencies dangerous for respectable society. Recently, the term got another twist. Now the word 'stigmata' is not used to accuse individuals, but rather as part of advocacy for people excluded from society. In fact, it no longer refers to a physical mark – the painful reminder of an event or a state experienced – but a sense of guilt that society has projected on the individual. When we speak of 'stigma', the term often refers to the marks that an event leaves imprinted on the soul and that the memory can never get rid of. However, according to the defenders of the outsiders, the stigma bearer should not feel guilty for he or she is a victim of the event or state experienced; the external perception of other people creates or intensifies the feeling of guilt and causes exclusion. It is for that reason that we now talk of 'stigmatization' with reference to AIDS patients, people of foreign parentage, those who work as prostitutes or have a criminal record. All these people are part of society, but are marginalized by the attitude of their fellow citizens to their 'stigmata'.

References

Adnès, Pierre, 'Stigmates', in *Dictionnaire de spiritualité, ascétique et mystique, doctrine et histoire*, Beauchesne, Paris, 1990

Dallemagne, Jules, *Les stigmates anatomiques de la criminalité*, Paris, G. Masson; Gauthier-Villars, 1896

Falk, Gerhard, *Stigma: how we treat outsiders*, Prometheus Books, Amherst, 2001

Goffman, Erving, *Stigmate: les usages sociaux des handicaps*, Ed. de Minuit, Paris, 2007

Hug, 'Stigmatías', in *Paulys Realenzyclopädie der classischen Altertumswissenschaft*, 1929

Imbert-Gourbeyre, Antoine, *La stigmatisation, l'extase divine et les miracles de Lourdes: réponse aux libres-penseurs*, Clermont-Ferrand, Bellet, 1824

Jones, Christopher P., '*Stigma*: Tattooing and Branding in Graeco-Roman Antiquity', in *Journal of Roman Studies*, vol. 77, 1987

Levin, Shana /van Laar, Colette, *Stigma and group inequality: social psychological perspectives*, Mawah: L. Erlbaum, 2006

Mayet, Lucien, *Les stigmates anatomiques et physiologiques de la dégénerescence et les pseudo-stigmates anatomiques et physiologiques de la criminalité*, A. Storck, Lyon, Paris, 1903

Vercelletto, Pierre, *Réflexions sur les stigmates*, L'Harmattan, Paris, 2005

Scars on the Soul: The Impact of Traumatic Experiences on Mind and Brain

TOBIAS BROSCH

Swiss Center for Affective Sciences, University of Geneva

We are all sometimes confronted with negative and stressful experiences, such as the loss of a cherished person, severe health problems, relationship troubles or job loss. Such events make us feel miserable, keep us awake at night and permanently occupy our thoughts. Usually, however, after some time has passed, we deal with the situation, integrate it into our life and thus learn to live with it. Yet, sometimes people experience events that are so extremely disturbing that they cannot cope properly; those events leave long-lasting scars on the psyche. In the aftermath of a traumatic life event, intense and distressing psychological reactions can develop. This can happen to people in extreme situations, such as soldiers in war zones, rape victims, refugees or victims of terrorist attacks, but also to people who experience more common situations, such as victims of road traffic accidents or domestic violence. Professional rescue workers, who are frequently confronted with scenes of extreme devastation and human suffering, are another high-risk population.

The impact of trauma has been described by psychologists as 'a blow to the psyche that breaks through one's defences so suddenly and with such brutal force that one cannot react to it effectively'. The extreme strain imposed by a traumatic event leads to extreme psychological responses: the traumatic event is re-experienced over and over again in the form of nightmares, intrusive memories and flashbacks, memories of the event can trigger extreme fear, sleep and concentration are disturbed, and the traumatized person avoids conscious recollections of the event, expressed as amnesia for the trauma and reluctance to discuss or think about the traumatic event. These symptoms do not necessarily begin immediately after the traumatic event has been experienced, but can have their onset many years later.

One of the first descriptions of this syndrome was recorded by Samuel Pepys, the writer who survived the Great Fire of London in 1666. He noted that 'so great was our fear, it was enough to put us out of our wits. Afterwards, news of a chimney fire some distance away put me into much fear and trouble.' This description reflects how remote memories or thoughts about the traumatic event can trigger the strongest emotional responses. Sigmund Freud later described the 'anxiety neurosis', explaining how a psychological event can lead to a physical symptom. Memories of traumatic events are repressed, i.e. not consciously accessible, but later manifest themselves in a variety of symptoms which he called hysterical, including both psychological and physiological expressions. The current official diagnostic criteria for post-traumatic stress disorder (PTSD) by the World Health Organization also emphasize that the impact of a traumatic stressor will have both psychological and biological consequences, by describing 'a delayed or protracted response to a stressful event or situation of an exceptionally threatening or catastrophic nature, which is likely to cause pervasive distress in almost anyone. Typical features include episodes of repeated reliving of the trauma in intrusive memories, dreams or nightmares, occurring against the persisting background of a sense of "numbness" and emotional blunting, detachment from other people, unresponsiveness to surroundings, anhedonia (the inability to experience pleasure), and avoidance of activities and situations reminiscent of the trauma. Anxiety and depression are commonly associated with the above symptoms and signs, and suicidal ideation is not infrequent. The onset follows the trauma with a latency period that may range from a few weeks to months. The course is fluctuating but recovery can be expected in the majority of cases. In a small proportion of cases the condition may follow a chronic course over many years, with eventual transition to an enduring personality change.'

Almost everybody suffers from extreme stress and adaptation problems when a catastrophic event happens. Thus, post-traumatic stress in itself should not be considered as pathological. It is a natural reaction, as it reflects the adaptive mental processes involved in the assimilation and integration of new information. A disaster can destroy treasured possessions, one's health, or the health or life of loved ones, and it can also shatter hopes, dreams and assumptions about life. We all like to think that bad things only happen to other people, not to us – the so-called 'myth of invulnerability'. When we experience a disaster, this reveals to us that it is just a myth, and that bad things can actually happen to us. As a consequence, we have to restructure our concept of life and what we expect of it. This is a very deep and fundamental process, so it is natural that a large amount of stress is involved in making repairs to our internal representation of reality. Post-traumatic stress in itself is thus natural and useful, and should not be regarded as pathological unless it lasts very long, exceeds the limits of the tolerable and interferes to a significant extent with the normal functioning of the person. In some people, in about ten per cent of those who experience trauma, the stress associated with trauma does not recede, but takes a pathological development. This seems to depend on personal characteristics of the person and on the kind of disaster involved. For example, the probability of pathological development after a trauma is twice as high for women as for men, and the most frequent kind of trauma involved is the violent death of a loved one. For children, symptoms are different from those observed in adults. Children's stress responses are usually manifested as striking changes in character. For example, a child that was very quiet and withdrawn suddenly becomes aggressive, or a child that was very open and contact-seeking suddenly becomes extremely introverted.

Post-traumatic stress disorder is primarily caused by the experience of a traumatic event and the memory thereof. Usually, events and memories are integrated into existing schemata that we have developed to organize our world and our experiences. That is to say, our memory is an active and constructive process, we do not just 'save' our memories like we save data on a hard disk, but we change our memories in order to make sense in the framework of our beliefs and experiences. For example, if somebody has a generally positive idea (schema) of their childhood, the person will remember more positive than negative events, and will even change the memory representation of negative events so that they appear less negative. Traumatic memories seem to be processed differently,

as nightmares associated with the traumatic event are experienced over and over again without modification. Whereas normal memory is based on language structures, memory of traumatic events may be organized on a more basic level, involving mainly bodily representations. Thus, the recollection of traumatic events may occur in the form of bodily sensations and behavioural re-enactments, rather than language-based propositions. This would explain why traumatic memories cannot easily be modified by language or integrated into our normal schemata. Other psychological theories emphasize the role of the learning of the association between the details of the traumatic event and the intense stress response that occurred during the event. Any stimulus that is reminiscent of the situation can trigger very intense panic reactions (for example, the sound of thunder can be very stressful for a soldier who was traumatized on the battlefield). Biological studies have shown that there might also be a genetic predisposition to develop PTSD.

Post-traumatic stress disorder is accompanied by changes in brain function. Patients have been shown to have atrophy in the hippocampus, a brain area that is important for explicit memory functioning. Further abnormalities have been observed in the orbitofrontal cortex, a brain area that plays a role in extinction learning, the unlearning of stimulus-event contingencies. For example, a soldier who reacts with panic to the sound of thunder because he was traumatized on the battlefield (and has 'learned' that thunder-like sounds are associated with danger), will make the experience that, in everyday life, thunder is not associated with any danger, and thus would normally unlearn the connection between thunder and fear at some point. Abnormalities in the functioning of the orbitofrontal cortex, however, are associated with impaired unlearning, and thus a preservation of the fear response. Further research has shown that patients differ from healthy people in how they process information in general, and indicates that they have problems in 'filtering' incoming information, that is, in deciding what is important and what is not. Furthermore, PTSD leads to an up-regulation of adrenalin production, a hormone associated with the stress response, and a down-regulation of endorphin production, which diminishes pain experiences. This leads to increased muscle tension and increased pain perception, which are two typical complaints of PTSD patients.

With regard to the treatment options, given the importance of memory processes, a very important aim of therapy consists in helping the patient to structure and integrate the traumatic event into his memory schemata and into his experience. One intervention technique is 'psychological debriefing', where trained psychiatric teams try to help the traumatized victim as early as possible after the catastrophic event (directly at the site of an accident), in order to give no time for a dysfunctional processing of the experience. In psychological debriefing, participants describe their experience of the incident and its aftermath; afterwards, the therapist gives some information about stress reaction and stress management. The rapid intervention is supposed to help the trauma victims to regard the impact of the trauma as an injury that is directly related to their experience. To put it differently, the victims learn that what they are feeling is a normal response to the intense trauma, and that they are not 'going crazy'. However, the usefulness of these rapid interventions is debated. Only ten per cent of traumatized people will actually develop PTSD, yet, following this approach, after a catastrophic event each victim is psychologically debriefed. The intense immediate confrontation with the trauma during debriefing may actually increase the trauma in some victims. Other, more long-term psychotherapeutic techniques, based for example on cognitive behaviour therapy or psychodynamic approaches, come in later, after the traumatic event, when actual symptoms are observed. During therapy sessions, the therapist helps patients to place the event *within* their whole life experience, which may allow them to develop a new perspective and to view the traumatic experience and the reaction to it with a sense of continuity.

Two Kinds of Empathy

TOM COCHRANE

Swiss Center for Affective Sciences, University of Geneva

When we look at the photographs in this book, we are invited to try and understand what is going on with the people depicted. Sometimes, we are confronted with a face. Sometimes we see only the environment in which people have lived or suffered.

To appreciate what is happening in these different cases we need to employ our empathetic capacities in different ways.

Empathy is the ability to recognize, understand and predict another person's thoughts, feelings and behaviours. It is closely related to, though distinct from, sympathy, which is defined as a sort of 'pro-attitude' towards another person. For example, someone may empathically recognize that I am feeling sad and as a consequence feel sympathy and a desire to help me. But equally someone could recognize that I am sad and rejoice in that very fact. Again, someone who is generally sympathetic to my concerns may, as a result, be more sensitive to what I am feeling and thinking. But that sensitivity could equally be motivated by the desire to do me as much harm as possible! Thus empathy is a more general capacity of mind than sympathy. It is something that can *serve* one's desires concerning other people, whatever those may be, rather than something that dictates a certain kind of desire.

Given this basic definition of empathy, there is then an ongoing debate in philosophical and psychological circles concerning how exactly empathy is achieved. The two main contenders are known as 'simulation theory', and the oddly named 'theory theory'. As is often the case in philosophical debates, the difference between the two positions can be rather subtle, and different theorists will combine and modify the viewpoints in various ways. However, we can summarize the central claims of the two positions as follows: In the case of 'theory theory', the claim is that we have basic beliefs, or theories, about how individuals are made up – how thoughts relate to actions, what kinds of things people desire and so on. And we are able to develop these theories thanks to a central grounding belief that 'other people are like me'. This belief justifies the use of analogy, applying what I know concerning the relation between my own mental states and behaviours to the case of other people. So for example, if I see that someone is smiling, I might infer that he is happy because in my own case I tend to smile when I am happy.

Now 'simulation theory' also claims that we base our judgments on the likeness between ourselves and others. But the crucial difference concerns the mechanism by which the likeness is recognized. Simulation theorists claim that we do not need generalized theories about how people are put together. Instead, we run simulations of their mental states using our own comparable mechanisms. So what we do is take the

currently known facts about the situation, say that John has missed the train, and we pretend that those facts are true of us. Having placed ourselves in this mental state we then simply see what happens next. So for example, having come to believe that I have missed my train, I find myself becoming angry. I then apply the results of my processing to John and judge that he is angry.

Now in order to explain why I pretend to be in John's situation, and why I apply the results of my simulation to him, it looks like I need a belief, that I am like John. And so it looks like simulation depends on theory. But the case I have described is actually fairly sophisticated. It is the kind of process that I could engage in even if John were absent, the kind of process that is encouraged by photographs depicting the aftermath of some disaster. And I can build in all kinds of contextual information about the situation or about the character of the person involved, in order to make my simulation more accurate. There is, however, another sort of empathy. This is the case where I simply see someone's face, or observe someone's behaviour, and automatically replicate what they are going through. In this case, an empathetic simulation process can be triggered without the mediation of any theory or belief.

The discovery of 'mirror neurons' in human brains strongly suggests that this process takes place. Mirror neurons fire both when the subject is engaging in an action and when they perceive that same action being performed by another. So at a neural level, it looks like we process information about other people in the same way as we process information about our own states. The mechanism is then reckoned to underlie our imitative capacities, as well as the phenomenon of emotional contagion, where as a result of unconsciously imitating the expressive behaviour of other people, we find ourselves undergoing the same emotion.

Now if looking at a photograph of somebody's face causes me to subtly replicate making that expression myself, and this causes me to enter into a similar mental state, then I already have the 'like-me' stance required for empathy. I will still require an extra step in order to judge that the mental state I have entered into was in fact derived from the other person, and here is where theory may come in. But the point is that the realization about the other person can follow the imitation, can even be grounded in the imitation. To explain, suppose that I am looking at someone

smiling, and quite automatically I begin to smile and as a result begin to feel happy. Now because I am mentally focused on the other person, my feeling can equally be focused on the other person. I am not aware of being stimulated myself, rather I seem to directly perceive the other person's feeling. Compare this to touching a hot surface: it causes my fingertips to heat up, but I perceive the surface as hot, not my fingers (or at least not without additional self-reflection). If empathy is like this, then we can perceive the emotion of another person *with* our feeling, a sort of 'projective perception'.

So there are two kinds of empathy: one in which I absorb all kinds of information about the other person's situation, their behaviour, their character and from this information try to derive judgments about their mental state. Here simulation and theory can combine in all kinds of complex ways. The other sort of empathy is when I am confronted with another person's expressive behaviour and seem to perceive their feeling directly. The two methods are complementary. Having perceived someone's feeling, I can then look around for suitable reasons to explain that feeling. Similarly, having judged how a person is likely to feel, given their situation, I can more easily detect those emotions as they are subtly manifested in their behaviour. At the same time however, these two methods are suited to different types of situation, where either the person is right in front of you, or you are presented only with certain indirect signs of their presence. I invite the reader to view the photographs in this book with these considerations in mind.

Emotion and Vision: From Image to Concept

DIDIER GRANDJEAN

Swiss Center for Affective Sciences, University of Geneva

DOUBLE MEANING

The emotions we feel when we encounter visual scenes, in this case in photographs, can be of at least two types: it can be about the content of the image itself, which may be outlined in a detailed manner, as for example a photograph of someone's face that has been injured by physical violence and visibly presents stigmata such as lesions of the skin. This type of image induces emotional processes in people looking at it by mechanisms that can be termed 'direct'. The second type of emotional processing related to pictures does not present visible content linked to negative or positive emotions; the visible content is rather of a peaceful nature, relatively unobtrusive, even positive. This type of image does not, a priori, induce negative emotions linked to visible contents of the image. On the other hand, the narratives – the stories linked to these images – the stigmata mentioned but not visible, induce very strong emotions. In this context of distancing between what is visible and the story behind it, the facts have to be communicated by means of verbal narrative. We are no longer confronted with the image presented, but find ourselves 'within' the image by means of contextualization and interpretation; and that is the second mechanism by which emotions can be induced.

How is our nervous system capable of on the one hand constructing a visual representation of a photograph, and how on the other hand does it gain access to a meaning beyond what is visible and 'perceived'?

EMOTIONS AND VISUAL PROCESSES

Visual perception allows us to make a representation of what is in our visual field and to assign meaning to it in terms of the present and past context associated. In fact, visual information reaches us in the form of photons that stimulate our retina and neurons, that part of our brain that enables us to transform the electromagnetic waves linked to light into electrical information which makes its way through our brain across a large number of neuron relays and finally constructs a visual representation, to which we give a meaning based on our past experiences and the current context. Thus our brain reconstructs the visual information thanks to a series of changes in the activity of billions of neurons. When the photon strikes a neuron situated in our retina, a complex metabolic mechanism within the nerve cell, known as rods and cones, comes into action, resulting in an electrical discharge from the neuron; this produces what is called an action potential. This action potential – the electrical trace in our brain of the photon from the outside world – now makes its way from the retina through the whole brain to the occipital cortex at the back of the head. This movement of hundreds of thousands of action potentials originating in the retina spreads through the nerve fibres, the optic nerve, linking our retina to the visual cortex at the back of our brain and takes place through a number of neuron relays.

Information presented to the right visual field of an individual gets sent on to the back regions of the brain (the occipital regions) in the left hemisphere – an example of what is called the cross-over of the visual pathways. Thus, at an early stage of visual information processing, the information is broken down, and that is only the beginning of a prodigious analysis of information into smaller and smaller constituents which then have to be reintegrated so as to get to the coherent visual representation that we experience in daily life.

Apart from basic processing of visual information, the central nervous system assigns semantic characteristics, or meanings, to the object represented. From the back of our brain, the information is sent on to the temporal regions, which are able to identify objects. When we perceive an object in a photograph, such as a door or a face, it means that our nervous system has to link together a set of neuronal modifications indicating initially a change of colour, light or shape on the visual level, which will result in the formation of a representation of an identifiable object, such as a door or window.

Thus, beginning with a modification of the activity of the retinal neurons, we end up with a reconstruction in the form of an identifiable object with which the individual will be able to interact – for example by opening a door.

This is a brief description of the mechanisms by which stimulation of our retina leads to the construction of a representation of an object. But what about the emotional processes linked to vision by what was defined initially as 'direct' effects? The capacity of visual stimuli to set off emotional processes has been widely studied in the field of cognitive neuropsychology, the discipline at the intersection of psychology and neuroscience. An emotional response is the result of a series of cognitive appraisals, the main ones being: 'To what extent is the object/event relevant for me in terms of my goals and needs ?', 'What will be the consequences of this object /event?', 'To what extent will I be able to adapt to these consequences , or else fight them?', 'How well does this object/event correspond to my values and norms and those of the social group with which I identify?'

Emotion is the result of intense cognitive activity which can take place at different levels of processing in the central nervous system. It is not really necessary for the individual to be aware of their appraisals; these may take place mostly unconsciously, to the same extent that we are not aware that the visual system processes the shape of an object and its colours separately – it still produces the illusion of an integral image.

Obviously emotion is not limited to the cognitive level, but the appraisals described above will, through the activity of certain cerebral regions, have a significant impact on bodily activity. Your heartbeat will speed up, your hands will moisten, your muscles – to free you up for action – will increase their tone so that you can react more quickly in the face of potential danger. Your facial expression will betray your feelings; other people will take note of your emotion because of the way you express it visibly. Apart from this bodily activity, there will also be modifications of motivation. When there is an event requiring a rapid response because it is potentially threatening, the motivations that were present before will be relegated to the background and the urgency of reacting will come to the fore, preparing the organism for appropriate action. Finally, the nervous system will construct an integrated representation of all these elements (cognitive, bodily and expressive, motivational, and those having to do with action tendencies) and thus facilitate the emergence of a subjective feeling accessible to consciousness – and that is what we identify in everyday language as an emotion. These different mechanisms are supported by networks of neurons distributed throughout the brain. One of the most intensively studied structures in the area of emotion is the amygdala. This organ is made up of various subcomponents and owes its name to its almond shape. It is present in each hemisphere, deep within the temporal lobe.

An emotional visual stimulus representing a danger or particularly relevant element for the individual is processed as a matter of top priority by the amygdala, which then modulates the activity of the different sensory regions, for example the visual cortex. Thus a very striking stimulus, for example an injured face, would activate representations at a primary level in the amygdala even before any elaborate processing at the level of the visual and the temporal cortex as discussed earlier. The activation of the amygdala would induce an increase in neuronal activity of the visual regions, allowing better processing of sensory information and also activating an entire neuronal network, including the hypothalamus, resulting in bodily changes (increased

heart activity and sweating, for example). We can thus distinguish a 'high' pathway allowing complex visual processing, from a 'low' pathway allowing very rapid activation of representations which will enable the individual to react more quickly than they could if this pathway were not activated. These are known as the two pathways of Ledoux.

EMOTION AND PRESENCE 'WITHIN' THE IMAGE

To return to the earlier distinction between emotions felt in response to a visual stimulus via a 'direct' pathway, and emotions felt by an 'indirect' pathway, a photograph of an injured face would be an example of a 'direct' case. However, emotions felt with regard to the photographs in this book are not the result of such a mechanism. In these photographs there is no intrinsically emotional visual content such as an injured face or scenes of violence. On the other hand, the narratives accompanying these images, of violent episodes that the protagonists have experienced, induce emotions via another set of mechanisms.

Reading or listening to a narrative enables us to construct a series of representations thanks to the knowledge of the world that we have accumulated during our development and from our own life experience. We are not moved by these photographs as we would be by stimuli that trigger an emotion because of their visual content, but by the representations that we construct thanks to the narrative accompanying these images. The linking of representations in terms of the objects and our inherited human cultural values is supported by a complex series of neuronal networks. This involves not only memory aspects and thereby a well-known region in the temporal lobe – the hippocampus – which is central to the linking of semantic information and its context (for example the spatial and environmental context of an event that has caused a strong emotion), but also complex connections requiring the activity of the frontal regions of our brain, particularly the frontal and orbito-frontal cortex.

The values we acquired during our development and the visualization of the suffering of others call mechanisms of empathy into play. These require the integrity of frontal brain regions such as the orbito-frontal cortex, a region situated just above the eye sockets. Lesions in this area lead to irregularities in behaviour in terms of failure to conform to rules and accepted social attitudes. They can also give rise to difficulties in realizing the effects of one's behaviour on others and the longer-term costs and benefits for others and for oneself. Individuals suffering from such lesions show behaviour that is oriented towards short-term gain. They are, as it were, 'hooked' by stimuli, being incapable of disengaging from over-learned responses to stimuli such as food. With these patients, the simple presence of an object, such as a glass, will induce stereotyped behaviours learned during development, independent of the current needs of the organism. These patients also have difficulty in inhibiting a response that will bring immediate gain but that will have negative consequences in the mid- to long term; they suffer from disinhibition. The linking of visual or auditory information and meaning is highly complex and requires not only the construction of a representation of the object but also its integration into a series of concepts which gives the individual the key to its meaning at any given moment.

The marked contrast between the visual settings (the peaceful appearance of some of the scenes, for example) and the horrors that the individuals have witnessed reinforces the feeling of dissonance and thus of the triggered emotion. Again, such an awareness requires the linking of numerous types of information accessible in memory and the activation of brain regions to include visual reconstruction, but also the linking of all of these to the narrative elements.

Through access to reading and language, man is the only animal capable of referring explicitly to past events that modify his understanding of the present. These peaceful images and portraits and the narratives associated with them appeal to the highest cognitive and emotional functions of empathy that exist, resulting from a complex evolution of nervous systems that developed over time so as to represent the reality around us.

Sources of illustrations

2–7 © Frédéric Sautereau
15 © Victoria and Albert Museum, London
17 © Bank of America LaSalle Collection, Chicago
18 © Sophie Ristelhueber/ADAGP
23–27 © Frank Schwere
29–31 © Paula Luttringer
33–37 © Peter Hebeisen
39–41 © Ivor Prickett
43–45 © Pieter Hugo. Courtesy Michael Stevenson
 Gallery, Cape Town
47–49 © Steven Laxton
51–53 © Franziska Vu
55–57 © Indre Serpytyte
59–61 © Anna Shteynshleyger
63–65 © Guillaume Herbaut/INSTITUTE
 Courtesy Galerie Paul Frèches, Paris
67–71 © Adam Broomberg and Oliver Chanarin.
 Courtesy The Goodman Gallery
73–77 © 2003/2010 Taryn Simon. Courtesy
 Gagosian Gallery, New York
79–83 © Ashley Gilbertson/VII Network
85–89 © Gustavo Germano. Courtesy Casa Amèrica
 Catalunya/Registro Único de la Verdad de Entre
 Ríos, Argentina/HIJOS Regional Paraná,
 Argentina
91–93 © Christian Schwager
95–97 © Peter Püntener
99–101 © Guy Tillim. Courtesy Michael Stevenson
 Gallery, Cape Town
103–107 © Robert Polidori. Grateful thanks for the
 assistance of Flowers Gallery, London
109–111 © Suzanne Opton

113–117 © Henk Wildschut
119–121 © Suzanne Opton
123–127 © Maziar Moradi
129–131 © Raphaël Dallaporta
133–137 © Dana Popa/AnzenbergerAgency,
 Autograph ABP
139–143 © Shai Kremer.
 Courtesy Julie M. Gallery, Tel Aviv
145–147 © Jim Naughten
149–151 © Simon Norfolk/INSTITUTE
153–157 © Juul Hondius
159–161 © Léa Eouzan
163–167 © Raphaël Dallaporta
169–171 © Sarah Pickering. Courtesy the artist
 and Meessen De Clercq Gallery, Brussels
173–175 © Christoph Schütz
177–181 © Susan E. Evans

Acknowledgments

First and foremost, I wish to thank the photographers for their willingness to participate in this project. I express my gratitude to the International Red Cross and Red Crescent Museum for its invitation, first to propose an exhibition project, and then to produce what would be called 'Stigmata'. I wish to thank its director, Roger Mayou, and Sandra Sunier, the project manager. Both of them responded enthusiastically to the concept and spared no effort to make it a success. I also thank the Swiss Center for Affective Sciences – CISA – based at the University of Geneva, for its significant contribution to this book. I am grateful to its director Klaus Scherer, and to Carole Varone, Knowledge Transfer and Communication delegate, as well as to the following researchers who contributed essays: Tobias Brosch, Tom Cochrane, Géraldine Coppin, Didier Grandjean, Marc Kolakowski, Agnes Anna Nagy, Francesca Prescendi, David Sander and Pascal Vrtička.

I also offer my thanks to the numerous individuals and institutions who offered their help and suggestions to the project: Federica Angelucci, Michael Stevenson Gallery, Cape Town; Matthias Bruggmann; Adi Cabili, Julie M. Gallery, Tel Aviv; Chris Littlewood, Flowers, London; Lesley Martin, Aperture Foundation, New York; James McKee, Gagosian Gallery, New York; Grazia Quaroni, Fondation Cartier pour l'art contemporain, Paris; Kathy Ryan, The New York Times Magazine, New York; Thomas Seelig, Fotomuseum Winterthur; Jérôme Sother; Laurie Platt Winfrey, Carousel Research, Inc., New York.

I thank the Fondation de l'Elysée for its encouragement to make the 'Stigmata' exhibition possible: my thanks to its president, Jean-Claude Falciola, and its members Daniel Girardin, Jacques Pilet, Camilla Rochat, Marco Solari and Brigitte Waridel.

I am grateful to the staff and interns of the Musée de l'Elysée for their commitment to the project: Sam Stourdzé, its director, and Fanny Abbott, Lucas Bettex, Jean-Christophe Blaser, Nathalie Choquard, Jean-Jean Clivaz, Corinne Coendoz, Achour Djekhiane, Lydia Dorner, Pierre Furrer, Daniel Girardin, Christine Giraud, Michèle Guibert, Laurence Hanna-Daher, Stefan Holenstein, Pascal Hufschmid, Emilie Jendly, Sinje Kappes, Aurélie Koecke, Marie-Claire Mermoud, Pascale Pahud, André Rouvinez, Elisa Rusca, Manuel Sigrist, Radu Stern, Michèle Vallotton and Bruno Verdi.

I am also extremely grateful to publisher Thomas Neurath of Thames & Hudson for having embraced the project with such enthusiasm. Heartfelt thanks to all the staff at Thames & Hudson in London and Paris.

Finally, I express my gratitude to William Ewing, director of the Musée de l'Elysée at the time of the project's conception, for his support and encouragement at every stage.

First published in the United Kingdom in 2011
by Thames & Hudson Ltd, 181A High Holborn,
London WC1V 7QX

Copyright © 2011 Musée de l'Elysée, Lausanne
Photographs © 2011 Individual photographers

British Library Cataloguing-in-Publication Data
A catalogue record for this book is available from
the British Library

ISBN 978-0-500-54398-6

Printed and bound in China by Hing Yip
Printing Co. Ltd

To find out about all our publications, please visit
www.thamesandhudson.com. There you can subscribe
to our e-newsletter, browse or download our current
catalogue, and buy any titles that are in print.